The Eye

of the Beholder

A Randy Craig Mystery

By

Janice MacDonald

RaveN
S T O N E

The Eye of the Beholder
copyright © Janice MacDonald 2018

Published by Ravenstone an imprint of Turnstone Press
Artspace Building, 206-100 Arthur Street, Winnipeg, MB. R3B 1H3 Canada
www.TurnstonePress.com

Turnstone Press gratefully acknowledges the assistance of the Canada
Council for the Arts, the Manitoba Arts Council, the Government of Canada,
and the Province of Manitoba through the Book Publishing Tax Credit and
the Book Publisher Marketing Assistance Program.

This novel is a work of fiction. Names, characters, places and incidents are
either the product of the author's imagination or are used fictitiously, and
any resemblance to actual persons living or dead, events or locales, is entirely
coincidental.

Printed and bound in Canada by Friesens for Turnstone Press.

Library and Archives Canada Cataloguing in Publication

MacDonald, Janice E. (Janice Elva), 1959-, author
 Eye of the beholder / by Janice MacDonald.

(A Randy Craig mystery)
Issued in print and electronic formats.
ISBN 978-0-88801-649-2 (softcover).--ISBN 978-0-88801-651-5 (Kindle).--
ISBN 978-0-88801-650-8 (EPUB).--ISBN 978-0-88801-652-2 (PDF)

 I. Title. II. Series: MacDonald, Janice E. (Janice Elva), 1959- .
Randy Craig mystery.

PS8575.D6325E94 2018 C813'.54 C2018-904309-1
 C2018-904310-5

Canada Council Conseil des arts
for the Arts du Canada

Funded by the Government of Canada
Financé par le gouvernement du Canada Canada

MIX
Paper from
responsible sources
FSC
www.fsc.org FSC® C016245

MANITOBA ARTS COUNCIL
CONSEIL DES ARTS DU MANITOBA Manitoba

This book is dedicated to all the various artists in my family
Randy the poet, Maddy the singer, Jossie the dancer,
Roddy the storyteller, Louise the painter,
and Joyce the architect of dreams.

I am a better person for having had each of you in my life.

The Eye

of the Beholder

1

It is a truth universally acknowledged that as the temperatures dip, every western Canadian yearns for a week in Mexico. I certainly did. And this year, thanks to circumstances turning me into the greatest of stereotypes, I was getting my heart's desire, accompanied by my heart's desire. It was my honeymoon, in paradise. The only problem was, it was Reading Week.

Steve Browning, now my better half, had floated the idea the day after we were married, on a Thursday afternoon in January. I was teaching a couple of Communications classes for Grant MacEwan University, and couldn't take any time off for a honeymoon, so he had sorted out a week's leave to coincide with our annual February term break, officially known as Reading Week and unofficially labeled Ski Week.

Steve did all the leg work of booking the flights and hotel, while I got my post-Reading Week lectures set ahead of time, purchased a data package so that my students could get hold of me, and bought and accessorized a bathing suit. None of this

"grab some shirts and shorts and your passport and be ready at 5:00 p.m." nonsense. At our age, a week's vacation needed to be planned out like the first half of a heist movie. Not that I was complaining. If there wasn't time for at least one list, I would not have fun, no matter where we were headed.

And where we were headed was a wonderful place. Puerto Vallarta had been a beautiful family holiday spot for my folks and me during the Christmas of my second year of undergrad. I had fond memories of the little fishing village turned fabulous vacation destination. We had stayed in a modest three-storey hotel, shaped around an inner courtyard pool, with another pool down the walkway, closer to the beach. A breakfast buffet was on offer every morning till noon, and a marimba band played in the bar I was officially legal to drink in, even though it still felt weird having a beer with my mom and dad.

I had lolled on a deck chair, bartering lazily with beach vendors selling hats, silver jewellery, sun dresses and carved rosewood swordfish. I had eaten my own weight in red snapper. I had fallen in love with mariachi music. And I had burned bright red on our last day there, peeling like a zombie through my second term classes to my horror and my friends' amusement.

I wasn't aware of blathering on about my nostalgic love for the early eighties holiday destinations of my youth, but possibly it was just how tuned in Steve was to my desires, because here we were, well into the twenty-first century, and I was going back to Puerto Vallarta, Jalisco, Mexico to celebrate my marriage to the sort of man my father was annoyed not to have been able to toast at a formal wedding, and whom my

mother had designated "a keeper." They weren't wrong. Steve was that and more.

We had met during a rather traumatic time, when a young woman enrolled in one of my classes was killed and he had been one of the police officers assigned to the case. Our relationship had weathered a few more adventures of the more terminal variety, but, all in all, we had grown closer with every year that passed.

Steve had asked me to marry him last fall, while I was helping my friend Denise with a class reunion of our grad studies cohort. While several people had gushed on their comment cards that it had been the most memorable reunion they'd ever attended or heard of, I was still trying to put that part of the autumn out of my mind. That was made easier to do with Denise waving bridal magazines in my face.

She had been advocating for a bijou wedding in the chapel in old St. Stephen's College, with a handful of guests, and a dinner after at the Faculty Club, possibly in the Papaschase Room. Steve was up for whatever I wanted, and since he had no mother around to demand a full dress uniform extravaganza, I took him at his word. I had looked at dresses Denise was bookmarking in the magazines, and a few my mother sent as email attachments, but nothing seemed right.

"Think of it as a uniform, hon," my mother had written, trying to be helpful, "you only have to wear for one day." Once she put it like that, it all seemed a bit silly. Instead, I pulled out a green velveteen dress that had made Steve's eyes light up the first time I'd worn it, called Service Alberta to find out how a civil

ceremony worked, applied for the licence, and began to cast an eye around the city for a place to meet up with a justice of the peace.

The pyramids of the Muttart Conservatory seemed perfect, and reasonably priced, seeing as how they were offering us a virtual outdoor wedding in the middle of January. We were allowed to set up in a corner of the tropical pavilion for half an hour in which to exchange our vows and agree to the terms of the union we were entering. They offered us another forty-five minutes to have photos taken, but as we were such a small party, we were out of there in fifteen.

Denise, Iain and Myra McCorquodale, and Neal Harkness, our JP, convened at two-thirty on the Thursday afternoon. Outside the glass pyramid it was a sunny and crisp -15°C. Here inside, with finches twittering and hibiscus flowering, it was 25°C. Steve and I had written our own vows, but they were modeled on the suggested service offered to us by Neal when we had booked his time.

Steve looked scrubbed and shiny, having treated himself to a full shave and haircut at the old school barber downtown. His pale green dress shirt was the same tone as my dress, and his tie the exact shade. He wore his charcoal grey double breasted suit that always made me think he was about to break into a medley of *Guys and Dolls* tunes, but which enhanced his broad shoulders and made the touch of silver hair appearing near his temples seem like an elegant enhancement.

My green dress pumped up the green of my eyes, which was one of the reasons I loved it. I had decided to let my hair hang

loose, using a curling iron to tame only the very ends. My winter boots had been shined and polished and went right to my knees, tucking under the hem of the dress easily. Denise had designated herself in charge of flowers and had produced an extraordinary bouquet for me to carry, with sprigs of white heather, red roses and baby's breath, and two soft drapey branches of green cedar hanging down, all tied with a white ribbon. Steve's boutonniere was a red rose with a stalk of heather and a tiny pinch of cedar, and Denise was carrying a cedar bough with two roses, the ends wrapped with a green satin ribbon. It was incredibly elegant without being fussy and exactly what I loved about Denise. I felt like a princess, meeting my prince on equal and happy ground.

Steve and I took our witnesses out to a splash-up dinner at The Crêperie, a French restaurant tucked into the basement of the old Boardwalk building. The food was delicious, the waiters professional and discreet, and the design principle of little rooms feeding into each other allowed for us to feel completely secluded while other celebrations and first dates happened around us.

I couldn't imagine a better way to start my married life with the man of my dreams. And now, to top it all off, just a month late, we were dashing from the cab into the airport, shivering in jackets far too light for the season, to catch our flight to Puerto Vallarta.

After all, you didn't wear a parka to paradise.

2

The flight had been packed full, but Steve had conveniently booked us the emergency aisle seats by the doors to the wings, so we had a bit more legroom than the rest of the sardines. After four and a half hours, I had read the latest Kate Atkinson, played a word tumble game on my phone, and patted Steve's arm several times, willing myself to believe it was all true. The landing was uneventful and soon we were snaking along the slow line-up that was Customs and Immigration in Mexico. For some reason, four or five different flights had arrived at the same time. I was thinking they could have staggered that better, but Steve suggested that perhaps five more were on their way.

Once we retrieved our suitcases, we joined another line to head through the customs inspection red light/green light game, where bags were checked arbitrarily depending on the result of your pressing a button. Steve's press yielded a lucky green, and we sailed through, and onward past the gauntlet of people

waving to entice us to drive with them, with a short detour to a timeshare presentation.

Steve had arranged for a car to take us to our hotel, and there indeed was a young man standing with a sign saying BROWNING and CRAIG, who broke into a glorious smile as we identified ourselves to him. Maybe he had thought he was waiting for a law firm.

He led us outside and to the left, where cars were arriving to pick up newcomers, along a different lane than those taxis hauling tired and happy tourists back to the airport. Although I was a little too travel-dazed to understand the process, I could see there was a very well organized plan at work under the seeming chaos of taxis, mini-buses, hotel vans and larger coaches all weaving into an already congested area.

Our guide waved at a white car with a green seahorse painted on the door, and helped load our suitcases into the ample trunk. We got into the back seat with the cold bottles of water they offered us, while the driver and guide conferred, and the paper with our name on it was exchanged. Our driver, once back in the car, turned to us with a lovely smile and said, "Casa Doña Susana?" to which Steve nodded. "No problem!" our driver shouted, and we were off, into the maelstrom of cars pushing their way out of the airport parking lot.

The heat had been immediate and intense on the way to the car, but the taxi was blissfully air conditioned. We had left an ordinary winter temperature of -18°C at home, and arrived at a sunny afternoon of 28°C.

"I could use a shower when we get to the hotel," I said.

"What about a dip in the pool?" Steve countered and smiled. That did sound good.

Our hotel was not directly on the beachfront, but tucked up a block in the Emiliano Zapata neighbourhood, more commonly known as Old Town Vallarta, which was presently known as the Romantic Zone, for being the area most populated by the gay community who flocked to Vallarta. It was associated with another hotel which did have beachfront access, and apparently we would be able to head down with our towels and sunhats and get a lounging chair on the beach if we showed our wristbands.

The peaceful stillness of the inner courtyard of the hotel was immediate, and even more profound after the hustle and bustle of the street and taxi noise. I stood there, soaking in the warm terracotta tiles, the lush greenery of the potted plants, and the delicate lace of the wrought iron bannisters up the stairway and along the inner balconies.

One of the maids, dressed in a pale blue uniform with a full skirt and woven sash, smiled and nodded as she went past. Steve tapped me on the shoulder. "The elevator is back there by the concierge's desk. I have our keycards."

We rolled our suitcases into the small elevator and headed up to the second floor. We found ourselves walking only a short distance along the open hall, which wrapped around the atrium where I had just been. Our room was on the south side of the building, offering an "ocean view," which meant a glimpse if you craned out and looked to the right from our small balcony, but since it was the only view there really was from our little hotel tucked up a quiet side street, I was happy enough.

Steve pulled out the luggage stand and plopped his suitcase on it, and turned to claim my case, which he hefted onto the wooden bench at the end of our king-sized bed. Then he stood, smiling, my handsome man, looking at me as if I was the rarest bird in the surrounding jungle.

"Welcome to Mexico, Wife."

"Very happy to be here, Husband," I said, and walked into his arms.

3

After a bit, we decided to shower and change into our bathing suits and cover-ups to explore the rest of the hotel, and perhaps walk down to the ocean. Steve had popped our passports, extra cash, and his tablet into the portable safe he travelled with—a steel meshed bag with a locking tie. After he'd secured it to the drain under the bathroom sink and set the spare toilet rolls back in front of it, we were ready to set off.

Meanwhile, I had slathered sunscreen on my legs, arms, and face, dug out my floppy hat that I normally only wore to the Folk Festival, and slid my feet into my puffy-soled walking slip-ons. I offered to spray sunscreen on to the backs of Steve's legs, and he obediently stood still. After checking I had the key card, I grabbed my sunglasses and followed him out into the hall.

First we went upstairs to the pool level. There was a couple sunning on lounging chairs at the short end of the elegant L-shaped pool but no one in the water.

"Are we sure we want to go exploring further afield right

away?" asked Steve. "I could go for some decompressing right here." I nodded.

"There are fresh towels over there by the elevator. Why don't we just chill here for what's left of the afternoon?" He wiggled his eyebrows at me, making me blush. It occurred to me that for the next week, everyone we met would be assessing us by whether we had just made love or were heading back to our room for more than a siesta. That was what you signed on for by admitting you were on honeymoon. "We can go out and explore when we head out for dinner."

I set out our towels on chairs respectfully at the other end of the pool to allow the other couple their privacy, and they nodded and smiled at us. Steve pulled off his shirt, and walked into the pool. I scrambled in my purse for a hair clip, and folded my braid up the back of my head to keep my hair from the water. My sundress got draped over the back of the chaise, and my bag plopped down on my shoes between our chairs. I pulled my phone out for a few quick snaps of Steve and our surroundings, and then I, too, was in the sparkling water, paddling over to the edge where we could see off the top of the roof to other roof tops, a school, a square with a lovely gazebo, and the blue sea beyond.

"This really is heavenly."

"You sure? I could have aimed for one of the all-inclusive places down in what they call the Hotel Zone, but this seemed a bit more intimate, and I liked the adults only aspect to it. There will be a lot of students flooding the place in the next week or so, and I figured you'd rather be away from that scene."

"You figured right," I agreed, and pushed forward to kiss him lightly. "Having a break from students at Reading Week is the real joy. Having a honeymoon with you is just icing."

"I figure we have at least tonight and most of tomorrow before they arrive, since most of them will have had to stay for Friday classes. By that time, we should have the lay of the land, and be able to navigate around the worst of it."

"You make them sound like locusts," I teased.

"You're the one who once said the university would be so pretty if they didn't keep inviting all those students in every September," laughed Steve.

We made our way to the tiled steps at the end of the pool and climbed out to flop on our lounging chairs. I reached into my bag for my sunscreen to check whether or not it was waterproof. It was, but I set it on the ground by my shoes, within easy reach. The sun was hot, and at its afternoon hottest. The last thing I wanted was to burn on my first day in Mexico and have to wander about all wrapped up in zinc and cotton the rest of the week.

The people at the other end of the pool had smiled vaguely at us, making me think that the accepted policy here was to pretend that we weren't all sharing the same area. That was fine with me. I could easily maintain the cocoon Steve and I had been enveloped in ever since we'd dolled ourselves up for the ceremony. There was something so heady about being newlyweds, even at our age, with our long relationship.

During the last month of work and teaching, we had been walking about, delighted with ourselves, as we moved my furniture over into Steve's condo and changed all the addresses and

links to read "Browning and Craig." I suppose that was just as well, because even by the minimal standards of ceremony we had set, weddings and all the hoopla that came with them were a bit exhausting. It would be fine with me to spend a week totally wrapped up in my man.

We lazed in the sunshine until we dried off, and then meandered down to our room to get ready to head out for dinner and drinks. Steve had decided that since it was our first evening there, we ought to splash out with the most famous restaurant in Puerto Vallarta, especially since it was only a couple of blocks from our hotel.

La Palapa, which refers to the restaurant's giant version of the palm frond umbrella roof that one saw dotted along the beach, was situated right on the oceanfront, with a glorious view of the Bay of Banderas. Green glassware sparkled on every table, especially those dotted on the sand in front of the restaurant proper, and the service was elegant and meticulous. We chose to eat within the roofed area, mostly because I thought we'd stand a better chance of actually sitting where Elizabeth Taylor and Richard Burton had once dined. When our waiter discovered it was our honeymoon, he brought two frothy margaritas to the table. In the middle of our meal, three musicians entered the restaurant, remnants of a mariachi group perhaps, one with a violin, another with a guitar, and the third with maracas. Steve nodded and they formed a semi-circle around our table and began to play. I snapped several pictures, at first surreptitiously, but they moved closer to accommodate me, even as they played. The one with the maracas had a beautiful tenor, and it soared as

they serenaded us with "Bésame Mucho," which seemed a fitting song for a honeymoon.

Steve, who had somehow managed to already have a wallet full of pesos, paid the musicians, while I thanked them verbally in my phrasebook Spanish. When they had gone, we laughed together, in happiness and disbelief that we had both allowed that to happen and enjoyed it so thoroughly. We were not overly demonstrative people back home, and usually liked to fly under the radar, rather than become part of the floorshow. But this was Mexico, and while sunbathing tourists might maintain a code of privacy, Mexicans in general did not. "Fiesta" was the watchword, and the more the merrier.

We strolled along the beach walk toward the river after supper. A night market had set up across the bridge, and people were milling about and promenading. I caught snatches of German, French, and British accents, as well as the North American drawl of English and the omnipresent Spanish. Puerto Vallarta was the tourist destination for the people who lived in Guadalajara as well as international sun seekers, which made it feel like a truly cosmopolitan place where almost everyone was a tourist. Supposedly, the industry was 98 per cent tourism, and it had been named the Friendliest City in the World by *Condé Nast* magazine. People did seem happy to have us here. I didn't sense the weary tolerance one sometimes feels in places where tourists throng.

We walked hand in hand across the bridge, toward a porpoise fountain by the Naval Museum, and the beginning of the Malecon, a long, seaside walkway beautifully paved with

interesting symbolic designs, some of which I could decipher, like a seahorse, and a tortoise. I took some photos, hoping they'd turn out in the darkening light, and made a mental note to return in daylight. Vendors were selling light up toys, and what looked like an authentic pirate ship was anchored offshore, setting off fireworks. The whole town seemed to be out, couples and families strolling in the warm night air. T-shirt shops were open and people were promoting their night clubs, tours we could sign up for, timeshare deals we could make, tequila tasting, and all manner of other delights.

We opted to go into the one shop that didn't seem to be hawking itself—an indigenous arts store, with brightly beaded statues in the window, and a man in the corner, industriously creating the same art we'd been attracted by. A young man greeted us and offered us a sheet of paper decoding all the designs used by the Huichol Indians of the mountains to explain their peyote dreams. I was delighted to be able to decode the designs on the Malecon and tucked the paper in my pocket. Steve was smitten with a small parrot with a sun on its head and scorpions on its wings. Even without the exchange rate it seemed like a great bargain for original art. The young man took us to the back of the shop where an older man wrapped the parrot carefully in bubble wrap and bagged it while the young man handled the money. We decided, after careful consideration, to pay for it from our souvenir fund, rather than the wedding gift my folks had given us.

My parents, in their wisdom, had given us $2,000 to spend on art for our home. It was a smart gift in many ways, and had

come with a lovely note explaining how coming together to purchase a work of art was one of the ways that they had understood themselves as a new entity in the world. To purchase something so idiosyncratic together brought your aesthetics into play, and you learned things about each other and declared things to the world about yourselves. While we had talked about possibly finding something in Mexico, we had decided to explore Alberta galleries when we got back to Edmonton.

There was no one else in the store, so Steve shared that we were new to the city and on our honeymoon, and asked if they could recommend anything for us to do or see while we were here.

"The Rhythms of the Night," said the salesman, "is a very wonderful evening. You go across the bay, and get a good meal and a magical show." I had seen signs for that tour in several places, including our hotel lobby, and nodded. The older man said something very fast in Spanish that neither Steve nor I caught. The young salesman smiled and said, "He says that waiting for the sunset at the Cheeky Monkey is a good thing to do with a margarita." We thanked them for their suggestions and made our way back out into the warm night air.

We passed a neon "Tattoos" sign over a narrow stairway upward, which I pointed out to Steve as somehow a universal concept for tattoo parlours.

"Some of the ones in Edmonton are now boasting how antiseptic and health-standards focused they are. You would think you were in a dentist's office," he responded. "Hey, do you want to get matching tattoos here on our honeymoon?"

"Honestly, that sounds romantic to you? It sounds like potential gangrene to me."

"Well, if you're sure," he said, feigning disappointment.

The day was beginning to catch up with both of us, so we headed back toward our hotel. The night clerk smiled and nodded at us, and we took the stairs in the courtyard up to our room. Although it had been a warm day, our room, with its lazy ceiling fan, was cool enough for sleeping, and pretty soon we were tucked in to our already familiar king-sized bed.

"Sweet dreams, Randy."

"Sweet dreams to you, too. And to another day in paradise."

4

In an attempt to not miss a minute of my time in paradise, I had set the alarm on my smartphone, which is not something I do a lot. That is why, when it rang, it took me a few moments before I figured out what was happening. I finally reached for the phone, and blearily recalled my password to turn off the annoyingly cheery circus music I seemed to have considered an appropriate alarm ringtone.

I was alone in the bed.

It took me a minute to adjust to where I was. I rolled out from under the single sheet I'd been comfortable sleeping under, and padded over to the bathroom, which was also empty. Looking for my misplaced husband could wait until I had used the facilities. I closed the door to be seemly and took my time. After a revivifying shower and some time spent dabbing sunscreen moisturizer onto my face and neck, I emerged wrapped in a fluffy white towel to see Steve grinning from the door to our balcony.

"Where were you?"

"Out foraging for coffee. Come on out."

"Let me get some clothes on first." I dropped the towel and pulled on some underwear, and shimmied into a sundress. My stomach was growling as I hung up the towel and headed on the balcony to see what Steve had brought back with him.

Two takeaway cups of coffee were on the little table, along with a huge plastic cup of raspberries.

"I went down for a quick stroll to see what was what. There is a fantastic coffee spot right on the corner here, and just around the block and down the road is what someone on the street told me was the best breakfast joint in town. There was a family selling fruit on the street right there, so I brought this up to whet your appetite and figure we could head down for Fredy's Tucan pancakes after?"

"This is divine, and so are you. Pancakes sound fantastic, too." I pulled out a raspberry as large as the end of my thumb and popped it in my mouth. Steve leaned over to kiss me, and then took the other chair on the balcony and pulled the coffee toward him.

"Did the noise last night disturb you?" he asked.

"What noise?"

"There seemed to be some sort of party going on maybe a block away. It really got going about one-thirty."

"I think I could sleep through the apocalypse. Did it wreck your sleep?"

"No, I brought some earplugs, just in case, and they did the trick. I was talking to the coffee lady, though, and she says that

while this area of town is known to be party hearty, the next few weeks will be especially rowdy all down the hotel zone end of things, too, with all the university students coming down for their various versions of spring break."

"And that all begins with our students as of today."

Steve nodded. "Yep, today or tomorrow at the latest. With any luck, the U of A gang won't be the rowdiest they'll see."

"Well, let's make the most of today, before they descend. Should I pack up and be ready to wander after breakfast, or would we be coming back this way right after?"

"Let's be prepared to head out from there. Might as well grab every minute. My thinking was we could explore in the morning, and then maybe spend the afternoon back by the pool today. Tomorrow, if you'd like, we could head to a beach I read about right after breakfast. It sounds like there are several fantastic beaches within a half hour's bus ride, besides the Playa Los Muertos down the street here."

"Los Muertos? As in Beach of the Dead?"

"Yes, it's an unfortunate name for a tourist destination, eh? I suspect this is the area of the bay where the tide brings everything in. But there are all sorts of sandy expanses with different names all along the Bay of Banderas. We should explore as many as possible since, with the exception of that newly formed sand spit on the edge of the river everyone has been flocking to, every beach worth its salt back home is at least an hour's drive away."

"Don't forget the waterpark at the Mall," I quipped and Steve grimaced.

"Just thinking about it make me feel a plantar's wart starting on the sole of my foot."

"Sorry. So we set out ready to be out all day. But breakfast first?"

"Breakfast first."

"Then that all sounds good. Lead on, Macduff."

Fredy's Tucan lived up to its reputation for breakfast. I ordered a fruit and pecan waffle that arrived looking like a mountain of fruit topped with real whipped cream. The pecans were cooked into the waffle batter and chipped into the whipped cream, making every bite along the way a treat of one kind or another. Steve ordered the Mexican breakfast, and was brought a platter filled with eggs, beans, tortillas, some braised chilis, and a heap of fresh salsa. The waiter seemed inordinately pleased that Steve cleaned the plate.

People were lining up to get into the restaurant, so we had one more refill of tasty coffee and then set out to explore the bustling little city.

Eastward, toward the Sierra Madres, there were glassware shops, several pharmacies, art galleries, a fruit market, and Steve pointed out where we would be catching the bus the next day out to the lovely beach where John Huston had filmed *The Night of the Iguana*, the film that had brought worldwide attention to what had been a sleepy little port.

I snapped photos all along the way. I was glad I'd upgraded the phone, mainly for the camera. Although both of us had bought roaming packages with our phone plans, I didn't think we'd spend much time apart. After all, it was our honeymoon.

Meanwhile, Denise, who had demanded plenty of photos upon our return, was going to get more than she'd bargained for. The colourful wares, the glorious foliage, the beautiful people, and the well-maintained architecture on either side of the cobbled streets were all attracting my admiration and my lens.

We walked a few blocks north and found ourselves at the river, so we strolled along in the shade of huge trees until we got to a small hanging bridge to an island. We crossed over and saw what looked like a children's arts camp area, closed down for the weekend. As we strolled through the island, we found ourselves passing a Cultural Centre, a statue of John Huston, a beautiful looking restaurant called the River Café, before we ended up at a gauntlet of flea market stands. Serapes, sundresses, hats, leather crafts, knitted goods, carvings, and more hung outside the cave-like tents, with even more inside. We just smiled and shook our heads, though I was rather smitten with a T-shirt with the face of Frida Kahlo on it. I figured I might have to find one of those to take home with me.

We passed another fancy restaurant and climbed the steps up to the same bridge we'd walked the night before, which arced over the final spit of the island that pointed out into the sea and tied the Old Town promenade to the Malecon. In the daytime, the Malecon wasn't quite as crowded, except for groups of walking tours, perhaps because it was so lacking in shade. Still, people wandered about. I hauled out the paper of symbols I'd gotten when Steve had bought his bird statue and managed to point out a few of the Huichol peyote designs worked into the flooring. The scorpion symbol, which I could recognize quite clearly,

was apparently a symbol of protection as well as danger. It surprised me that anyone would let such a deadly little creature get close to them, let alone perceive them as protective. If they were native to these parts, I was going to start shaking out my shoes before putting them on.

An old man wearing a straw hat and a pristine white shirt, stood with a large gourd at his feet and a woven bag over his shoulder. I saw someone purchase an enticing looking drink from him and we decided to be adventurous. Steve counted out a very reasonable number of pesos for two glasses of cloudy coconut water, onto which he sprinkled walnuts and chopped apple. "*Tuba*," he explained, which we later found out was a traditional beverage. It was delicious, and absolutely refreshing.

We walked all the way down the Malecon to the end, admiring the verdigris statues along the way. My favourite were the little nun-like women climbing a ladder and looking out to sea, supposedly looking for intelligent life.

Steve liked the odd sea creatures who doubled as chairs, and we took a bunch of pictures of each of us sitting in them.

When we got to the rather anachronistic McDonald's at the end of the promenade, we turned back, looking for a place to eat lunch. The Cerveceria Union looked familiar, and I realized it had been the restaurant featured in a rather tortured movie I'd watched once just because it had Puerto Vallarta in the title. Steve looked at the menu and then spotted a man inside eating what looked like an old-fashioned milk shake glass full of octopus and shrimp.

"What is that?" he asked the hostess, pointing.

"Seafood cocktail," she smiled, and pulling two menus, guided us in to sit in what I was pretty sure was the exact spot where Scott Glenn had sat when he'd shot someone on the Malecon in *Puerto Vallarta Squeeze,* the movie I obviously remembered too much of for it to have been so low on my ratings.

I opted for fish tacos while Steve dug into his own seafood cocktail, delightedly describing every new urchin he was discovering in the lemony broth. The beer list was extensive, and we both decided that noon was a good time to begin drinking, especially on our honeymoon. Steve opted for a Negro Modelo, and I chose a Minerva Cobriza, mostly because I had never heard of it before.

With no place to go, we decided to order coffee and dessert. Our waitress recommended the mescal crème brulée, and who were we to disagree? Before we knew it, she was back, with a flat bowl of custard and a small blowtorch. She proceeded to burn off the mescal at the table, creating an evenly browned crust to the custard.

"The safety standards leave a bit to be desired, but the results are amazing," Steve commented as we dug into what had to be the best crème brulée I'd ever tasted. "I mean, did you notice those guys fixing their balcony back near the river? I think they were balanced on two buckets of grouting and a plank on the roof of a van."

I was too busy eating more than my fair share of our dessert to respond.

We strolled back along the Malecon, noting the location of the Cheeky Monkey for a future sunset drink, and dodging

hucksters wanting us to sign up with them for tours and time-share presentations.

There was a fresh breeze gently nudging the gauze curtains in our room, which had been set to rights by a maid who had also left an origami swan in the middle of the bed, made out of two of the hand towels and a washcloth. Steve excused himself to the bathroom, and I kicked off my sandals and lay down on the bed to rest my eyes.

The next thing I knew, Steve was rubbing my arm lightly.

"Sorry to wake you up, but if you sleep too long, I think you'll have trouble tonight."

"Oh gosh, how long have I been asleep?"

"A couple of hours."

"I'm sorry, I just meant to rest my eyes for a minute."

"That's okay, Randy. This is our vacation—we're supposed to be relaxing."

"Well, technically it is our honeymoon, and we're supposed to be enjoying it together. And you wanted to go to the pool."

"No worries. I caught some sun from our patio, looked through the hotel materials, and read my book." He motioned to the Lee Child paperback he had picked up at the airport. "If you feel like it, we could clean up and head out to watch the sunset from that bar on the Malecon, and then decide where we might want to eat."

"That sounds lovely." I heaved myself off the bed, and headed for the bathroom. "I guess this is what happens when you honeymoon in middle age."

"What?" Steve smiled.

"You end up spending a lot of time in your hotel room ... napping."

Steve laughed. "Oh, I think we can give the young ones a run for their money this week."

I shimmied in mock seduction down the side of the bathroom doorway.

"Rrrrrr," I growled, and then went to have a shower and wash the sleep drool off my cheek.

5

In Mexico, it's customary to close down business for three or four hours in the afternoon for a siesta, a time to rest, nap, or regroup in the shade, during from the hottest part of the day. Of course, in a tourist mecca such as Puerto Vallarta, most of the stores and restaurants didn't close, but I was betting it would be easier to get a plumber or electrician out at five p.m. than at two p.m.

Now, freshened up and wearing my pretty black sundress with the huge cabbage roses dotted on it, my black strappy sandals, and my Sophia Loren sunglasses, I felt like the whole town was laid out for me, a shiny new bride. Steve, even out of his uniform, turned heads, and both men and women eyed his strong, tall frame. His arms and legs visible now, as he wore a plaid short-sleeved shirt and cargo shorts, weren't as burnished as some of the people we passed, but he wasn't as glowingly white as some due to his Black Irish ancestry. The ropiness of his arms and strong muscles in his calves made up for the leathery

tropical tan of long-term visitors or the natural glow of the Mexican nationals.

Steve tanned easily, but I was going to have to watch myself, because as time went on, I had become more and more sun sensitive. It would be a fine thing to come back from a honeymoon in paradise with a horrible rash all over my arms and legs.

We found the Cheeky Monkey, and told the hostess that we had come to celebrate the sunset. She nodded enthusiastically and led us to a table by the open air window, where a waiter immediately came to offer us a selection of margaritas, and left menus to tempt us to stay for supper. Shortly after our drinks arrived and our order for fish tacos went in, the music level rose from background to dominant, and "Con te partiro" by Andrea Bocelli and Sarah Brightman began to play.

The sun was nearing the ocean, and as the music swelled, it sank into the sea. The song ended and the whole restaurant erupted in applause, as if the sun had performed exclusively for our benefit. I found it charming, though that might have been the margaritas talking.

We wandered back to our hotel in the old part of town, passing night clubs open to the Malecon, and their electronic music, girls on swings, pulsing lights, and the promise of foam parties.

"I have no doubt those will be even hotter spots come tomorrow," Steve noted, ever the cop. I was too busy watching a little girl seriously choosing a coloured wand from a street vendor while her mother and father looked on happily. Everyone we saw was focused on having a pleasant holiday and the staff at

every venue, including the street and beach hawkers, seemed to wish the same thing for their visitors.

We decided to take the beach walk once we were back in Old Town, and as we rounded the corner, we heard the unmistakable sound of mariachi music. There was a full band playing in a restaurant, resplendent in maroon costumes with silver starbursts down the sides of their trousers. We asked the hostess if we could come in for just a drink and she smiled and nodded, pointing us toward the bar at the far end of the open room.

We settled in, after ordering strawberry margaritas, to hear the music. There were eight of them, a guitar player, two violinists, two trumpeters, a fellow playing a mini guitar called a *vihuela* that was about twice the size of a ukulele, a large man with an even larger guitar called a *guitaron*, and a singer. I took a few snaps, and vowed to buy some mariachi CDs when I got home.

They played all my favourites from my mother's old Mariachi Vargas records: "Cielito Lindo," "Guadalajara," "La Bikina," "Jalisco," "La Bamba," and a new song to me, "Mariachi Loco." After a few more songs I didn't recognize, they bowed and took a break.

"According to the magazine in the room," Steve said, "Jalisco—the state we're in—is famous for several things: mariachi and ranchera music, tequila, rodeos, and sombreros."

"So, in other words, most of what we foreigners think about when we think of Mexico?"

"Yep. Did you know there is a Mariachi Music Festival yearly in Guadalajara?"

"That sounds like a wonderful vacation all on its own!"

"Maybe as an anniversary trip, Ms. Craig?"

"You're on, Mr. Browning."

After paying for our drinks, we wandered another block down the beach walk to the street that led up to our hotel, and I felt as if weights were sliding off my shoulders. It had been a busy time, teaching and simultaneously planning the logistics of the wedding, sorting out all the bureaucratic changes that were going to have to happen, as well as the hassles of moving and combining households. Steve had been right to suggest we do all that before the wedding, though, because now we could truly relax and indulge ourselves.

That was one of the best parts of being married, I was finding—having two heads when it came to deciding things. I smiled to myself as we climbed the stairs to our room. How long was that going to seem like a benefit in married life?

The next morning I began to realize that Steve really had been busy while I had napped the day before. He nudged me awake, telling me the shower was all mine, but we should hop down to breakfast pretty quick because we had a walking tour booked that started at ten o'clock.

"What sort of walking tour?" I called from the bathroom.

"A food tour," he called back.

"So I have to hurry up and eat before heading off to eat?"

"What can I tell you? This is paradise," he laughed. I turned on the shower and shook my head at myself in the mirror. It was a good thing we'd be doing a lot of walking or I'd be purchasing a whole new wardrobe after the honeymoon. Come to think of

it, it was a good thing my bathing suits had elastic shirring on them right here and now.

After a quick shower, I toweled my hair dry and braided it back, and scrambled into capris and a T-shirt. Deciding it was better to be prepared, I popped my tiny toothpaste and tooth-brush into the small inner pocket of my beach bag purse, along with my Alison Brown banjo cap. I sprayed sunscreen on my neck, arms, and legs, and spread SPF moisturizer on my face. If Steve wanted to head to the tour's meeting spot straight from breakfast, I was set. My watch, sunglasses, and phone were by the bed, and I popped the watch on my wrist, sunglasses on top of my head, and slid my phone into its little pocket in my purse.

My puffy-soled slip-on runners would probably be my best bet for the uneven pavements of the city. I slid into them and stood in my best Wonder Woman pose. I had accomplished all this in less than ten minutes.

Steve looked up from reading something on his phone in the corner where the Wi-fi seemed the best. "Ready? Let's go."

We considered trying somewhere else for about ten seconds, but both decided to head back to Fredy's Tucan, and were soon downing terrific Mexican coffee and digging into a shared order of fruit covered pancakes, my concession to the thought that we would be nibbling all over town later that morning. "I'm not sure what more I need to discover on this food tour, to tell you the truth," I said, wiping some whipped cream from the side of my mouth.

"I know, but Mark in Cyber Crimes was telling me about this tour, and said we really should do it early into our visit,

because there were some places off the beaten track that were worth finding. Apparently, we get a taste everywhere we go, and a lot of history and local info while we're walking along. They let about eight or ten people on per tour."

"Sounds fun. Where are we supposed to meet up?"

"By that statue of the little nuns on the ladder."

"My favourite!"

"Yes, I figured it was a good omen. That, by the way, is the work of a local artist Sergio Bustamante, who has a gallery here in town. If you're that taken with that statue, we should maybe check out the rest of his stuff. That might be where we could start scouting to spend your parents' art wedding money. He's famous for silver jewellery, but also for painting and sculpture."

"How long was I asleep yesterday? You sound as if you know everything about Puerto Vallarta!"

Steve laughed. "Not really. That's a very good magazine there in the hotel, and I did some research before we came."

"Of course you did. I would have, if I'd had the time, but honestly, it seems as if I've been playing catch up ever since the whole alumni reunion thing."

"I would say you had your hands full recovering from that, and packing up your place to move, and planning the greatest wedding ever."

"It was nice, wasn't it?" I reached over and squeezed the top of his large, firm hand. "I'm so happy, you know."

"So am I, Randy. This is the best thing that has ever happened to me, and until now I thought I had a pretty good life going there. This eclipses it all."

"Sorry to interrupt you honeymooners, but would you care for more coffee?" Our little waiter smiled as we untangled hands and allowed him to refill our mugs.

"Do you think he was just teasing us, or do we exude newly-wed status?"

"Would it matter?" Steve smiled and stirred cream into his coffee.

"Not at all, I'm just impressed with his powers of observation. Of course, they likely do see a lot of honeymooners here."

"And they likely shine on a lot of older couples by calling them that ... all fresh and new and in love." Steve took a look at the bill, and reached for his wallet. "Everyone wants to be thought to look young and in love, right?"

"I don't know. To me, it's the older couples who still walk hand in hand, or dance together on the floor like they've danced together all their lives, that really display the true meaning of love."

"Well, we have a shot at that, at least we do if we get me some dance lessons!" I laughed at him, and excused myself to let him pay up while I used the bathroom and brushed my teeth. I wiped the lovely ceramic basin with my damp paper towel and pulled on my baseball cap, yanking my braid through the hole in the back to tether it on my head.

When I got back to the table, Steve was just leaving a tip under his saucer, and ready to roll. We turned right out of the restaurant and headed back toward the beach bridge, which was already a cooler walk than the bridge two blocks inland. Without the breeze from the sea, the sun was crazy hot. I was glad I'd brought my hat.

As we crossed the bridge over the end of the island in the Cuale River, that we'd explored the day before, I stopped to take photos of the bay sparkling in the morning light. The water was clear all the way out to what I assumed was Las Caletas at the far end of the bay. I leaned out to get a shot of Vallarta to the right. I spied a girl below who had already staked out her sun tanning area right at the end of the spit of sand at the end of the island in the river. She had a woven mat laid out with an orangey-red beach towel on top. She herself was in a red bathing suit, with a large white and yellow straw hat covering her face.

It was odd to see the solitary sunbather there, rather than in front of one of the hotels, but perhaps that was where we off-beach hotel dwellers were supposed to go. I took a photo of her, mostly for the odd tableau composition of her and her belongings fanned out around her, with the wide ocean as a backdrop, so solitary in the midst of so many people. Tourism Puerto Vallarta might pay me for the image, proving you could get away from it all, so close to such a vibrant, busy city.

A man asking us if we had booked our tours yet startled me out of my reveries and we hurried along to meet up with our foodie group by my favourite statue.

6

Our tour guide was a very cosmopolitan fellow named Philip, who was originally from Puerto Vallarta, but had travelled widely, including schooling in San Francisco and some time running a business in Spain, before returning to his home town. He emanated a calm, mellow, good-humour, and was adept at herding twelve awkward gringos through the streets from one delicious stop to the next.

We ate at a street taco restaurant that was apparently famous among the workmen of Vallarta, who loaded up on the *birria* for breakfast before starting their labours.

We then went to a lovely open restaurant on a sunny corner that was touted as the best in town for *ceviche* by Philip, noting that the family who owned the restaurant also owned several fishing boats and kept all the best of each catch for their restaurant. There was a large table set up for us here, where we all got to introduce ourselves and mention where we were from.

We weren't the only honeymooners, as it turned out. Alison

and Simon from England were about half our age, and completely intertwined. She was a physiotherapist, but I couldn't quite understand what he was saying, so I just smiled and nodded whenever he spoke, which wasn't often. Alison seemed to be their designated speaker. We learned that they were staying at the Fiesta Americana, and she raved about the fiesta night the hotel had put on the night before.

"There was a fella standing on horseback doing rope tricks, which were absolutely brill. So was the dancing and of course all the mariachis. And Si didn't mind the tequila flowing freely." She laughed and Simon nodded in support, as she leaned her shoulder happily into his. I allowed as to how our hotel likely couldn't accommodate a horse, and she smiled sympathetically. I saw Steve suppress a laugh. I had a feeling these two weren't going to become our vacation buddies. Neither would the mother and daughter from Saskatoon, who were the least adventurous of the lot of us when it came to trying things.

There was another couple from Edmonton, making us feel like it was a very small world. They introduced themselves as David Rivers and Alessandra Delahaya.

"Alexandra?" I asked, not quite sure from her soft voice.

"Alessandra," she pronounced, sternly. "The Spanish version of the name."

"Are you from Mexico?" I asked, trying to make up for the faux pas of her name.

"My parents were from Mexico City. I grew up in Toronto, where I met David. His art interests have brought me closer to my heritage in the past several years, and we've done quite a lot

of touring in Mexico, but this is our first time in Puerto Vallarta. My cousin owns some pharmacies here, and suggested we come to visit."

I turned to her husband.

"Are you an artist?"

"Yes, in fact, I was the artist-in-residence at the University of Alberta last year, and am continuing on this year, covering for a professor on sabbatical."

I mentioned that I worked at Grant MacEwan University, which didn't seem to interest him at all, so we then turned to chat with the family of four from New York who were utterly delighted with ceviche, the dish of raw fish "cooked" in lime juice that we'd just been introduced to.

Elaine and Murray Reines were holidaying with their teenaged boys, who sounded as if they were on the food tour by sufferance, and relishing the thought of a snorkeling tour the next day.

Elaine and I exchanged email addresses after discovering that she was an adjunct English professor in Albany. It sounded as if the sessional lecturer situation was no better in the States than it was in Canada, but neither of us wanted to spoil our vacations discussing the depressing state of affairs.

Murray and Steve hit it off, too, and I was thinking we might connect with them again during the vacation, perhaps without their rambunctious progeny.

The mother and daughter duo refused to eat the ceviche, to Philip's consternation, but Steve gallantly offered to take a second portion, so we left enough empty plates not to cause an international embarrassment.

We watched tortillas being made at a local factory on our way to taste iced tamarind juice with chicken mole at Gaby's, an amazing restaurant up the street from the iconic crowned church in the middle of town. Philip mentioned that they projected old Mexican movies on the adjacent wall during the evening for their guests' entertainment, and Steve and I shared a wordless agreement to try to return later in the week.

Coconut meat seasoned with chili and lime juice from a street vendor kept us munching happily on our way to a candy factory, where we were exhorted to try another coconut confection. Alessandra waved off the candy, which was probably how she remained so chic and slender, but Elaine and I, her boys, and the British newlyweds dived in with gusto. Mucho gusto.

I bought some candy to take back to Denise, and Steve thanked Philip and tipped him generously for his time. The folks from Saskatoon seemed intent on purchasing a bit of everything in the candy store, so we left them to it. We waved to our new friends from New York, Alison and Simon, and the arty couple from Edmonton, and dispersed from the candy factory to do some more shopping in the downtown area.

"So, what should we do for dinner?" Steve asked, deadpan.

I hooted. "Explode? My god, I don't think I've eaten so much over the course of three hours in my life. And it was all so good!"

"I know, and I doubt we'd have found any of it, except perhaps this candy store, on our own."

"I definitely want to get more coconut chili this week."

"And that ceviche."

"Oh, damn, yes!"

We wandered along the street one up from the Malecon, where shiny yellow and white cabs bounced along the cobbles between middling decrepit blue buses, all sporting different destinations on the signs over their windows and a list of stops in white along the side of the windscreen. We moved around groups of people stopped at designated bus stops, and peered in shop windows. Steve popped into one of the drug stores and got us bottles of cold water, and we ambled on the shady side of the street, moving back toward the river at a leisurely pace. The Sergio Bustamante gallery was suddenly in front of us, with whimsical faces for door pulls. We decided to see what else his brilliant imagination had thought up and went inside.

A professional young woman was talking with a young man at a desk to the side. She smiled and welcomed us, inviting us to look around. I went immediately to a small version of my ladder ladies in the middle of the store. They were so charming with their nun-like wimples and headpieces, and cartoonish faces. Steve found them dotted on a silk scarf, and on several pieces of jewellery, too, forever climbing up their winding ladders.

There were also silver suns with happy faces beaming from jewellery for both women and men, and moon faces sliding out from bracelets, but the larger work for hanging on walls or making a statement in an alcove were really the scene stealers. Bustamante blended the delight of a children's illustrator with the brooding power of more primitive sculptures. I was smitten.

While one of his sculptures would have been amazing to own, they all cost approximately double what my parents had gifted us, and the cost of shipping would likely send that price

up another few notches. Still, I couldn't help smiling at the whimsical nuns.

Steve signaled to the young woman, who glided over to unlock a display case, and the next thing I knew I was leaving the store wearing a moon bracelet and some happy sun earrings, with a ladder nun scarf tucked in my bag. Steve was calling them wedding presents. As if all this wasn't enough.

"But what can I get you?" I hadn't thought that we should be giving each other gifts. I figured the pile of crystal and small appliances we'd been given by friends and family was enough. Steve smiled.

"Well, I have my eye on a set of golf clubs back home."

"Golf? Are we turning into our parents?"

"Iain has said he'll coach me a bit, but that it's a good way to move up in the organization."

"This sounds like some throwback to the 1950s. This whole marriage venture has tossed us back in time!"

"There was a lot to be said for the fifties. The fashion, for one thing. You look great in pencil skirts and boat neck tops and I think I rock a double-breasted suit."

"Do you ever. But there was more than fashion happening. The fifties had the Cold War, and civil rights issues, and women's liberation fulminating, with the glass ceiling at work and anti-depressants at home. Not that we've made much progress on any of that, except perhaps for not prescribing Valium to everyone." We had been walking along as we talked, and I looked around to get my bearings. "I'm perfectly happy in the here and now, husband dear, if only I knew where here and now actually was."

"The bridge is just around that corner ahead," Steve pointed along past the market vendors smiling and motioning to their wares along the block ahead.

Sure enough, as we turned the corner, we saw the bridge ahead. "And there's a nice place to have a refreshing beverage."

He was right again. The restaurant, with a bizarre, pale white marble statue of Elizabeth Taylor and Richard Burton that seemed to have been carved in lard, was tucked into the side of the bridge, and we sprinted across to avoid a lumbering truck and two yellow taxis.

The waiter motioned for us to choose any table, and we made our way to one in the shade by the river. He was soon by with menus and a small bowl of salsa and chips. Steve ordered another Negro Modelo, which apparently had become his go-to beer, and I had a Victoria, another beer I'd never heard of at home. I really couldn't eat anything more, but Steve decided to check the menu anyhow and ordered some guacamole and chips.

"I am not going to fit into the winter weight clothes I wore down here if I keep this up," I said, dipping a chip into the complimentary salsa.

"But think about all the walking and swimming we're doing. And don't forget, according to my exercise tracker, lovemaking burns forty-five calories per half hour."

"So, by the end of this week, we should have each worked off the equivalent of two margaritas? Not that I'm complaining. And as for the other activities, technically, we're ambling and floating. I'm not sure those qualify as aerobic workouts."

"This is not really what we need to be discussing. What we should be figuring out is where we intend to have supper tonight."

I laughed so loudly that the two solitary drinkers by the bar looked over.

Steve smiled, but I don't think he was actually kidding.

A man came into the restaurant and headed to the electric piano set up in the corner. He began to play beautiful music I didn't recognize, but which sounded romantic and wistful. We had no place to be and all day to get there, so we ordered two more beers, this time trying a different one each—Steve had a Dos Equis Ambar and I had a Bohemia. The man continued to play, and we watched a white ibis standing in the river. The sun sparkled on the water, and the heat wrapped around us like a warm massage towel.

More people had entered the restaurant, and by the time we left it was half-full. I was glad, because I wanted the musician to be fairly recompensed. We popped a couple of bills into his jar, hoping to promote the other patrons to pony up as well. He smiled and nodded as he continued to play a clever variation on "Cielito Lindo." It was funny. Either it was because I was married, or because it was Mexico, but I felt as if men were looking at me more appraisingly and approvingly. Maybe they always had and I had never noticed it before, but I didn't think so. Of course, I normally didn't walk around drinking at noon in the hot sun, so that might have been part of it. Perhaps it was just happiness they were noticing, somehow honing in on our newlywed aura. Or perhaps smiling at women was the Latin

American male default position. It wasn't exactly ogling, but it wasn't exactly innocent, either.

It made me even happier to be walking hand in hand with my beautiful husband, and we strolled across the bridge we'd been sitting next to, aiming in the general direction of our hotel. We passed the coconut man, and I made a mental note of how to get back there for more of his chili coconut meat. Steve was entranced with the *huarache* factory on the corner, and we spent the better part of half an hour trying on sandals, surrounded by the smell of warm leather. I felt as if I was in my Uncle Don's tack shop.

Finally, Steve chose a pair of traditional sandals with soles crafted from old tires, while one of the younger fellows teased him for the size of his feet by calling him "Sasquatch." When he admitted he was from northern Canada, they all laughed even harder.

I found a beautiful pair of red leather sandals that fit my foot, but pinched my little toes a bit. The older cobbler noticed, and put his finger right where the pinch was and raised his eyebrows in a question and I nodded. He pulled my shoe off, like I'd imagined one of the Prince's courtiers would have done to a stepsister in a fairytale, poured some rubbing alcohol into the leather in that spot and slid the shoe onto a wooden foot-shaped stretcher. He did the same with the other one, and then brought them back to me to try on. This time I wiggled my toes, the shoes feeling perfect. We paid for our footwear and shook hands all around before heading on our way.

The pool on the roof of our hotel beckoned and we spent the rest of the afternoon lazing in and out of the water, reading our books and re-slathering each other with sunscreen. Steve

disappeared for a few minutes down to the lobby, and returned with cold water bottles and the news that he had snared us a reservation at Ah Caramba for eight o'clock. And despite my moaning about overeating earlier in the afternoon, the thought of sitting above the town in one of Puerto Vallarta's most panoramic restaurants sounded like an absolutely perfect way to end a perfect day in paradise.

We left the pool at seven, noticing that it looked much different with the lamps lit around the patio, and went down to our room to change for dinner. Steve assured me that it would be casual but I opted for my best sundress. Men in Mexico seemed to get away with white trousers and a clean *guayabera* to look dressy, one of those shirts with the small pleats and vertical embroidery that Latin men wore so elegantly. Steve looked fine in his light linen jacket, coral T-shirt and brown trousers, with his new huaraches on his feet.

We popped into a cab at the end of our street, and though Steve was ready to offer him the address our concierge had written out for us, the driver knew exactly where we were headed and pointed his cab back into the downtown area, and then up a hill, along a winding road.

Ah Caramba was crowded, but we were seated right at the far end of the restaurant, looking over the lights of the town and the sea beyond. A young man with a cart offering fresh guacamole came by and made the glorious avocado salsa right before our eyes, while I took photos and Steve pushed pesos into his tip jar. He rolled his cart off to another table and I was just as happy to focus completely on my husband, who was perusing the drinks

menu and trying to decide between a banana daiquiri and a passion fruit mojito. I had already decided on a strawberry margarita, because I had seen one delivered to the table beside us.

We both ordered the shrimp and fish special and ate till we groaned. The food was divine and to think that we were eating in a restaurant tucked up the hill from Gringo Gulch, where Richard Burton and Elizabeth Taylor had owned connected villas which hadn't changed that much in the interim, was the icing on the evening. It made you wonder just what would have happened to this little village if the gossip magazines hadn't followed Liz and Dick down here during the filming of *The Night of the Iguana*. Would it have become the tourist mecca it was today? Would the Mexican government have determined it should become another Acapulco, catering to nationals and international tourists, without that push? Would we be sitting somewhere else entirely on our honeymoon without all that twisting path of history?

I couldn't see us honeymooning in the States, given the political upheaval and unrest occurring there. So California or Hawaii would have been out.

We might have chosen a trip to New Zealand. I knew we both wanted to visit the Antipodes, but it would have been impossible to fit in a trip of that length during Reading Week. We'd have spent the bulk of our honeymoon on planes.

I raised my glass in a toast, and Steve obliged.

"To Elizabeth Taylor, whose love and passion made all of this possible."

"To Elizabeth Taylor, and to working off that margarita."

"I'll certainly drink to that."

7

The next morning, we were up and packed for the beach early. Steve suggested we eat at Fredy's Tucan again before catching the bus, but I opted for coffee and a bowl of oatmeal at the charming Café de Olla instead. He grumbled a bit, but succumbed when he took a sip of their amazing cinnamon brewed coffee.

Even with the time it took to eat, we were on one of the first buses out to Mismaloya, equipped with cold water and a bag of fruit a little girl and her mother were selling next to the bus line-up. The orange buses pulled out as they filled, and soon we were bumping our way past Millionaire Row, and along the southern coast road. It stopped two or three places to drop off uniformed men and women for their shifts at fancy hotels, and we got off at the corner stop for Mismaloya, with the bus driver pointing the road down the hill to us. Very few people and no tourists got off with us, so we weren't entirely sure we were going the right direction, but as we wound our way down the hill past

a parking area for the huge fancy hotel we were circumnavigating to get to the beach, we both sighed with delight at the same time.

Mismaloya Beach, where Huston had actually filmed the Tennessee Williams epic, was bisected by a small waterway, easily forded by a bright orange bridge. To the right, where we had been, was hotel beach. To the left, where we were headed, were palapas maintained by two or three beach restaurants, and then several massage places, skirting the beach all the way to a pathway leading to the old movie set disintegrating behind a discreet chain link fence.

After walking the entire beach, we negotiated with a nice young man from the second restaurant, and set up camp under a palm frond umbrella at two lounge chairs with a tiny plastic table wedged between us. For the price of a drink every now and then, and lunch eventually, the chairs were ours for the day.

We swam in the clear water, already sun-warmed, and lazed on our towel-covered chairs. A family originally from Kentucky—two brothers, their wives and young children—set up next to us, and generously included us in an order of grilled shrimp that their children took against. They were staying together in a villa up the hillside, and had been coming to this spot for their family reunions for several years. We chatted happily with them, and I played cards with the two little girls while their moms and dads took a swim together at one point in the afternoon.

"Do you wish we'd started this life together earlier?" Steve asked, as we trudged up the hill to the bus later in the afternoon,

after saying goodbye to our newfound friends. "You were awfully good with those little girls."

"For an hour or so for one afternoon, but probably not for life. I honestly don't think I am the mothering sort. I think I would be very impatient, waiting for the time when a child would get interesting enough to actually talk to."

Steve laughed and pulled me close to him, making me realize I might have got a tad too much sun on my shoulders. The bus came shortly after we reached the stop, and we bumped our way happily back to town, my head on Steve's shoulder, which seemed to have escaped a burn.

To make up for eating our way across Vallarta the day before, we opted for a plate of fruit sent up to our room, and went to bed early. Steve slathered aloe lotion all over my shoulders and made me drink two bottles of water and take some aspirin before going to bed. I carefully lay down on my back, pushing my hair above my head on the pillow, to avoid irritating or rolling onto the sensitive areas. Heat throbbed along my shoulders and up my neck until the pills took hold, offering me some relief from the burn.

I slept like the dead.

8

Monday morning I woke up with the realization that we were on the downward slide of the vacation, with fewer hours left before we headed home than we had spent. Time truly is relative, in case anyone was wanting a solid second opinion before accepting Albert Einstein's theory. In my experience, the first half of any set time or event always seems to be fluid and expansive, and the time stretches out before you like a billowing duvet being shaken onto a king-sized bed.

Then, when you hit the midway point, even though you have exactly the same amount of time left, the clocks seem to speed up, and before you know it the entire sequence is just a set of memories. This is fine when you are having a tooth extracted or getting through a degree-granting program, but when it comes to holidays and honeymoons, or even summertime in Alberta, time's slippery tendencies can be a bit irritating.

We had two and a half more days in Vallarta. I still wanted to fit in the Rhythms of the Night tour, and Steve wanted to find a

snorkeling adventure. A woman by the pool had raved about a tour that took people out to see petroglyphs, a country bakery, the botanical gardens, and the requisite visit to a tequila factory, which also sounded nice. Steve and I decided we needed to check out Vallarta Adventures, the tour company that ran most of these planned outings, to see if we could fit in one or more before we had to return to reality.

Meanwhile, one of the things I wanted to do right after breakfast was to find the ArtVallarta gallery, because I had seen a poster for an exhibit in the restaurant bathroom the night before last. Apparently, local artists had responded to Frida Kahlo's art with their own, and they were displaying it under the title "Fearless Fridas." It sounded great.

Steve, while not quite as fixated on Frida Kahlo as I had always been, harboured a movie crush on Salma Hayak, so I'd been able to interest him in the movie she had produced and starred in. It was Frida, though, who had always fascinated me. I had been blessed with a social studies teacher who had expanded our unit on *Animal Farm* to include Trotsky's fleeing to Mexico, though Mr. Nelson hadn't elaborated on Frida's affair with the Russian exile. I had been wonderfully impressed with Kahlo, her thick, uncompromising eyebrows and her fierce adoption of native dress in a time when the whole world seemed hell bent on assimilating.

We set out with our small tourist map, and the picture of the poster I had snapped the night before, and turned left up the hill on Olas Altas instead of right back into the town when we got to our regular corner. I wasn't certain whether I was leading

us on a wild goose chase because the road seemed to peter out uphill after three blocks, but as we reached the crest of the road, we noticed that the street sign to the right said one thing, while a small sign pointing left into what looked like a cul-de-sac was the street we were looking for. A few steps down that lane, and I spotted the sign that said ArtVallarta above an open doorway that looked as if it was leading into a private home.

We looked at each other quizzically, shrugged and went in.

A woman was signing up for art classes at a front desk, while two elderly people walked past beyond into a studio. We were waved upstairs to the gallery, and left to our own devices.

The display was housed in three or four adjoining rooms, and included life-sized portraits of Frida and Diego Rivera painted on the women's and men's room doors of the gallery washrooms. We wandered past a dinner table set up with high backed chairs on which were painted the guests, including, to my delight, Trotsky.

Frida's style was borrowed to paint other subjects, and we saw Jim Morrison sitting with a cat and a monkey in one portrait, and Patti Smith as unibrowed Frida in another. The reverse was also true, and Frida was incorporated into *Le dejeuner sur l'herbe*, popped into a *Pietà*, and superimposed over the *Mona Lisa*. The variety was impressive and we found ourselves laughing and exclaiming as we rounded a corner to yet another take on the genius of Frida Kahlo.

One of the women we passed in the hall explained to us the concept of the place we were in. Apparently, as well as a gallery, ArtVallarta offered lodging to visiting artists, and ran classes for

ex-pat retirees. It was two or three buildings knocked together, and had been in operation for a dozen years or so. We were lucky to see the Fearless Frida exhibit, because they were in the process of pulling it down that afternoon to make way for a student exhibit.

"When we retire we could come here and take art classes," I mused as we re-emerged into the bright sunny street. "Did you see that sign for Watercolour with Veronica Rangel? She is the one who painted that magnificent whale hanging in the front foyer of our hotel. Can you imagine being able to learn from her?"

"You planning on retiring any time soon? I have a wedding to pay off still," Steve teased.

"No, not soon, but eventually, I think I would like to try my hand at living without set boundaries. It's not as if I have much in the way of savings, of course, but if I commit to eating lentils and lint, I think my RRSP could see us through about nine or ten months. I'm banking on your pension keeping us in the manner to which I would like to grow accustomed, to tell you the truth."

Steve laughed.

"Yes, I think it will manage that. And remember, now that we're together, a lot of our collective bills have been halved. One condo fee instead of that and your rent and utilities. One grocery bill, albeit a tad larger. One Internet and cable bill. Don't worry, Randy, we'll be able to retire in some sort of style."

"Marrying you was the most economically sound idea I have ever had."

"You still have to go back to work next Monday, though."

"I know, and don't remind me. There are seventy expository essays awaiting grades on my desk for when we get back from this Shangri-la."

Steve shuddered in sympathetic horror. "Let's not even think about work and Edmonton here. We'll be home soon enough. Don't let it intrude now."

I slid my hand into his and squeezed it. "Agreed."

We made our way back down the hill and aimed for the seafood restaurant with the great ceviche we had been introduced to on the food tour. Although it was barely noon, we thought nothing of ordering mojitos with our lunch. What was it about Mexico that made us so easy-going? If I even thought about having a beer with lunch at home, I could guarantee I'd be napping by two, and yet here we seemed to be half-cut and functioning most of the day. I wondered how it was for people in the all-inclusive resorts, where the drinks and food flowed freely.

I was intent on shopping for treats for Denise and some useful souvenirs for us, so after lunch we wound our way back along the main road. We popped into a textile shop selling cushion covers, rugs and tablecloths, and found a circular tablecloth with the bright squares of colour we'd been seeing in our favourite restaurants.

In a similar store down the next block, I found woven coasters, and a kicky leather wallet, tooled and stamped with the Aztec clock on the overflap. Denise would adore it. I also was taken with a little wooden heart covered in metal charms, which

the woman told me were *milagros*, or miracles, which would bring blessings into our home.

We crossed the bridge by the restaurant we'd patronized a couple of days earlier, and poked about in downtown shops, avoiding the overpowering mass of goods pouring out of The Flea Market next to the river. I was certain that I was expected to barter with the people running the stalls, which was not something I enjoyed or excelled at. Instead, we found a clothing store near the Church of Our Lady of Guadalupe, where the prices were fixed and the woman owner no nonsense.

She fitted me for an embroidered blouse, and then provided me with a choice of colours in my size. I settled on a black blouse with short sleeves and bright flowers embroidered on the yoke for myself, a cream one with tan embroidery for Denise, and a turquoise one with similar flowers to send to my mother. Steve was taken with the *guayaberas*, and we ended up buying him a light brown one with creamy embroidery, and picked up a grey one with black embroidery for Iain. Altogether, we spent less than eighty dollars Canadian on exquisitely made, hand embroidered clothing. I tried to keep visions of sweat shops out of my mind as I thanked the proprietress and climbed the short set of stairs back to the street.

We bought two glasses of tuba from the same elderly man with his gourd, whom Phillip, our food guide, had referred to as "Mr. Concepción," and sat on a wrought iron bench in the city square, under the shade of one of the large leafy trees. A school of dancers were giving a demonstration for the tourists, in cotton skirts and leotards. I presumed one paid dearly for the

massive frilly skirts and beaten silver studded trousers of the folkloric dance costumes we had seen pictured on the front of the tourist guidebook in our room. I wondered how many of these students were saving up for costumes of their own.

This whole city was focused on tourism, but I was happy to see that some of the training was aligned with keeping traditional arts and crafts alive. The embroidery, the dance, the music, the beadwork were all part of what made this such a special place, and it was heartening to see that the municipal and governing minds saw that as essential, too. If only our Canadian cities were as dedicated to cultivating and preserving culture.

Steve had finished his drink and walked over to a nearby litter barrel to dispose of the plastic glass. I watched him pull out his phone to take some photos of the dancers. I could tell from his angles that he was lining up a shot of the tall girl in the blue skirt dancing with the shortest of the boys, who didn't seem to mind at all that his partner towered over him. He was focused on his footwork and brandishing his machismo as he stomped forward, and then turned her into his side. She complied and somehow they looked more connected and attuned than the other pairs more evenly matched in height. I was impressed with both them and their teacher, who had obviously noted the innate talent in the two of them.

While I was watching the whole process of Steve watching them, I detected a change come over his body. He stiffened, and his phone, which he had been holding steady and touching lightly to snap a photo every time the pair turned to face our direction, was brought in closer to his chest, so he could read something.

He was receiving a text message, obviously, but it startled me because we had been so removed from that aspect of our everyday lives for the past five days.

We had actually talked about it before we left, whether or not to stay connected while on vacation. I had just been using my phone as a camera since we'd arrived in Mexico, even though I'd got the data plan in case students needed to reach me. I had rather forcefully mentioned to my classes that it was my honeymoon, and so far none of them had intruded. Of course, Superintendent Keller, Steve's boss, had insisted that Steve be accessible, on the theory that if a case he was involved in required his insight, he needed to be available. Steve had also purchased a roaming package for texts and calling, but mentioned it only to Keller.

So, if someone was texting Steve, it was work related. As if I couldn't tell that from the way his shoulders had tensed up in a way that had just recently taken the first two days of the honeymoon to relax.

I sat there, wondering how much I would be told about whatever it was that was about to intrude on my honeymoon. I decided to let him tell me if he wanted to, rather than asking. It would be an indication of how I meant to go forward in our marriage, not impinging on his career in any way.

It turned out I didn't have to task myself with such martyrdom. Steve trotted back to the bench and offered me a hand to get up.

"We have to find City Hall and connect with an international liaison to the police department right away. Apparently, an Edmonton tourist has been killed here."

9

I pointed to the big brick building just beyond where the children were dancing.

"That's City Hall."

"Okay, let's go."

I shivered as we walked from the warmth of the plaza into the cool of the dark brick building; it could have just been the air-conditioning, but I wasn't so sure. My mind had jumped to the Edmonton couple, the artist and his wife, we had met the day before, and it shook me to think we might have been eating with someone who was later murdered. Steve introduced himself at the front desk, showed his identification in his wallet, and we were asked to wait to the side.

We stood, and I checked out a mosaic on the wall, till a young woman in uniform came down a set of stairs and asked us to follow her. Up the stairs we went, and along a hall of glass walls with busy office cubicles filled beyond. We turned down the other length of the building and came to a rather magnificent

foyer, with carved double doors beyond. There were two leather couches on either side of the doors, and a couple of carved chairs by a small table in one corner.

Our guide knocked on the doors lightly, waited a moment, then opened the door and ushered us through it. Several people were in the room and most of them were in uniform. We were welcomed by a man in a guayabera and linen trousers, who introduced himself as the director for tourism, Emmanuel Robles. Señor Robles then introduced us to the mayor of Puerto Vallarta, the Chief of Police, the Director of the Tourist Police, the Canadian Consul from Guadalajara, and two detectives who had been assigned the case.

Although we were about to discuss a fatality, everyone smiled warmly at us as they were introduced. Steve introduced me as his wife, and I couldn't help grinning a bit when I heard it in the air. I immediately felt foolish for smiling in such circumstances, but the word "wife" still tingled as I quietly took a step back out of the business discussion. It was still going to take some time to get used to that appellation.

The consul spoke to us next, having looked to the others and received tacit nods of approval.

"Thank you for taking time from your honeymoon, as I understand, to help us in this terrible situation, Staff Inspector Browning. We're hoping that bringing you in at this time will facilitate matters in your own investigation at home, should we conclusively rule out involvement of a Mexican national in the case."

"I understand an Edmonton woman has been killed?" asked Steve. I just sat back in my allotted chair and tried to be invisible,

hoping they'd just forget I was there, as much as you can forget someone in bright coral capri pants.

"Yes, a tourist named Kristin Perry, who had flown in on Thursday evening. She was a student at the University of Alberta, coming for her spring break."

I felt a slight relief at hearing the victim was someone I had never met.

"They call it Reading Week, but I am afraid not much reading gets done," explained Steve, and everyone smiled ruefully, staying solemn in respect for the discussion of death hanging over us all. "We may have been on the same flight as the victim. We came on Westjet's Flight 254."

One of the detectives flipped her notebook pages and nodded.

"Yes, Ms. Perry was on that flight, along with her friends Andrea McManus and Jeannie Chua. They were sharing a room at the Sheraton Bougainvillea. They had gone out partying the first night, checking out the fiesta night at their hotel and then attending a foam party at the Mandala on the Malecon, and on Friday they had gone on two tours, one a Historic Mexico Adventure through Vallarta Adventures in the daytime, and then on the pirate ship booze cruise. The women met some young men onboard, one of whom they knew from university, and they chummed together throughout the tour. Ms. McManus and Ms. Chua state that they lost track of each other once they returned to the marina, but had agreed ahead of time that, since they all had keycards to their hotel room, they would meet up back there. Each one says that she came into the hotel room without turning on the light, and crawled into bed as quietly as possible."

"On Saturday morning, they awoke later than they had intended, and Ms. Perry wasn't in the room. It was hard to tell whether she had slept there the night before or not, since they had been doing without maid service to save on tipping. Her bed seemed rumpled, but they weren't sure." The officer flipped a page in her notebook. "They were in a room with two queen beds and a roll-away cot, and Ms. Perry had been in one of the queen beds."

"They checked downstairs in both restaurants and at the pool bar, asking if anyone had seen their friend, but they were still not overly concerned. Apparently, Ms. Perry was a very self-reliant young woman, who may well have decided to head off on her own for the day."

"They didn't call her? Surely they all had smartphones?" Steve asked.

The officer flipped back a few pages in her notebook, and consulted with the other, older, detective for a translation.

"The girls had all decided not to purchase 'roaming packages' for their mobile phones to save money, so they were reluctant to text or call her."

"By Saturday evening, they were annoyed more than worried, thinking that Ms. Perry might have extended a liaison with one of the young men they had met up with. They got dressed and went to the Rhythms of the Night, leaving Ms. Perry a note on the table of the hotel room in an obvious place. She didn't make the launch time at the marina, and hadn't appeared to have returned to the room. At this point, they got worried and sent her a text, which went unanswered."

"Early Sunday morning, three young boys from Vallarta were going fishing off the spit of the island in the River Cuale. They saw a woman lying on the beach on a red towel, with a hat over her head. It was too early for sunbathing, and the woman wasn't moving. When they got closer they could see that she had a very bad sunburn, and what they had taken for a red towel was actually blood."

"They swore they didn't touch anything, and one of them came straight away to the police station while the other two stood watch. We sent officers down immediately to secure the scene and my partner and I arrived at the same time as the coroner. Although the time of death is still not official, the sunburn would indicate that Ms. Perry had been lying there a full day."

The mention of the spit of sand at the end of the island scratched my memory, as did the red towel.

"I think I saw her," I said, screwing up my vow of silence. I scrambled for my phone, to see if my photos would back me up and tell us the time. It had been on route to the food tour we had taken. I remembered seeing a sunbather in red, lying on that spit of sand. I flipped back through photos of Steve with various edibles to find the photo I was remembering.

There it was, the solitary girl in the red bathing suit. I clicked the properties of the photo to find the time stamp. It was nine forty-five a.m., just before our food tour of Vallarta.

I had taken a photo of a dead woman while on my way to eat my way across the town. I felt the joy of our vacation slipping away, like water sliding off sunscreen-oiled skin. The honeymoon was over.

10

After I had emailed the photo to Steve and his Mexican counterparts, I was made to feel redundant. We agreed that I would head back to the hotel and Steve would continue to liaise with the police detectives, and meet up with the victim's roommates, who had been at the police station filing a missing person's report at the same time as her body had been discovered. One of them had required sedation, and both of them were sticking close to their hotel until their flight home, which coincidentally was the same one we were booked on. They had probably chosen the same tour package Steve had booked for us, little realizing how linked we would all end up being with him as investigating officer and them as witnesses. And victim.

The thinking was that Steve could learn what was available from his associates here, and then manage the inquiry for the Edmonton end of the investigation. The thinking and tacit message he was receiving from all the people in the mayor's office was that this was a situation completely Canadian that had

unfortunately transferred itself onto Mexican soil, but otherwise had little to do with Mexico itself. I could understand that. This was a tourist mecca; they didn't want something like murder besmirching their reputation.

And the odds were in their favour. Most major crimes involved either love or money, and since apparently Ms. Perry's wallet had been back at the hotel and she'd not had time to form a passionate enough relationship here, if love was involved, it had followed her here.

I dawdled on the way back to the hotel, picking up some fancy chocolates from a tiny shop and raspberries from a street vendor. When I got to our room which, since we were not doing anything so ridiculous as to eschew maid service, was beautifully cleaned and straightened. I got into my bathing suit, swearing to myself never to buy a red one.

I left a note for Steve and headed up to the pool with my hat, and my bag full of a towel, cover up, sunscreen, a book, a water bottle, chocolates, and raspberries. There were three or four people staked out already, but they nodded lazily to me, and I set up toward the long end of the pool, where I could see the green Sierra Madre mountains to the east.

The water felt refreshing after the heat of the streets, and I swam back and forth in the pool, pretending to myself that I was Angie Abdou, the Canadian sports fiction writer and competitive swimmer, cleaving a tight, clean line down the race lane. Of course, I was using a rather ungainly crawl I'd learned at summer camp years ago, and had never mastered the quirky little somersault to turn at the end of a lap, so I probably looked more

like Carol Burnett parodying an Esther Williams extravaganza. No matter; it did the trick, and by the time I pulled my dripping body out of the pool and phlumped down on the towel-draped chaise, I felt cleared of the stress that had descended while I was sitting with Steve and the officials in that office in City Hall.

So, there had been a murder. It was nothing to do with me, and, although it might cramp the style of our last day and a half of honeymoon, those were the breaks when you married a cop. We would get home, Steve would lead his investigation and life would go on.

Well, not for Kristin Perry, it wouldn't. The words of my book swam in front of my eyes as I recalled the solitary sunbather, left to burn and blister with no one to bother her. How had she come to be in that particular spot? Had her murderer lured her there in order to kill her? And, if she had been taken there straight from the nightclub, how had she been found in a bathing suit with all her beachwear? I made a note on my phone to tell Steve what I thought was a brilliant question, and then, in her honour, pulled out my 50 SPF sunscreen and slathered it all over my legs, arms and décolletage. My slight burn from Mismaloya had diminished, and I didn't want it returning.

Tans are a funny thing. Back in feudal times, it was unseemly to have sun-weathered skin, because it spoke of needing to labour on the land. Highborn women bathed in milk like Cleopatra, or at least covered their faces with wide-brimmed hats and wore gloves to ward off a tan.

Then, when the Industrial Revolution pushed the working classes into factories, gaining their skin a lovely pallor, the

· wealthy classes took to tennis and yachting and a tan became a coveted feature. To keep up, the working class tanned on weekends and vacations, baking with baby oil and reflecting the sun with tin foil to up the browning factor.

Now that the sun has become slightly less friendly, and melanomas more frequent and deadly, we are once more wary of overly tanned features, and those who are desperate for the beauty sensibilities of their youth head to spray tan boutiques. Of course, there are still those who gamble with their fates and sunbathe or visit tanning parlours, but I had noticed far fewer tanning parlours in Edmonton of late, whereas they used to be plentiful, offering heat and glow to people wanting to prepare for a winter holiday or preserve a summer tint.

I had tanned easily in my youth, but had been quick to espouse sunscreen after an uncle had lost a good chunk of his nose to a melanoma. Now, my own skin never got more than a light tan, just enough not to glow fish belly white when exposed to daylight. Besides, if I didn't wear a hat, my nose got incredibly freckled, and I felt that it didn't help, when trying to keep a university class in order, to resemble Pippi Longstocking.

On the whole, the people I had seen at our hotel pool were a sensible lot. They all had sunscreen bottles sitting by their books and beers, and most were wearing floppy sun hats. Mexican nationals themselves, at least in the shops and hotels, were always well dressed, in looser, flowing outfits like the men's guayaberas and linen trousers or the women's embroidered blouses and full skirts that repelled the heat and welcomed any breeze possible. Those who didn't work in the tourist industry, or who

chose tighter jeans and T-shirts, weren't doing themselves any favours in this climate, but they probably didn't see it that way.

I was probably going to live in my embroidered blouse during summer weekends in Edmonton; I could already imagine it. In fact, with our new tablecloth, and the few pieces of glassware we'd picked up, and our tops and shoes, there would be a great many markers back home to conjure up memories of our magical days in Puerto Vallarta. And wasn't that what you wanted from a honeymoon, or indeed any vacation?

Why had Kristin Perry and her friends come to Puerto Vallarta? Was it just a Reading Week get away? Sun, sand, and sin? Or was there something special that drew them to Mexico rather than Honolulu or Vegas or Disneyland? That was another thing to note down for Steve, although I was pretty sure he would already be thinking along those lines.

Before sliding my phone back in its little pocket in my bag, I checked the time. Steve wasn't back yet and it was already past five o'clock. Most of the people had left the pool deck, although an elderly couple was still sitting at one of the patio tables with an umbrella up the middle, playing cribbage.

I figured I should go back to the room to change before the sun moved too far toward the edge of the ocean, so I gathered up my towel, and slipped on my sandals, tossing my book and sunscreen into my bag. There was a woven basket for bottles and cans next to the garbage bin, and I tossed my two water bottles.

Back in the room, I got dressed in my new blouse and a denim skort. I turned on the television for company. There was a soccer game playing on one channel, a rather steamy telenovela

on another, and a news program on a third. The commentator was speaking very clear Spanish, but it was still too rapid for me to catch more than a word here or there. I kept trying to hear similarities to French, which was my only other competent language, but they really didn't correlate. In fact, I remember my mother having a story about being in a restaurant with friends in Spain, and having one of them attempt to order for herself, instead of having Mom the amateur linguist of the group, help her. She had ordered *café* and a slice of *gâteau*, and the horrified waiter turned away and never came back, leaving them to pack up and depart without anything. It was only later, when their urchin guide was walking them back to their hotel that a stray cat ran across the street and he pointed, saying "*Gato!*" that they had realized how they had offended the restaurateurs.

The news anchor here wasn't talking about cats, but I did catch a couple of words, especially the word "Canadian." There were no gory pictures, but the cameraman had caught a photo of fishermen standing on the spit of land where the body had been found, and then cut to the nightclub where the foam party had been, just down the Malecon from the club where the giant swing went out over the crowd outside.

They were obviously talking about Kristin Perry, and I watched to see if they might have caught Steve talking with the Vallarta police anywhere. But no, that was all they had. I couldn't even tell from the rapid Spanish whether they knew that Canadian police were helping with the investigation. The newscast went on to feature a car accident near Nuevo Vallarta, some

stingray-stung tourists in Sayulita, and a record-setting marlin being caught by a local fisherman from Boca de Tomatlan.

The weather was going to continue glorious, and just like back home, the rest of the newscast was devoted to sports. I turned back to the soccer game, not because I particularly enjoyed watching it, but because I knew the rules and could follow it in any language. The telenovela would be too hard to figure out, although I could try to look up the words "evil twin" in my phrase book.

Steve walked into the room just as the match was finished, with Guadalajara beating out the Jaguares Chiapas 3-1. His eyebrows shot up as I whooped for my newfound team.

"Where is my wife and what have you done with her?"

I jumped up and hugged him, I was so glad to see him and it felt like it had been ages since we'd been together. While I knew Steve could take care of himself, an absence that long, especially with thoughts of tourist murders in my mind, had a chilling effect. He returned my hug with just as much pressure, and I knew it hadn't been a good afternoon for him.

"Do you have to go back tomorrow to deal with this?" I asked, hoping he'd say no.

Steve shrugged his shoulders. "I'm really not sure. The roommates have been interviewed, and I read through translated transcripts of theirs and the nightclub workers' interviews, and another set of interviews with the pirates, who are actors and sailing enthusiasts, but there is no way to find all the folks who had been there on either evening who might have seen anything. They are planning to put a flyer in the lobbies of some

of the more popular hotels with the tourists who might have frequented either event, but aren't optimistic. Who wants to get involved with a criminal investigation while on holiday?

"That said, I do have some good news. If you can handle two tours tomorrow, you and I have tickets to the tours that Kristin Perry and her friends booked: the historic Mexico tour during the day that they all were on, and the Rhythms of the Night, which the two went on, hoping to see Kristin there. The idea is for the Canadian arm of the investigation to be familiar with all the territory discussed in the interviews. I will have to ask the guides a few questions and report back to the local authorities before we head home, but it shouldn't get in the way of our having fun on the tours. How does that sound to you?"

Rhythms of the Night was the tour everyone had been recommending, and the historic Mexico tour sounded similar to the one the Reineses from Albany had been on that sounded intriguing. Or maybe it had been the older couple by the hotel pool who had raved about it. People were starting to swim together in my mind. At any rate, at the risk of sounding ghoulish, I was delighted to be going on those particular tours. Although it would mean Steve's snorkeling tour was off, his having to connect with the Mexican police had likely already put the kybosh on it, anyhow. And if we were getting the tours for free, maybe I could therefore afford to buy one of the lovely vases we had seen in a gallery down the street.

"And whoever the local version of your Staff Superintendent Keller isn't going to be upset that I am along with you on the tours?"

Steve smiled. His boss really did seem to be averse to my being part of any incidents Steve was involved with back home.

"No worries. In fact, one of the detectives in charge thinks that our being a honeymooning couple works in the investigation's favour, since he believes the guides we'll be speaking to will be more at ease dealing with us than with officials in uniform."

"Well, in that case, count me in!"

11

The next morning, we had to bounce out of the hotel early and grab a cab all the way to the marina district to meet up with the tour. Vallarta Adventures was housed in a strip mall with a small shop, large check-in counter and washrooms inside, and a seating area along the side of the shop outdoors, where guides would come and ask you to follow them based on the tours you'd signed up for.

There were twelve of us signed on for Historic Mexico, and Luz, an intrepid young woman wearing red shorts, hiking boots, a Vallarta Adventure polo shirt and a kerchief around her neck, led us out of the holding pen and down the block to our Unimog, a huge utility vehicle with benches down either side of the back. Our driver, Fernando, helped us up the wooden step to get in, and once we and Luz were settled, he loaded the stool under one of the benches, strapped canvas strips across the back, and headed around to climb into the cab. The wheels were huge and capable of off road adventures when the tours went down

riverbeds and into the jungle, but Luz assured us that while we were going to be on some backroads, we were using the Unimog mostly so that we could see the sights more easily. She did mention that we might get chilly as we went into the mountains, and that it might get windy along the highway, so I was glad I'd brought my sweater and my own windtunnel scarf, an extra wide hair band marketed mainly to skiers, but which I found useful on even ground, as well. It made a nice neck scarf when not needed, and kept my hair out of my eyes and mouth during Edmonton's windy days in the spring and fall.

As we headed out of the city along the route Steve and I had taken by bus to the beach, Luz pointed out the villas along the highway.

"These are for wealthy people who have come here to live from the USA, some Canadians, too." She smiled at us, inclusively, as if we could be included in that grouping—or perhaps knowingly including us in the group who would always be outside looking in. The places were ostentatiously innocuous from the road, offering only a driveway and garage doors, but the homes themselves were built down the cliffside with an unimpeded view of the ocean. In blustery weather, they'd be buffeted, I thought, but that could have just been sour grapes talking.

We passed Mismaloya, and Boca de Tomatlan, and continued down the highway. Eventually, we turned off the highway onto a country road, which meandered through scrub farmland until we found ourselves on an actual farm track and Luz announced we had reached our first stop. My initial reaction was disappointment. This was historic Mexico? However, we all

gamely climbed out of the Unimog and followed Luz down a track between two pastures. About fifty metres in, she turned into one of the pastures at an opening in the fence, and led us to some black basalt outcroppings.

As we gathered around, she pointed out the petroglyphs which Luz announced anthropologists were still uncertain about, though some seemed to indicate season, and others showed numbers. It was posited that this was a hunting area, and the third stone was either a place where they dressed the meat or where they made sacrifices, because bloodstains had been noted there. The people of ancient Mexico were nomadic in nature in the same way as western Canada's original indigenous inhabitants, moving with the seasons and the food supplies.

I surveyed the farms near the stones. A cactus crop was being tended in straight lines in one field, and goats were grazing in another. Ingenious farmers had developed ways to sustain themselves in this area, where most of the fields had been given over to growing blue agave for the tequila industry. I considered the groceries we bought at home and wondered if I'd see where my tomatoes and strawberries came from, but Luz told me that the strawberries I ate all winter long most likely came from the state of Veracruz rather than Jalisco.

We ambled back down the farm lane and climbed back into the truck with the help of Fernando, who was also doling out bottles of water from a cooler. I noticed that Steve had managed to walk back behind the rest of us, in discussion with Luz. While it may have looked to the others that my husband was an anthropology geek, I knew that he was more likely quizzing Luz

about whether or not she recalled Kristin Perry and her friends during this same tour earlier in the week. Luz was nodding seriously and quite animatedly using her hands to describe the girls: one very petite, another tall, and Kristin in between, with long hair and a good figure.

Steve must have impressed Luz not to ruin the tour for the rest of the people by sharing who he was with the nice family from Seattle, the retired couple from Calgary, the touchingly young newlyweds from Winnipeg, and the pair of British travel writers.

On we went to see a tequila factory, a rosewood carver trained by his father and grandfather before him, the city square in El Tuito where, according to Luz, each evening, the entire town would take a stroll, and a small cheese factory where we were given tortillas and salsa with the lovely fresh cheese to sprinkle on top. Then we went to the botanical gardens where we were toured through medicinal plants and shown the magical properties of cactus, and finally, to my personal favourite, a roadside bakery carved out of the side of a clay cliff, with the ovens part of the hillside and the sales area just a long table under a canvas awning. The product was a rectangular pastry the length of an éclair, with different flavours baked inside, from sweet to savoury. Luz cut a few up for us to sample, and we were encouraged to purchase some for ourselves. The elderly couple with us declined to buy anything, and the others only bought one each. Trying singlehandedly to improve the Mexican economy, I bought several, since both Steve and I had been taken by the smooth taste of the pastry dough; the fillings were just a bonus.

The price, given the product, was negligible, and I couldn't figure out how a bakery, way out in what seemed like the middle of nowhere, could make a profit. Luz assured us that this was actually a well-travelled road for commuters and that the bakery often sold out by midday. That tempered my irritation with my tour group compatriots for not buying more.

Luz and Steve had been conferring a bit more, and once we were back bumping along in the noisy Unimog, he leaned into my ear and told me she was quite helpful in recalling things as we drove along. Perhaps, having the same tour stops was jogging her memory, but she had been able to give him a strong sense of what the relationship between the three girls had been the day before Kristin was killed.

Fernando wheeled the Unimog into a stylish estate that reminded me of a golf course back home, and Luz announced that this is where we would be eating lunch. A Vallarta Adventures crew had come out ahead of us and cooked up a meal featuring the same cactus I'd seen growing in the farm field, guacamole, salsa, chicken, and of course, refried beans. A makeshift bar was set up and Luz was pouring margaritas and mojitos for everyone except the two teens from Seattle, who had to settle for guava juice. We ate heartily, and I spent most of my time with the travel writers, alternating between envying them their lifestyle and trying to lure them up to visit western Canada with promises of bison, mountains, and green, glacier-fed lakes. What can I say? I'm an Alberta booster.

Our final stop was appropriately the final stop for most Mexicans—a graveyard. Luz walked us through the dazzling

spectacle of little houses built over graves, and intricate decorations for the dead. She explained the concept of the Dia de los Muertos, or the Day of the Dead, where families went out to the graveyard to visit with their ancestors, clean the graveyard, and party. Some of the houses around us contained chairs and televisions, so that the dear departed could be entertained when they came back to visit. Steve smirked and I knew he was thinking the same thing I was: that it was more likely a way to entertain those coming who didn't want to be pulling weeds or polishing marble.

Every spare inch of the graveyard seemed to be occupied, and some of the graves were newer and more ornate than others. We fanned out to explore, and once again Steve and Luz walked on together while I diplomatically hung back and took photos of the graves that caught my eye.

One had a complete *hacienda* built over it, with a red clay tiled roof and whitewashed window-wells on either side. Another had a locked glass door, beyond which was a ceramic tiled room with painted statuary of the Virgin and possibly St. Joseph, and a large white plastic bucket between them. Presumably, even in heaven the roofs leaked.

I was stepping back to photograph a lovely grave with a small blue house at the rear, with an orange flowering bush planted right in front of it. At the base of the bush was a gravestone made to look like an open book. The entire lay out pleased me aesthetically, though I had never before considered what I'd like my final resting place to look like. I especially liked the contrast between the blue of the small wall, and the orange flowers.

I looked around. Many of the flowers visible were made of plastic or silk, and I supposed it was too much to ask roses and peonies to bloom in the desert soil. Some shrubs were viable, though, and a few trees offered shade to the shades. In fact, one tree had grown, gnarled and huge, right in the middle of an older part of the graveyard, and was crushing a smaller, less ornate grave in its wake. I suspected no one came to visit that grave on November 2nd.

Fernando honked his horn, and we all made our way back to the entrance to climb into the Unimog for the last time. Luz asked us where we all were staying, and conferred with Fernando before climbing in the back with us. She pulled out a second cooler, and handed out beers to everyone except the teens, to whom she offered pop cans. Fernando would drop us all at our hotels, but it was a longish drive back to town, so we might as well have a drink and enjoy ourselves.

I pulled my scarf up over my hair and ears, and leaned into the warmth of Steve. If we hadn't been sitting sideways in the back of an open truckbed, I might have been lulled into a nap. Steve put his arm around me and I zoned out a bit. Just before we got back into the city, Luz pointed out Los Arcos, the huge rocks off the shore where seabirds whirled about. They were a national park preserve, she said, and a place people liked to dive. She mentioned that if we were planning to go to Las Caletas or Yelapa on a tour, the boats would stop for a bit in Los Arcos. Steve asked if the boat to the Rhythms of the Night would stop there, and she shook her head. Apparently, it was situated in Las

Caletas, but it was the evening run, and aimed more directly across the bay to save time.

I had forgotten we would be heading out there in just a few hours. We would barely have enough time to change, run a comb through our hair, and grab a cab for the Maritime Terminal where the huge cruise ships docked, which was not to be confused with the marina district where the tour office was located. I had a feeling my photos were going to be my memory guide for this jam-packed day, since my senses were already on overload.

Soon, Fernando was guiding the Unimog backwards into the small side street of our hotel, and he and Luz helped us out of the back. Steve pressed tips into their hands as he shook them, and I thanked them both profusely and waved to our fellow passengers, who were all staying in the hotel zone past the Old Town and the downtown district.

"Thank you for letting me ignore you so much of the tour," Steve said, squeezing my shoulders as we took the small elevator up to our room. "I got some useful information from Luz, I think."

"She's one smart cookie," I agreed. "I don't think she misses much."

"You take the first run at the washroom to clean up, while I write down some notes," Steve nodded toward my hair, which I discovered was completely windblown when I turned to look in the mirror.

"Oh god, how long do we have? Thank goodness no one knows us here."

We really didn't have time to shower, so I opted for wetting down my hair with conditioner under a soaking washcloth while I splashed water on my face and put on some eye make-up. Then I combed the smoothing liquid through my hair, braided it back and rediscovered an approximation of my normal self. My nose was getting red from the reflective glare of my sunglasses, and I added a second layer of sunscreen to it by way of moisturizer.

I slipped my red and green flowered sundress on and pulled on three red bracelets I'd bought in a shop along the town square in El Tuito. With my red sandals and nose, I was very coordinated.

Steve looked up approvingly as I posed in the doorway.

"Your turn," I ushered him toward the bathroom, and went to look out the balcony window.

Within minutes, Steve reappeared, looking glorious in black trousers and a gleaming white guayabera.

"They are going to think you are the maître d," I teased, and kissed him.

We caught a cab easily, and were soon making our way through the maze of gates at the Maritime Terminal. You had to pay a nominal fee to get in to the terminal to get your cruise. There were no cruise ships docked as we got there, but the pirate ship was front and centre, with its crew of dandified sailors entertaining their waiting passengers.

We Rhythms of the Night folks lined up to hand in our tickets and be counted, and were then ushered around to the far end of the terminal where Vallarta Adventures Boats 8 and 5 were

waiting for us. A crew of pleasant young men saw us onto Boat 8, which had two levels of chairs and benches, and before we were even away from the dock, they were bringing around trays of complimentary rum punch.

Trusting the conditioner and braid, I claimed seats along the portside of the boat, so we could see all of the city as we went past. The crew, aside from the bartender who was still cranking out rum punch, began a show of comic and quite intricate dancing at the bow of the boat, keeping us entertained all across the bay. The focus was to entertain and keep the tourists happy wherever we seemed to go, and this was no exception. We clapped and hooted as they wiggled and danced, as did most of the rest of the crowd we were with. I scanned the group for any of the people we'd spent the day with, but I didn't see anyone I recognized. For a small city, Puerto Vallarta could certainly absorb a lot of visitors. I wondered idly how many people could be housed at capacity if all the hotel rooms were filled. And yet, I had not felt crowded anywhere we had gone the entire week. Perhaps it was another wrinkle on the theory of relativity, based on the relative beauty of a place versus the discomfort you were willing to feel.

Steve wasn't drinking, in order to question whoever might recall the three girls from two days earlier, but I had two rum punches on the trip out. I wasn't sure it was worth Steve staying sober, since the crew seemed too busy to talk to anyone and I wasn't all that sure they'd recall anyone in particular with several boatloads of similar tourists in between to cloud their memories.

Steve's counter argument to that was that these were professionals required to take care of gormless tourists who might

wander off at any time, either snorkeling or exploring beaches or small towns, so they might be more likely to have strong recollections of people in order to do their jobs. It was a good theory, but I would rather get my money's worth in liquor.

When the boats docked, we were ushered off the gangway onto a long pier. Music was playing, and several young people in amazing costumes were posing on rocky outcroppings as an eerie welcoming. We let the majority of people off the boat, and as we exited, Steve asked a few of the crew members if they recalled the women in the pictures he offered them. Neither the bartender nor the director recognized them, but one of the sailors pointed at them and said "These two, yes."

"You remember them being on the tour on Saturday evening? Your memory is very good."

"It is because they are dressed the same, but one is so tall and the other so tiny, I remember."

"And was the third girl with them? Do you remember seeing her at all?"

He looked again at the photo of Kristin. I was wondering if she seemed familiar to him since she'd been on the news earlier. He shook his head slowly.

"No, only these two and their boyfriends."

"They were with men?"

"Not certain whether they came all together, or got together on the boat, but they were with two college boys. The waiters on land will know if they were together, because they sit them in groups for the meal. You check with the waiters." He tapped the photo of Kristin's roommates, and nodded to us, and then

excused himself to go coil a rope, or whatever it was sailors needed to do.

We moved along the dock, bringing up the rear. Although it wasn't dusk yet, torches were lit along the side of the pathway. We soon caught up with the crowd, who were stopped in groups to take a photo with two characters in feathers and tattoos. I presumed they were part of the dinner show. Another character, dressed like a huge iguana, was sunning himself on a rock up to our right. I would rather have had my photo made with him, but we settled for the pretty women and men to the left. I doubted we'd purchase the photo, but on the other hand, it would be a souvenir of our honeymoon—and who didn't want a photo of their new husband surrounded by lithe dancers in feathers and wisps of costume?

The dining rooms were outdoors, built on several levels close to the beach. We were assigned a waiter to follow, and were soon seated on an upper level, with several other tables for two and four. Perhaps this was where they put all the couples, I thought, since I'd seen another area with two or three larger tables set up. It was buffet dining, but a waiter came to our table to take our drink orders and bring us chips and salsa.

Steve showed him the photo, and he shook his head, but pointed to another fellow whom he called over to our table. Neither of them had seen the girls, but the second fellow paused as he looked at the photo of Kristin. Steve noticed it, too. He asked him if he had seen her anywhere, not necessarily here. The young man shook his head, slowly. Perhaps it was a case of

having seen the news and not yet put two and two together. Or maybe he had seen her along the Malecon on his day off.

"She couldn't have been out here without her girlfriends having spotted her, right?" I asked Steve. "I thought we'd already established that she didn't use her ticket because she was already dead."

"Not necessarily. The coroner still hasn't confirmed a time of death. And the girls say she had her ticket. The tour company says all tickets issued were validated, so someone was here on that ticket. She may have been on the upper deck. She may have been on Boat 5 instead of Boat 8. Or she may have been with her friends all along and they could be lying to throw us off track."

"You think they could have killed her and left her out on the beach like that?"

"I don't rule out anything, Randy. You have to allow your mind to be open to every possibility so that you don't blind yourself with assumptions. They told us she hadn't turned up the night before. Until I have a coroner's report telling me Kristin Perry was definitely dead beforehand, I owe it to her to consider that she may have managed to get here on her own steam."

"Another possibility is that whoever killed her scalped her ticket. Or used it to confuse the timeframe."

"They said all the tickets were validated. So, if he or she didn't sell it, maybe the killer came for dinner."

That was an unsettling thought. When our waiter came back to the table with water, Steve asked him if solitary people ever came out to dine and see the show, and he nodded and pointed

to another level down, where the seats were artfully arranged to give single seats along a table overlooking the small bay.

Steve excused himself for a few minutes to go question the waiters in that area, while I worked my way through a plateful of delights. Ever since Luz had told us about the strictures against pesticides and genetically modified seeds in Mexico, I'd had a whole new vision of the healthful eating I was doing. Of course, overdoing any kind of eating was likely unhealthy in the long run, but I had a few more cold winter months to work it off.

Steve didn't take long.

"Manuel is the waiter of that area every evening, and he was there on Saturday. He had fewer patrons than usual, only five. Three were men, two were women. Older women, and one of those was a Mexican national," he specified, seeing my look of mounting interest. "So no blonde Kristin, unless she insinuated herself into another group, or was actually with her roommates who for some reason are lying about it. The three men weren't all that memorable to him." Steve checked his notes. "One was in his fifties and read a book with his meal. One was young and Mexican, and Manuel thought he might be a tour salesman, taking the tour to know the ropes. And the other, he doesn't have much recollection of, though he recalled he tipped him big."

"Funny not to have a clear memory of someone who tipped big."

"Unless a person didn't want to be recalled. You dress in nondescript colours, you blend in, you don't make a lot of eye

contact. You are there to use the ticket, maybe to observe the roommates."

"But if you want to blend in, why tip so big?"

"If you are a tourist, unsure of the currency, maybe you just made a mistake?"

I nodded. That had a logical ring to it.

Our waiter came up to us with a tray of Mexican coffee, full of cinnamon.

"May I suggest the ice cream and *sopapillas* for dessert, and then to make your way to the amphitheatre, Señor?"

Steve raised his brown ceramic mug to clink mine in a toast.

"Aside from this investigation clouding things, I'm enjoying this tour with you."

"Me too. It's a very romantic setting, especially now that the sun's set and the torches are earning their living."

"I'm sorry this is getting in the way of our honeymoon, Randy. I promise to make it up to you. Maybe a weekend up at the Jasper Park Lodge in a few months' time?"

"Are you kidding? That would be twice what this entire week is costing us!"

Steve laughed. I smiled. I wasn't joking.

"It doesn't matter, you know. I understand the job comes first."

"Maybe before a honeymoon plan, but not before you. Ever."

I sipped my coffee, basking in the loving gaze of my husband. Who knew that a married Steve Browning would be even more romantic than a courting Steve Browning?

The theatre was spectacular, along the lines of the Cirque du

Soleil meeting *Les Feux-Follets,* the Canadian touring show of my childhood. Aztec myths were brought to life, and enacted, with actors like my iguana friend crawling through the audience or ziplining above our heads. After an hour of glorious symbolic spectacle, we were herded back out to the pathway leading to the dock, and boarded our respective boats to head back to Puerto Vallarta.

Steve and I headed to the upper deck, and watched the lights along the shore while the crew below entertained with manic hijinks. By the time we were ashore, in a cab and back to our hotel, it was ten thirty and I was ready for bed.

"Just because we're ready for bed doesn't mean that twenty-year-olds would feel the same way, right?"

Steve laughed. "There are clubs that don't even get started till about ten o'clock."

"So, Kristin and her friends going partying after the pirate ship seems believable. And her roommates would likely go find a club as soon as they got back to the Maritime Terminal after this tour, too."

He nodded. "Very likely."

"Well, they're going to have to get someone else to investigate Mexican nightlife, Mr. Browning, because we are definitely calling it a night."

"On our last full night of our honeymoon, Ms. Craig? You'd better believe we're heading for bed."

On the whole, we probably worked off another entire margarita.

12

Our plane wasn't taking off till four in the afternoon, so we had a leisurely breakfast at Fredy's Tucan, bidding our favourite waiter goodbye, and then walked the entire length of the Malecon, taking photos of each of the statues in order.

Steve popped into the City Hall to report his investigative findings to his counterpart on the case, and I found my way back to the same clothing store where we'd bought our tops and picked up an embroidered dress with the pesos cluttering up my wallet. It would be nice to wear on our first anniversary, to remind us of the lovely honeymoon.

I met up with Steve by the gazebo in the square, and we walked back toward our hotel to brush our teeth and pack our bags. The concierge had kindly suggested we stack our bags in the back of her office for the afternoon, so we popped on our bathing suits, folded our travelling clothes up into plastic bags, and headed up to the pool deck. The plan was to sun, swim, squeeze the water out of our suits and change in the poolside

washrooms, then get lunch somewhere near the hotel before calling a cab to get us to the airport the requisite amount of time ahead of our flight.

I had finished my book, and intended to leave it in the courtyard bookcase, to spread Canadian content further around the world. On the way back to the hotel, I had steered us into A Page in the Sun, the coffee shop bookstore by the Old Town square, and searched for a book for the plane. I found a thick, secondhand Tana French that would satisfy the task and impulsively added a book on Frida Kahlo that was stacked by the till. It would be a lovely remembrance of our visit to the ArtVallarta gallery. Once back at the hotel, I packed it into my suitcase, and took the mystery up to the pool.

Steve was absorbing his *Maclean's* magazine by osmosis, with it tented over his face as he snoozed. I checked to make sure his chest was still gleaming with sunscreen, and felt a weird little smile come over my face. For the first time, I knew how Scarlett O'Hara must have felt after her marriage to Rhett Butler. There in front of me was the person I was connected to and responsible for. It mattered to me whether or not he burned. My hold on the universe no longer ended at the tips of my fingertips, but slid on, through them, to him.

Religious nuts who constantly clamour for chastity before marriage should just let their young flock know how much better married sex is than unmarried sex. Every joke about love life getting stale once married was probably just hiding how great it was to be able to just lean into someone while looking in a shop window, and know that you were united. Everything became a part of lovemaking, far more than just the physical act.

Not that we had been avoiding that. Steve had joked that we probably could have ordered a few more margaritas without worrying about their caloric content. The origins of the word "honeymoon" referred to the month after the nuptials, when couples were left to their own devices, and not expected to rejoin the community activities. It had since morphed into a getaway vacation for the bride and groom, to relax after the tensions of the wedding planning. And while we weren't even getting a full week's worth of days to fritter and sigh, this honeymoon was so much more than I'd ever dreamed possible.

I wonder when I had stopped thinking pink unicorn thoughts of weddings and marriage and babies, or if I'd ever thought them at all. Steve had been a part of my life for so long now that this transition in our status, while delightful, seemed almost inevitable. And of course, we were certainly too far down the road to consider children, even adopted ones. Some people our age were becoming grandparents already.

No, we were fine as we were, loving and supporting each other and doing our bit to keep the planet sustainable, even if we wouldn't be doing much for the Canada Pension Plan. I looked at my watch and reluctantly patted Steve on the arm to wake him up. We would have to change now if we hoped to have one more fabulous lunch before heading homeward.

My suit was almost dry as it was, so I wasn't overly afraid of it mildewing in the hold of the airplane. We stuffed the bag with our suits into Steve's suitcase and walked around the corner to Joe Jack's Fish Shack for our last lunch in Mexico.

The place was already full, but we were led upstairs to a table

halfway onto the open patio. Steve ordered the three-ceviche platter, and I opted for the fish tacos. We also decided to throw caution about being level-headed for Customs to the wind, and ordered mojitos.

"I heard she was a cheerleader," said a woman at a table near us to her companion.

"Right? And she was killed by her football playing boyfriend," her friend replied.

Steve's eyebrow shot up.

"They're not having the success they hoped tamping down the news, from the sounds of it," he whispered to me. "They were hoping the general populace wouldn't be aware of the investigation at all."

"In a city this size? I can imagine everyone knows about it."

"Probably every resident knows, but tourists, especially those with limited or no Spanish, were hoped to be kept in the dark. After all, they don't want people thinking it's an unsafe destination."

"No kidding. Although, Denise went on a Jack the Ripper tour the last time she was in London. Maybe murder would be a selling point? After all, the beach is called Los Muertos Beach."

"Historical murders targeting one specific group of women that have almost entered the realm of legend rather than fact are one thing; trying to make a tourist mecca out of a warzone would be more in keeping with the concept they are trying to avoid."

Steve took a long sip of his mojito, pushing the straw into the mint leaves for maximum zest. He put down his blue-rimmed tumbler and gazed about the restaurant.

"How many of these people do you think are feeling safe and easy, now that there's talk of a homicide on the beach?"

"All of them. No one thinks they will be the target of something like that. Besides, all these people are with someone else, and I will bet you that even the single girls travelling together will stick a bit closer together for the next little while. And from what I understand of the subtext before the Mexican Superintendent Keller hustled me out of the office, the general idea is that she brought her killer with her, so there is no danger to anyone here in Vallarta, right? The killer, whoever it is, is presumably heading home with us." I looked around the restaurant, echoing Steve's movement of a minute before. "Boy, doesn't that make me feel all warm and cozy."

"You're right, of course. That is how they want to play it, and I've got orders from Edmonton to maintain connections with the officials here once we're back. I think Iain has already spoken to the girl's family, but we'll likely go out again when I get back. I'm just hoping that they keep an open mind about it possibly being a Mexican national. I wouldn't want murder swept under the carpet for the sake of a shiny reputation for tourism."

We couldn't overhear any other conversations from where we were sitting, so we reluctantly paid up and headed back to our hotel. The concierge hugged us and offered us a bottle of chocolate infused tequila, which Steve somehow found room for in his suitcase. A yellow and white cab was called and soon we and our suitcases were bumping along the cobblestone roads heading to the airport.

The terminal was full of tired, happy looking people, mostly

red, some brown. Steve may have been on the lookout for Kristin's roommates, who were supposedly on the same flight as us, although they may have been on the Sunwing flight heading homeward half an hour later than ours, but I was determined to keep them out of my mind.

It was amazing to me that Puerto Vallarta, that compact little city, could have held all these people—none of whom I had seen in any of our forays about the town, or on the tours we had taken—and more besides. How was it possible for it to maintain such an easygoing attitude when it must have been at capacity for filled hotel rooms, judging by the crowd in the airport, and the numbers lined up below us waiting to be let through into the sunshine? It was attitude and magic, I decided. In this part of Mexico, everyone was welcomed readily, and the pace was so even and serene that you didn't feel crowded. Oh Puerto Vallarta, I was going to miss you.

Reading my thoughts, Steve leaned over and kissed my hair.

"We'll come back, Randy. I promise."

13

I slept in Thursday morning, and then, armed with a pot of coffee and guilt-ridden homage to my pioneer grandparents, I sat at the kitchen island in what had been Steve's and now was our condo, dressed in leggings, a pullover sweater, a cardigan, and thick wooly socks, marking two piles of essays. I had no foundation for complaining, either, since I'd just spent a week in paradise, without a care in the world.

Likewise, Steve had picked up the mantle of responsibility and headed out to work after starting a load of vacation laundry that I promised to sort for the dryer when the buzzer went off.

While we had moved what belongings I needed and wanted to keep to Steve's a week before the wedding, having given notice to my landlords a month earlier, it didn't yet feel like our place; more like his place with a hint of me about. That was primarily because I had not been quite so acquisitive since my belongings had all been trashed in a break-and-enter some time earlier. I

had replaced necessities, but hadn't had much of a chance to rebuild my library or record collection.

My clothes were now along half of Steve's walk in closet, and we had wedged my old dresser in there, too, partially so I could reach for underwear at the same time as I was deciding on what clothes to wear, and mostly because it just didn't match Steve's Danish modern sensibilities. I loved his bedroom just as it was, although I tended to creep out of bed and open the drapes after we had turned out the lights, so that we could wake to the view of the dawn on the river valley.

We were discussing the addition of some bookshelves in the condo. I was advocating for floor-to-ceiling shelves along one wall in the living room and all down the halls, which were terrifically wide and spacious. Maybe the builders were thinking we'd be there till we required wheelchairs, which was a nice consideration for them to have had. However, at the moment, it was the need to expand the library we were now sharing. Steve had books in one small bookcase just outside the kitchen alcove, and in about five piles on the floor in the corner of the bedroom.

While I wasn't up to par, given my setback, books cling to me like cat hair to black trousers, and I had moved in with seventeen liquor store boxes filled with literature. I didn't really expect that to slow down, either. Steve acknowledged my need for books graciously, but I didn't really give him too many props for that since to me it would be like graciously allowing someone with diabetes access to insulin.

I expected to receive some physical tokens of inheritance when my parents either passed on or downsized, but on the

whole, I was entering this marriage, middle-aged and world weary, with about the same amount of belongings as a co-ed moving into a dorm for the first time. Luckily, I had no time to think about the pathetic quality of that because I had to focus on thirty-four more papers offering insight into what the green light on the dock meant to Jay Gatsby.

I had made quite a dent in the pile by the time Steve called at lunchtime. At peak marking, I can manage three essays an hour, and counting back, I could see I'd been running true to form. I had a pile of ten graded papers, marked up with green ink and margin notes, and only about eight hours left to go to get through this class. The other class had sat a midterm in-class essay prior to Reading Week, and their papers would go faster, since I went easier on their grammar and punctuation. I anticipated being through marking by Friday evening, and able to spend the weekend thinking about the last push of the term and what to wear on Monday.

Steve's call had been more than a check in. He wasn't going to be home for supper, because he and Iain had to brief both the university and the Canadian Consulate about the murder in Mexico.

While we had still been in Puerto Vallarta, Iain McCorquodale, Steve's partner, had taken on interviewing and informing Kristin's family. Though her parents lived in Edmonton, Kristin had decided to move out and live closer to campus with her two roommates, which said to me that either she had a phenomenal part-time job, or her parents were loaded. In this economy, very few students who could pull off free room and board in town passed on the chance to stay home.

Or maybe they had a difficult relationship, Kristin and her parents. Or perhaps they were seeing this step toward full independence as a transition, and were underwriting it for her as a learning process.

Whatever the reason, they had of course taken the news hard. Kristin was an only child, and they had been relatively older when she was born. Now, the promise of someone to care for them in their older years was gone, and the added horror of the violence of her death probably brought their own mortality shuddering closer to them.

That was my imagination and too many essays about Scott Fitzgerald fueling the simple facts Steve had gleaned after he'd talked to Iain on the phone the night before. He had merely been relieved that Iain had got the notifications out of the way.

Steve had anticipated talking to the roommates again once they were back in Edmonton, but everything was, of course, complicated by the cross-border aspect to the crime. Staff Superintendent Keller had been sorting through the formalities required of the situation, and assigned a few more people to Steve and Iain's investigation, with the hope that the Mexican authorities would note how seriously the Canadians were taking things and keep up their end of the process accordingly.

I had so much marking to do that my new husband deserting me for his own work didn't bother me in the slightest. What did bother me was the lingering memory of seeing Kristin lying on that spit of sand, alone in the blazing sun. My conscious mind knew that she had been already dead when I had spotted her, but something in my soul kept gnawing at my conscience,

blaming me for not running down to the island's edge and waking her from her fate.

While I had more than enough experience with death, I hadn't seen all that many corpses in my life, and even though I had thought her sunbathing, not posed in death, Kristin Perry monopolized my thoughts. I stretched, and slid off the high chair to head to the bathroom, then made another pot of coffee. I was determined to get through the essays in one shot, and to make a dent in the midterms.

That way, I could do a little research of my own, although I wasn't sure Steve would appreciate it, and I knew his boss would be apoplectic if he found out. Keller had taken an early dislike to my "interference," as he termed it, in Steve's investigations. He wasn't entirely certain Steve didn't share more than he was allowed in any particular investigation, but he needn't have worried. My husband had absorbed the ethics of law enforcement and lived and breathed the rules.

It was just that I was often somehow connected to situations he ended up investigating. It was how we had met, after all. I knew, even then, that Steve had information he'd never be able to share with me, and that most of our conversations dealing with any of the cases where we'd interconnect were more about him quizzing me rather than him sharing classified secrets. As for inside information, I heard only what he would tell reporters or any other witness he was questioning.

One thing that he and Iain might not have picked up on, though, which I had found fascinating when I had heard about it, was the nature of Kristin's interest in Mexican art. Her parents

had informed Iain that she was an Art and Design student who had travelled to Mexico for Reading Week. She had visited galleries, and her notebooks, which Steve had only seen that morning in the luggage that was delivered directly to the police station from Mexico, were full of sketches. Maybe, for Kristin at least, the trip was more than a tequila getaway. Maybe she had been working on something up here that would give Steve an indication of where she had been while in Puerto Vallarta and whom she had talked to or interacted with.

The investigation back in Mexico had assumed Kristin and her roommates were just typical party girls, wanting to let off some Reading Week steam. Maybe there had been more to it than that, and we'd missed the real connections she might have been making, one of them a fatal one.

I could hear the frustration in Steve's voice when he mentioned the notebooks and her major. If he'd had that sort of information while we'd been in Vallarta, it might have been very helpful. I hated to think he was going to beat himself up about it, especially because I knew he had been working full out while he should have been relaxing.

Maybe I could help. If I could scout the art students' studios for some ideas of what was driving Kristin's interest in Mexico, it might be of use to Steve. And it might get Kristin and her lonely, sunburned body out of my head.

But first things first. I had to get these papers marked. By five o'clock, I had turned on the overhead lights to illuminate my work on the island better. An hour later, I got up to stretch and

turn on the living room lights. By seven, I was finished the long essays, and recording the marks in my roster.

There was still no sign of Steve, though there were several text messages on my phone. He suggested bringing pizza home with him in an hour or so, to which I texted delighted approval.

Not cooking for a week had not made me long for my own kitchen; it had pushed me into the other direction, where I was quite happy to contemplate budgeting for more restaurant meals. I knew it couldn't last, but today, at least, all my energy was focused on getting through my marking. How could I be expected to drop everything and whip up a pot roast, especially with Steve being away all hours? I was totally happy with his exhibiting his hunter-gatherer capacity, and looked forward to him carrying in the mighty pizza when he arrived.

It took longer than either of us had anticipated, and I only had five of the shorter essays left to mark when he finally walked through the door around nine thirty. He looked tired around the eyes, and I realized I hadn't seen that look for more than a week. The job he had chosen was a difficult one, and it took a lot out of him, I could tell, having just seen so clearly what a full-tilt vacation could do to clear those lines and furrows from his face.

I slid off the chair stool, and went round the island to greet him.

"I brought the pizza. I hope you weren't starving in the meantime?"

"I didn't eat, but until I smelled it, I wasn't hungry, so that's okay."

I burrowed into his chest, smelling the cold of the outdoors

on him and feeling it chill me. "Welcome home. You must be exhausted. What a long day to have as a first day back on the job."

"It felt like three days in one," he nodded to me as he shrugged off his parka. I busied myself getting out plates, napkins and parmesan cheese while he went to hang up his coat and shuck his teal pullover. He was wearing a tieless shirt of blue and teal gingham beneath, and I could tell how long a day it had been by the fact that he didn't immediately head off to hang it up and change into a T-shirt. He probably felt as if he had sweated through his work-dress shirt sufficiently to warrant a wash, rather than airing it and hanging it for another day or two's wear.

He rolled up his sleeves, and I tidied away my piles of marking, and together we ate silently, polishing off two-thirds of the huge beef and onion pizza before either of us made a sound other than my normal food moans.

"Iain made a few cracks about getting the short straw in this case, and not having the tan to go with the file." Steve laughed, but it was a short bark, probably because he, too, was remembering Kristin's sunburned body. "But he's done a lot of the legwork already, even more than I had thought. He had a hard time locating the boyfriend, though he eventually found him sleeping in one of the art studios."

"Is he homeless?"

"No, apparently he is working on some time-activated project, where he has to take a photo every hour of things that change slightly, like a bean seed and a melting popsicle and some shadows. I'm not certain whether it is going to be a film or a mosaic of some sort, and I don't know if he knows, either.

Iain wasn't all that impressed with it, as far as I could tell, but I wouldn't mind checking it out."

"Sounds a little derivative of films like *Koyaanisqatsi*, from what you're describing."

"That's exactly what popped into my head, too, so maybe it's my interpretation of Iain's description that's leading us both there. I should check it out for myself."

"At any rate, if he has to take the photos physically, every hour, you can determine his alibi. Count the stills and see if he could have skipped off to Mexico over the weekend."

Steve laughed. "We are totally on the same wave length. That is exactly what I said to Iain."

I wasn't so sure it was much of an alibi in an age where you could start your dinner from your smartphone across the city. Why not time cameras to take photos on the hour? Wasn't that the principle of time-lapse photography? I wondered what had made Iain so quick to believe the fellow.

"Do you think Iain's acceptance of the boyfriend's alibi has something to do with his not having been near the crime site? Maybe it just doesn't feel real to him?"

"I think it's more likely to have something to do with the boyfriend's demeanor. Iain is moved by earnestness, I think, more so than he might believe."

"So, you're thinking it's not the boyfriend, oh bother, does he have a name, this boyfriend? I am sick of calling someone 'the boyfriend' over and over."

"Is that why you finally married me? So you could start calling me 'the husband'?" Steve said, teasingly. "Kristin Perry's

boyfriend's name is…" he flipped open his notebook to find the detail he was looking for, "Cole Vandermeer. He is twenty-two, six foot two, blond, and in his second year of Art and Design. He transferred in after doing three years of a poli sci degree, which is an interesting move when you think about it."

"Lots of artists are highly political," I shrugged. "Just think about Frida Kahlo and Diego Rivera. They were active Marxists."

"I suppose," Steve agreed grudgingly. "It just seems like a leap, especially in one's final year, to start all over in something so completely different."

"Maybe it's not about changing so much as not finishing. Some people get frightened of leaving academe and facing the real world, so they change majors and burrow in."

"Or they could just be finding their way. I've always thought we ask a lot of twenty-year-olds to determine what course they want to set for the rest of their lives."

"At least we are asking them now. In earlier generations, children knew they'd be going into the family business, or they were apprenticed at the age of twelve to learn a trade or a craft. Nowadays, we tell children they can be anything they want to be from the day they are born, and send them off to make their own mistakes."

"Mistakes?"

"Or great discoveries. The point is, when decisions are made for you, you can either rail against them or tuck in and make your mark in that field. But the additional pressure of determining what your path will be is taken off your shoulders, and in some ways I can see that being a great weight removed."

"Don't forget that in that same time you're thinking of, it was more likely that you'd have married someone your father picked out for you, based on whether or not he coveted the grazing land your father-in-law had for his sheep."

"Yes, and if I had been part of an arranged marriage, I'd likely be celebrating my thirtieth wedding anniversary surrounded by children and possibly even a grandchild by this time, rather than my honeymoon, so way to make me feel like I've let down the population."

"Do you mind that?"

"What?"

"Not having children and increasing the population." Steve had come around the island to my side, and wrapped his arms around me. I leaned back into his chest, and closed my eyes.

"That was a door I closed a long time ago, Steve. If I had been hell bent on having kids, I probably would have figured out a way to get married sometime in my twenties, don't you think? It's not so easy for academics, or those of us who wanted the life. If you find someone in academe, the chances of both of you finding work in the same university are crazy small. I can think of only about four instances, and in one case it was a job-sharing scheme. On the other hand, finding a partner who isn't in grad school while you're beavering away on research or a thesis is also a crapshoot. So, it is honestly one of those forks in the road you have to decide on. After all, my biological clock was timing out when I decided to go back to grad school, and that was a couple of years before I even met you."

Steve squeezed me in a tighter bear hug.

"And I am so glad I met you, Randy Craig."

I reached my arms up behind me to catch Steve's head and bring it down to my level so I could kiss him.

"What about you? Did you never dream of kids and a white picket fence?"

"Not so much. I've told you about the girl I dated once I was out of university, who seemed to be pressuring us to move through all the requisite hoops so much that I just balked. After that, I sort of steered clear of entanglements for awhile, and aside from a date or two here and there, it was a lot easier to be single. And then I met you, and I didn't even know I was going to. I had jotted down your name and thought I was heading off to meet a male lecturer. I even had you penciled in on my suspect list until I met you."

"Really? You never told me that before. That's so sweet. We should have found a way to make that part of our vows!"

Steve laughed and tickled me just enough to make me wiggle out of his hold and turn around on my stool.

"Have you eaten all you wanted? Should I be bustling about getting my husband a salad and dessert to go with the pizza, which I note you've not had much of? At least not by the standards of your appetite last week."

"I'm honestly too bushed to eat any more. What I would really like to do is take my wife to bed."

"Oh, well that can certainly be arranged."

"And there you go, being married is so much better than being single."

14

It was just after noon on Friday that I managed to record all my grades onto the spreadsheet I maintained. At the end of the term, the final tallies would have to be entered the computer program the university favoured, but I would keep my grade sheet for two years, bundled with the eventual class evaluations and a copy of the original syllabus.

No one had ever come back after final grades to question their various marks, but it was wise to keep records, I supposed. I had heard of such complaints. My students were usually pretty aware of how they were doing, because I pushed myself to get their papers graded quickly and back to them within a class or two. I wanted them to be building on the comments I had painstakingly made on their previous work, to better their next efforts.

And mostly it wasn't in vain. Some of them soared, even within the timeframe of a full term course. And some of them had gone on to "Do great things," as the University of Alberta

was now promoting as its motto. Maybe it was the modern motto, while *Quaecumque Vera,* or "Whatsoever Things are True," was still the traditional motto, like the double list of traditional versus modern anniversary gifts you could find listed on the Internet or in Hallmark stores. Copper or desk sets, china or platinum, truth or action.

MacEwan University's motto was "Through learning, we flourish" and it was pretty accurate, too. One of my former Grant MacEwan students now worked at the University of Alberta Press, a job I wouldn't have minded myself. Another was a freelance writer whose byline I saw all over the place, even in the airplane magazine on our way down to Puerto Vallarta. I took a modicum of pride in thinking I had helped them hone their craft and style in some small way. Of course, for all I knew, others of my past students were racing about breaking grammar rules with glorious impunity and sneering at their distant English class as something they'd had to endure but not retain.

Marking always seemed to drop me into this introspective chasm. The concrete proof of whether or not my teaching was reaching the classes who sat so politely before me had a tendency to make me question myself.

Denise was, as always, more cavalier. She had phoned to invite me to tea at a place on Whyte Avenue that she was longing to try, and had to listen to my train of thought first.

"If you really want to know how you're doing, check your grades. Take away the top mark and the lowest mark, because those are your outliers—they already came to you fully formed—brilliant or dense. Now look at the number of those

who are clocking in above 60 per cent. Now, count the number below that. Is the first number higher? Right. Now do the same thing for the previous mark for the same class. Has that number increased? Right. You're a great teacher. Now go get dressed. I'm picking you up in half an hour."

It did sound like a lovely way to cap the last of Reading Week, so I obligingly nestled all my papers into my work satchel and toddled off to get ready to go out into the world. I texted Steve my plans, which was the modern equivalent of leaving a note, but just to be certain, I left a note on the counter, too.

Denise pulled up to the half circle driveway in front of our condo building spot on the half hour, and I was ready to hop into her car. I missed her cream coloured Bug, but her new car was just as stylish. It looked like a Mini Cooper on steroids, and was racing green with a white line along one side. The front seats had heating, and I felt immediately cozy.

Denise gave my arm a quick squeeze, the in-car equivalent to a greeting hug, and grinned at me.

"You look fabulous! Not many newlyweds actually come home with a tan, you know. So, tell me everything!"

She pulled out onto Saskatchewan Drive and within a few turns was soon cruising down Whyte Avenue toward Calley's Teas. She found parking on the street because it was a Friday rather than a weekend, but even so seemed to be a minor miracle, and soon we were ensconced in a warm and inviting wee tea shop, where a variety of mismatched tables were laden with tiered serving trays and cozy-covered teapots.

"I don't suppose my Reading Week was as exciting as yours.

All that happened here was that the boiler at my condo went on the fritz, and we all had to spend two days keeping our ovens on with the doors open and space heaters blowing to keep the pipes from freezing while the plumbers replaced it. I looked like the Michelin Man in the middle of my living room, in sweats, and wooly socks, and a down-filled parka. I might as well have gone skiing. But it's all fixed now and aside from a spider plant that seems to have caught a chill, everything is fine." Denise picked at one of the fairy cakes and took a sip of tea.

"But what about you? Tell me everything. I have been wondering about Puerto Vallarta all my life, after reading about Elizabeth Taylor's romance with Richard Burton."

"It's still there, I think, even though the Hotel Zone has grown up along the beach all the way to the marina, and huge cruise ships come right into port. The old town streets are still cobbled. The area where Taylor and Burton had connected villas, which was called Gringo Gulch, is now considered a traditional area, because newer million dollar villas have been built all along the coastline and up the hills south of town. It's totally charming, and absolutely focused on making tourists and long-term visitors happy. There is a rather large ex-pat community there made up of retired Canadians and Americans, so it's easy to find English spoken anywhere."

I presented her with her embroidered top, which she loved, and then pulled out my phone to show her some of my photos. Denise oohed and ahhed appropriately at my sunset photos, and asked the sort of questions that made her sound truly interested in our vacation, rather than merely polite.

When we got to the photo of what I now knew was a picture of a crime scene, she paused, catching on what I had initially seen myself.

"What a strange place to be sun tanning alone," she remarked. "Is there a hotel or condo nearby?"

"Not that close," I shook my head. "The closest condo is over the bridge I was standing on, so you'd have to cross the bridge halfway, take the stairs down, and make your way to the sandy spit. Then it's a walk through a stony area and sort of a dank bit under the bridge to get there. Usually, we would spot people fishing off the spit, but this was the only sunbather." I looked around the teashop to be certain we couldn't be overheard.

"And it turned out she wasn't sunbathing. She had been murdered and posed that way. She was found a day later, in that same pose. I just took her picture coincidentally. Steve was called in to connect on the case because it turns out she was from Edmonton, so there isn't all that much I can say more than that, but it was eerie to realize that one of my photos turned out to be valuable as a time indicator on a police case."

"Shut up! You went on your honeymoon and still wound up getting immersed in a homicide? What are you, some sort of murder magnet like Jessica Fletcher?" Denise laughed, and it struck me that I might not have been far off the mark in my interpretation of Iain McCorquodale's take on the boyfriend, Cole. Somehow, because, to quote Marlowe, the crime scene was "in another country and besides the wench was dead," it seemed less real, and therefore easier to discuss in a frivolous manner.

But it wasn't frivolous to me. I had seen that girl, all alone,

posed as some sort of art installation of a happy tourist, but lost and dead far too soon. How could Denise feel that, though? Time and distance, and hot tea and crumpets insulated her. I couldn't blame her for sounding unsympathetic. She wasn't affected by it in the same way I was.

She had slid past the photo by now, and was admiring the pool area of our hotel, which I had snapped the last day, to remind myself of that happy oasis.

"It looks like you had a fabulous time, even with the hiccough of Steve having to work a bit. Would you go back?"

"In a heartbeat. In fact, Steve was talking about making it an anniversary destination in a few years."

"Good idea! You can avoid an Edmonton winter and celebrate your anniversary. Well played, Randy."

Our conversation continued along the lines of what we'd been reading, what we'd be teaching, and whether or not we thought Tom Burke would make as great a Cormoran Strike in filming of the Robert Galbraith mystery novels as he had a Musketeer. Denise thought he could do anything, whereas I figured he was lovely but physically too slight. I would have rathered someone like Jamie Redknapp play Strike; he had a sportier physique, and was showing some strong acting chops, or Adam Hills, who legitimately was a one-legged actor.

Denise offered to drive me back to the condo, but I declined in favour of popping into the K & K, a German grocery shop. We hugged properly near her car, and then I set across Whyte Avenue.

It was mild for February, but perhaps a week in the tropics

had thinned my blood. I was shivering by the time I got half-way back to Saskatchewan Drive with my groceries. I had been wearing my wooly headband inside my parka's hood, so I hadn't heard the buzz of my phone telling me Steve had been texting me. Of course, it wasn't a good plan to pull out one's phone on the street in February since smartphones had been known to freeze up and then get wonky from the cold.

My boots had their own shelf in the front hall closet, so I couldn't just kick them off and leave them by the door. I hung up my parka and draped my scarf over the back rail of the boot bench in the foyer to dry out from the frost my steamy breathing had created.

I set the phone on the kitchen island and put the rye bread, veggies, and cold cuts away in the fridge and the mustard and potatoes into the pantry. I filled the kettle and clicked it on to make another pot of tea, as if I hadn't had enough already. Once that was done, I was ready to check my messages. That was the thing about winter in the north, everything took longer because of having to either bundle up into or peel out of layers of winter wear.

Steve had been texting to let me know he wouldn't be home for dinner again. There had been a long conference call with the Vallarta police and the embassy lawyers, which had skewed all of Steve's plans to interview various people connected to the dead girl back home. He had made arrangements to talk with her parents and her roommates this evening and I was not to wait dinner for him. Luckily, I had decided to go with potato salad and cold cuts, which could keep easily.

I worked on lecture notes while my little potatoes boiled. I mashed them up with mustard, mayonnaise, and chopped green onions and set the bowl in the fridge before leaving the kitchen to sort out my wardrobe for the week to come. My sense of smell was not the greatest and my ability to zone out and forget things on the stove was legendary, so I made it a point never to leave the kitchen unless the burners were off or a timer with a loud buzzer set.

I set outfits together onto the back of the closet door, five of them, so that I could move on autopilot first thing in the morning and not repeat myself, wearing the same thing on a Tuesday and Thursday, to see the same students. My classroom outfits had matured a bit since I had first started teaching, but were generally based on comfort of fit, cleanness of line and pockets. I had enough to deal with being at the front of a lecture hall, knowing that if I was doing my job right to engage their minds, all eyes would be on me; I didn't need to worry about gaping necklines or bulges.

I cleaned up the rest of the vacation detritus, pulling out my good brush and moisturizer from my travel makeup bag, and storing it under the bathroom vanity. My suitcase was already collapsed and nestled in Steve's larger, hard-sided case on a high shelf in the storage room off the foyer. My summery clothes had been laundered and folded by Steve, and I sadly placed them in the plastic bin with the rest of that season's clothing in the same storage room. It was a weird feeling, all this sorting and organizing. Not only was I moving back into the actual frozen season we were all facing for another two or three months, I was doing

so in a new environment, one I had been visiting for a long time but had only really occupied for a fortnight before we'd gone on our honeymoon.

This cleaving-to-another business was a strange thing, and probably made even stranger by the fact that Steve wasn't part of the picture at the moment. I curled up in the oversized armchair under the best reading light in the living room and enjoyed the momentary pause before diving into a new book. This was the biography of Frida Kahlo I had purchased in the bookstore across the plaza in the Old Town the morning of our last day in Vallarta.

This book, a handsome trade paperback, had been at the front of the shop in the small section of new books, the rest of the shop being given over mostly to shelves of secondhand beach reads and a cozy coffee shop. There had been some other local titles and a few more books on topics such as tequila and mariachi, sort of like the local interest shelves Audreys Books had near the front till here at home. I was all about the concept of "when in Rome" reading, and had been hard pressed not to take home two or three coffee table books. Steve had reminded me of our weight restrictions for the luggage and the fact that I'd already purchased several earthenware plates and a *molcajete*, which was a mortar and pestle made from volcanic basalt used in traditional salsa making. I put back the hardbound books, but kept the Frida bio.

It offered two or three sections of colour plates throughout, with both photographs of Frida and Diego and reproductions of her paintings, along with some of his murals. The Salma Hayek

movie *Frida* had given me a general idea of her life, but this book grounded her in the world at large, allowing me to equate the situations of her life to the historical markers I recognized from the Eurocentric vision of history I'd been fed in high school.

No wonder there had been such an exuberant uptake on that art exhibit we'd been to see. I could understand how Mexican artists would embrace Frida as their icon of national pride. I could also see how female artists everywhere would see her as a heroine, much like Georgia O'Keefe and Judy Chicago. Frida Kahlo pushed back against every wall that was raised against her and lived an authentic life on her own terms.

Steve arrived home around ten p.m., and found me snoozing, my book spread open on my chest and my head cricked into the side of the chair. He made just enough noise on the periphery of my consciousness to wake me, and I could tell that it was a good thing he'd made it home when he did or I'd have had a sore neck for the rest of the weekend.

"There's potato salad in the fridge, and rye bread from the K & K," I said, as he kissed the top of my forehead.

"I ate with Iain earlier, that's okay. I think it's time to just head to bed."

"Sounds good to me," I said as I pulled myself upright. I set my book on the coffee table in front of me. I didn't think I had much reading time left in me and besides, I had a fall-asleep book on my bedside table already.

Steve took a look at the book, and a shadow crossed over his face, which I wouldn't have caught if I hadn't been looking right at him.

"What's the matter?"

"It's that book. I've seen it before."

"Yes, in that funny bookstore-coffee shop next to that fabulous bar with the jalapeño martinis. You were there when I bought it."

"No, I mean, yes, I recall that now, but I should have put it together before this. That book was in Kristin Perry's beach bag when they found her."

"So she bought the same book?"

"Or whoever killed her bought it and staged it for us to find."

"Why would they do that?"

"I don't know, but there are several things that have come to light about the way the body was staged that the Vallarta police are concerned with." Steve looked pensive. "Randy, I hate to ask this of you, because I know how you feel with both Keller and the detectives in Mexico being so dismissive of you, but would you mind making a report of the book for me?"

"Sure I can, I'm reading it anyway. What sort of report do you want?"

"I guess a synopsis of the book, along with your analysis of whether or not Kristin would have purchased that book herself, or whether you think it may have been planted for us to find."

"Of course I'll do it, for you. Keller doesn't have to know, or even if he knows, at least this is something where I could honestly be an expert opinion. After all, where else would you take a book to analyze than to an English department?"

"You're a doll."

We were in the bedroom by this time, and I had sloughed off

my clothes and slid into my oversized T-shirt, which stood in for what, in another generation, would have been a nightgown and peignoir.

Steve kissed me and headed into the bathroom for a quick shower, a habit he had when he came home. I recalled a mature student once writing in his class journal that he had returned to school to make the transition from a job where he showered at the end of the day to one where he showered at the beginning of the day. I'd thought it a nice demarcation at the time, but now I noted that Steve showered twice a day: once to be presentable for those he would meet and deal with, and once again when he returned, to wash away the sorrows and horrors he'd been privy to throughout his shift. Being the police was not an easy role, but I never heard him complain.

By the time he came to bed, I was almost asleep. I felt him stroke my hair and whisper goodnight, and sensed the warmth of him in the bed, but that was all I knew until my alarm sounded the next morning.

15

Steve's side of the bed was empty, and I could feel my heart do a little sad lurch. Then my ears caught on to noises beyond the bedroom. I paddled out to the kitchen in my saggy T-shirt to see my husband flipping a pancake into the air with flair.

"How did I never know you could do this before?"

He turned to smile at me with such warmth and love that I realized anew just how expertly police officers and detectives could compartmentalize their lives. There was no worry, no background calculations going on behind his eyes. He was fully in the moment, a man in his own home making breakfast for the woman he loved. I walked up behind him and encircled his waist with my arms, leaning my unbrushed head against his neck.

"You will always be a wonder to me, Steve Browning," I murmured. He leaned us both to the left as he deposited another perfect pancake onto a stack he had warming on a plate in the oven.

"Breakfast is either ready immediately or in ten minutes, take your pick," he said. I opted for the ten and scurried off to jump in the shower.

Eight minutes later I was back in jeans, a sweatshirt and a damp braid down my back.

"Can I help with anything?"

"Want to pour us each a glass of orange juice?" At this point, he was patting bacon strips down between sheets of paper towels to get the excess grease off and setting them on a serving plate with a fresh paper towel lining it.

I took two small glasses full of orange juice to the dining room table where Steve had assembled pancakes, scrambled eggs and bacon, with a selection of syrups and fruit butters.

"This is better than any service we got on our honeymoon," I exclaimed and Steve beamed.

"Dig in. I thought we should celebrate our first day off together."

He didn't have to ask me twice.

What is it about breakfast? I could eat breakfast foods for every meal. There were so many wonderful combinations thereof, also. Pancakes, French toast, porridge, cereals, muesli, fruit smoothies, omelettes, bacon, sausages, fried eggs, poached eggs, boiled eggs with toast soldiers, fruit and yogurt, dim sum, waffles. I drew the line at steak and eggs combinations or fried chicken before noon, but I'd seen them sneak into breakfast tables, too.

I followed Steve's lead and took some of everything. I reached for the sugar-free syrup, though. Our honeymoon had added

six pounds to my weight, and from experience I knew that I had best tackle it right away. Right after these pancakes.

"So, what would you like to do today?" Steve smiled at me, and opened his arms wide. "I am at your disposal."

"I have the day free, too. My marks are all recorded, my lessons prepped, my outfits laid out. The day is completely ours. Why don't we clean up here and then head out and check out the galleries on 124th Street?"

"Great idea. We could even have lunch over there. Some great little restaurants are dotted throughout that area."

"How can you even think about food? I'm stuffed."

"It's what propels me through the day, as a hunter-gatherer. What will my next meal be?"

I helped clear the dishes into the dishwasher, and scrubbed up the pans in the sink. Steve went off to have his own shower, and soon we were heading down in the elevator to the parking level to get in Steve's car. Although it was several years old, his blue Subaru Forester was still shiny and new-smelling, probably because it had relatively few miles on it. Most of the time, Steve was in an Edmonton Police Service vehicle.

We drove up out of the underground level into a vividly bright February morning. The sky was that startling western blue without a cloud in the sky, stretching high and wide over the crisp whiteness of an Edmonton winter. Light reflected off the snow, making nights less opaque and daytimes dazzling. I scrambled for my sunglasses in my bag, and Steve pulled his driving sunglasses out of a small pocket on the dash.

We had been looking at art in Mexico, and while we'd seen some pieces we'd really liked, a lot of it felt too flamboyant for our walls back north. My parents had been right; choosing art together was a really good exercise in understanding each other's tastes and needs.

It was also a way, I knew, for my mother to help me feel as if Steve's home was my home. I wasn't bringing much in the way of furniture, so if we could make some choices of what would hang on the walls, she was banking on my being more comfortable with the space.

Steve, to his credit, had recognized this ploy for what it was but approved it wholeheartedly.

"They say you should never buy art as a gift, and this is the corollary of that principle. You should always buy art together if it goes on shared walls. Your parents are very wise."

"I'm guessing we should give credit to my mother. My dad was probably thinking a new barbecue would be a better gift."

"And what went on their walls, and who do you think chose it?"

"When I was little, we were always in military housing, and Mom had only a few things she took everywhere. There was an Irish linen tea towel with "house rules" from some old manor house like Downton Abbey that hung over the kitchen table. She had two little pictures from her mother of a little boy and his grandfather sailing toy sailboats with larger ships in the distance and those always went in the hall, and a couple of plaster sea horses that hung in the bathroom. And we had a painting my grandmother did that always went over the living room sofa.

The rest of the décor was our teen posters, and a couple of those collage-type frames of family and school photos."

"That sounds pretty subdued from what I've seen of your mom."

"Well, when he retired out of the armed forces, my dad set about building Mom the house he said she deserved, for trekking and packing and unpacking after his work all those years. He created that great room idea a good ten years before it was everywhere, so that Mom never had to leave the party to check on the dinner. They live in that room, really. And I think she burned that tea towel in some sort of crazy ceremony with her best friends from the base, two of whom we had known forever and called Aunty Myrna and Aunty Jean, because we were always in each other's houses. She took my dad art shopping, and they have turned out to be quite canny collectors. They have a small Norval Morrisseau, and a Harry Wolfarth arctic landscape, and a Margaret Mooney portrait of a woman looking in a mirror. They also have some original Sue Coleman animal paintings with the Haida shadow of the animal worked in, which I love. And when I went to see them last Christmas, I noticed she had hung up the little sailor boy pictures in her laundry room. So I guess she didn't get rid of all of her make-do art."

"They sound quite serious about art. What if we end up getting things they don't like?"

"I think that would make her very happy. Art is supposed to be what you like, not what you think people will judge you on."

"And what if we can't find art we agree on?"

"Do you really think that's going to happen? Have you always felt comfortable in my old apartment?"

"Well, aside from your bed, which was too small."

"And I think your, now our, condo is absolutely beautiful, if a bit stark."

"I agree on the starkness. I've just never had money to focus on art with before."

"You know, there was once a rule that any building getting a permit here in the city needed to devote one per cent of its budget to art in the public areas, to allow for the support of local artists and the aesthetic enhancement of the city. I'm not sure if that is still on the books or not."

We were at the gallery district by now. The area at the eastern end of Jasper Avenue, where it abruptly turned into 124th Street due to the river valley's capricious addition of a gulch, had become the de facto gallery district due to the number of small, beautiful galleries along a four-block stretch. On either side of the street, and down a couple of side avenues, discreet signs led into peaceful spaces where people wandered, looking at the art available at a variety of prices.

Twice a year, all the galleries organized a two-day gallery walk, with hors d'oeuvres and beverages along the way. This wasn't that weekend, but plenty of people were browsing here and there.

We began with the Bearclaw Gallery that specialized in Indigenous art, and strolled through, admiring the clean lines of Haida art, and the exquisite soapstone carvings depicting Inuit life and the animals who helped make it possible.

I was taken by the thick dollops of paint creating fallen leaves in a huge painting in the next gallery we visited, just across the avenue. Both Steve and I moved in and then stepped back from the mountain scene, enjoying the combination of photorealism with paint technique impressionism. It was too big for any of our walls, but I picked up an artist sheet to remind us of him.

We moved rather quickly through the next store, noting that we likely couldn't have made even a down payment on any of their items with our art budget.

The West End Gallery captivated us for quite a while. The land-scapes were by seven or eight different artists but all shared a vitality and wildness that we both seemed to enjoy. Steve was taken by a group of dinghies tied together at a wharf, which didn't do much for me except in a sort of touristy way. It wasn't my world.

I moved toward a pathway through birch trees, set in that magical autumn weekend when all the colours change and the wind hasn't blown all the leaves away yet. You could almost smell the mulchy richness of the ravine path. Steve came up behind me and rested his chin on my shoulder.

"It's amazing that a riot of yellow and red and orange can be so calming," he said. He was right, I was taken by the meditative quality it produced.

"He did the cows, too."

I looked to the right of the autumn pathway painting to see some deliriously happy pink and red cows walking toward the foreground of a prairie scene. It was a crazy combination of realism and surrealism and it made me giggle. Now, that was a painting I could live with for a good long time.

"Let's pick up the information on this artist and go for lunch now?" Steve suggested, and I nodded happily, dislodging his head from its resting place. We chatted briefly to the woman in the gallery, who wasn't personally acquainted with the artist, but said he was from near Red Deer.

"All our artists are from Alberta," she said proudly. I looked around the large gallery, impressed with the scope and breadth of our visual artists. We had been through four galleries in the last hour or so, and it was already enough to note that the visual arts were thriving in our province.

We popped across 124th Street and into the Prairie Noodle Shop, a charming newish restaurant with large windows frosting up in the winter cold.

Both of us ordered ramen, me opting for the least salty version, and an order of edamame to share. When our lunch arrived, it was in steaming bowls of heaven and just as wonderful to eat. We drank large cups of tea with our meal, and talked art.

I spent some time offering up insights from my reading about Frida Kahlo, and Steve countered with some ideas gleaned from a long ago art history class. Both of us knew we were taken with impressionist and primitive art. Steve was also impressed with the big sky paintings of Sylvain Voyer and Ian Shelton, one who painted sunny blue skies over his canola fields and the other who countered with storms on the horizon.

I wasn't certain I could handle that much sky. On the whole, while I admired them, the prairies frightened me. There was too much openness, and I had the sense I could be blown away or plucked out of my tentative existence there. I was always much

more grounded and secure in mountain scenery, where there was something on the horizon to link me to my surroundings and something to grab on to should the winds pick up.

"I also like the universe that you can explore in a very small world, like when the artist zones in on just part of a trunk of a tree, or the corner of a building. Sometimes that is the zen for me, exploring the beauty in lines and corners you don't normally pay attention to."

"You know, I think we're sitting in the wrong chairs, then." Steve pointed over my shoulder. "What do you think of that? I've been noticing it the whole time we've been eating, but it wasn't mountains, so I didn't say anything."

I turned to look at a close up of several sunflower heads vying with each other for attention. It was a large photo print, and yet not quite a photo. I leaned in to the small sign beside the frame to read "John Wright. *Sunflowers*. Photo manipulation."

"It's wonderful. There's a John Wright who is a Shakesperian actor here in town, do you think it's the same person?"

"I may not know John Wright, but I know what I like. This is well within our budget, what do you say we buy this for the wall right by the kitchen island?"

I thought about sitting at the island, marking, and being able to look up at the joy in this splash of flowers.

"Yes, that would be perfect!" So this is what my mother had been hoping for, that bright moment when you connected over a piece of art. Steve and I beamed at each other, and he waved the waiter over to see what the mechanisms were to purchase one of their collection.

We would need to wait three weeks to pick up our painting, but we happily watched the waiter put a red sticker onto the sign beside it, denoting it was sold. We left the restaurant feeling well fed and pleased with ourselves.

"There are three galleries on this side of the street, or do you want to pick up where we left off and do the full circuit?"

"Let's go back to where we left off. I don't get down here often enough to skip over any of it."

"Well, remember, your parents won't mind if we don't spend all their money right away. We can go at this over some length of time."

"For sure. I don't want to buy just because we need a painting to match the sofa. I never want to be those people."

Steve laughed.

"Don't worry. I don't think you could even pretend to be that sort of person."

We caught the walk light and went back across 124th Street and up the block to where we had stopped to forage for lunch. There were two more glass-fronted shop galleries that held nothing that wowed us. We left the second ten minutes after entering. Steve looked down the block.

"There is just this one little house left, and then we need to cross over to the Lando Gallery to head back on the other side."

"Are you sure this house is a gallery?"

Steve pointed to the sign, saying "Abernathy's Gallery," which indicated the entrance to the gallery was down a small set of stairs. A young woman all in black met us near the door, and welcomed us in.

"We are a collective of new artists, students and new immigrants. The mandate is to introduce new names to the public and offer new artists that first leg up in their gallery careers. However, we are not affiliated with the University or any particular art school. Shows are curated as in any other professional gallery."

I liked the idea behind the gallery immediately. It reminded me a bit of the Art Walk that happened in Old Strathcona annually, where local and upcoming artists and craftspeople purchased outdoor sites all along Whyte Avenue and a couple of side streets, and sold their pieces directly to the street traffic pedestrians who wandered the length of the avenue, looking for new work.

We moved into the gallery, which was indeed in the basement of an old house. The first room was the largest, and held some white sculptures of the human form with an unfinished air to them. They were white stucco over fabric, with metal chicken wire sticking out of one edge or another. Then I realized that hanging behind the chicken wire was a shiny, perfect red or brown organ—heart or liver—and the opening was there for us to see it. I wasn't sure what I was meant to take from these shambling mummies, or where I could put one in our living room, even if I'd wanted to.

On the walls were multimedia pieces either by the same artist, or his friend in internal anatomy, with photos of hearts and lungs placed in paintings of nudes, with collaged bits of *Grey's Anatomy* glued on. While it was an interesting commentary on how we objectify the human body, it wasn't necessarily something I could live with comfortably on my walls.

We moved in toward the back of the gallery and the rooms got smaller. I suppose it had been a basement suite in another lifetime, this area we were wandering through. The hall had a series of paintings that were quite cunning. One small section of the canvas contained a shiny photograph of a tea cup, and the rest of the canvas was painted in relation to the placement of the photo. In some cases, it was a logical extension, such as on a counter amid dirty dishes, or with other tea cups on a coffee table. In others, the painted section took on a surreal aspect, but still logical in some weird way. I liked the one in which the tea cup was set on the side of a sick bed, with tissues and books and cough syrup and what seemed to be a huge werewolf hand reaching for it. Steve didn't seem all that interested in them, and I wasn't thrilled enough to want any of them on my own hallway walls, so I moved along, too.

In what might have been the basement bedroom, we came across a splash of colours that took us both back to our time in Mexico. There was an homage to Kahlo, with a woman sitting like Kahlo in her ornately embroidered, colourful clothing, but with a mirror in place of her face.

Another piece showed several female figures dressed like Kahlo, standing one behind the next in front of a blue wall. It reminded me of the house Kahlo lived in next to her husband's that I had just been reading about. Were all the women Frida herself? Or were they other women inspired to be artists because of her initial vision? A third painting was a study of male human figures, one dark haired man who looked vaguely familiar sitting at a ninety degree angle from the viewer, a

stockier red-headed younger man standing with his back to the artist holding a sombrero in one hand, and a young blond in the bottom right whose hair flopped over his face as he kneeled forward on an intricately woven rug, making him impossible to identify. The first two figures were less articulated than the females in the previous painting, with more cartoonlike limbs and very strong shoulders, but the colours were similar and they were in front of a blue background, like the Casa Azul blue wall. The blond man's arms had more in common with the women in the other painting than the other two men he was sharing a frame with. It was as if Diego Rivera had leaned over and tried to add some people into his wife's painting. I wasn't sure I had ever seen a painting with two warring styles on the same canvas.

"Have you ever felt like you were living an example of gestalt so clearly?" I asked Steve, who was also drawn to the Frida-esque paintings. "We go to Mexico. We see a Frida exhibit. We decide to buy art. We see Frida everywhere. It's not like I wasn't aware of Kahlo's work before, but suddenly she is everywhere."

Steve was peering at the information besides the three paintings.

"Here's another element of gestalt or synchronicity, or coincidence, if you want to believe in that. Guess who painted all three of these paintings?"

"Oh no," I said, jumping to the awful conclusion just as Steve nodded.

"Yep, this is work by Kristin Perry, and being deceased, I am sure their value just went up."

16

I took photos of the paintings while Steve went to talk to the girl in the gallery. I emailed the photos to Steve so he could forward them to Iain and the Mexican police working the case back in Puerto Vallarta.

These paintings had been hanging since the beginning of February, and were slated to be rotated out on March 15, when the gallery would have a new show starting. While the gallery girl knew the tea cup painter personally, she only knew of the other artists, including Kristin Perry, by name. The gallery owner was connected to the Fine Arts Department at the University of Alberta through a friendship with some of the faculty, and regularly showed student work. That was all she knew, but diligently wrote out all the names and numbers Steve requested, the first being the gallery owner, Drake Abernathy, and the other students being displayed. Steve reasoned they might be in Kristin's class and would be useful people to question.

I sat on a small wrought iron stool near the door waiting for

him, and took a photo of a poster behind the door, detailing the shows for the first half of the year. All the artists' names were listed, but only one work was featured. This was one of the white sculptures with the shiny heart showing through the exposed chicken wire chest. Granted, it was big and memorable, but not to my mind one of the most interesting things in the gallery. I peered at the show prior to this. The featured work then had been a wooden heart covered in milagros, those little metal blessing favours that looked like feet or hands or hearts or donkeys that people used as prayers in Mexico, in a sort of combination of Catholicism and some earlier religion. It was not like the valentine heart we'd bought, more like the sacred hearts that Catholic statues held. I wondered which of the listed artists had also been focused on Mexico, and whether they had anything more in common with Kristin. Maybe they had connected while they were pulling down their displays and she was putting up the new work. I zoned in on the list, and snapped another picture, hoping the close up feature on my phone would make the tiny print legible. Steve might be interested in those students, too.

We finally left the gallery, climbing the narrow concrete stairs out front, and found ourselves back on 124th Street. My interest in art galleries had waned considerably, as had Steve's. We made our way back to his car, and headed home.

Back in the condo, I put on the kettle for a pot of tea, and Steve got on the phone with Iain. It looked like his day off was going to get whittled away if we didn't watch out. I went over my notes for Monday's lectures and took the shoe buffer to my

black boots. In just another month and a half, I'd be able to push my boots to the back of the closet, but these days they were all I would wear, morning and night. There was no point in creating outfits that couldn't handle tall leather boots or grippy short booties, because although Grant MacEwan was entirely interconnected with pedways between the buildings, getting there was another matter. From where we lived, I either took a bus, which only came within five blocks of the campus, or I walked a mile back to the university LRT stop and caught the train. Either way, I was going to be walking through a winter wonderland of slush, ice, snowdrifts and/or grime for quite a distance.

Fortunately for me, my wardrobe didn't favour much more than boots in the winter and flats or sandals in the summer. It wasn't that I hadn't inherited the shoe-buying gene, I think it was just that the book-buying gene was so much stronger.

Having checked on my wardrobe for the coming week, I wandered back out into the kitchen where it seemed Steve was still talking to Iain. I got a bit closer and realized he was reading something in Spanish into the phone. He must have decided to contact the Vallarta police after getting Ana Maria de Valle, a bilingual Edmonton police officer, to translate what he needed to say. Iain had conscripted Ana Maria from the downtown station the minute Steve had called back to Edmonton with the news of the Canadian connection in the crime, and she was proving very useful as a conduit. She had been translating for Iain, who was taping everything the Mexican detectives said over the phone, and Steve was using her to make sure the material shared in return was received accurately.

I saw him turn on the small recorder he kept in his kit, and sure enough I could soon hear very fast Spanish coming through the receiver. I tiptoed off to the living area to make myself useful by taking notes on what had earlier been my relaxing reading material.

Now, of course, it was an obligation, and as a result, lost quite a bit of its lustre as entertainment. This was likely how my students felt diving into novels I'd lovingly placed on syllabi. Oh well. I brought out a notepad, and roughed out the earlier part of the book as I recalled it from my initial reading.

Frida had been a bit of a tomboy, or else was trying to please her father who had wanted a son, but she had polio in her leg as a child. Her father pushed to make her compensate for her issues by striving to be faster and better in every way. She was an eager and bright student from the sounds of things, until she was injured severely in a bus crash when she was eighteen. She spent more than a year in a body cast, and would suffer thirty operations throughout her life to deal with a broken back and excruciating pain.

Her handicaps became her strengths. While the rest of the female intelligentsia and art set in Mexico were wearing the same body-skimming styles as the rest of the early twentieth century, she adopted traditional Techuana styles of dressing, with long full skirts and blousy, embroidered tops to mask her medical corsets and her shorter leg. After she died, Diego Rivera ordered all her clothing packed up and locked into a room in the Blue House until fifteen years after his death. Eventually, an exhibit of her clothing, smelling of tobacco and turpentine, went on display at the Frida Kahlo museum in Mexico City.

She painted her corsets, which she wore to help her tortured spine, to take ownership of her situation. She also turned to self-portraiture not from ego, but because of all her time spent in solitary confinement in her bedchamber. She said that she herself was the subject she knew the best.

Her famous strong eyebrowed self-portraits were often tortured with arrows or missing parts. In some ways, while delineating her own personal pain, she was also speaking to Mexico's search for independence and autonomy, and tying an umbilical cord between the Mexico of the milagros and peasant revolts and the atomic age holding a promise of world unification.

She was a fascinating person full of contradictions, as so many of the most interesting people are. I could certainly see why a young visual artist would be inspired by her, so much so that she spent her spring break week in Mexico, soaking in the ambiance that had created a Frida.

Of course, Kristin's holiday plans could have been entirely coincidental. After all, it wasn't as if she was making an accurate Frida pilgrimage. That would have entailed visiting Mexico City and the Casa Azul, which had been the Kahlo family home and then where she and Rivera lived off and on, and was now the Frida Kahlo Museum. Or she would have headed to Cuernavaca where Frida and Diego had spent time after they were first married.

Maybe she had planned a trip to Puerto Vallarta to coincide with the Fantastic Fridas display that Steve and I had stumbled upon and enjoyed so much. I made a note in the margin of my notepad to remind Steve of that exhibit. Perhaps the Vallarta

police could compare a list of the artists in that display to the list of people known to Kristin that Steve and Iain were compiling.

Maybe it was all a big coincidence that Kristin and her friends had chosen Mexico instead of Hawaii or Florida for their Reading Week destination. After all, flights from Edmonton to Puerto Vallarta were considerably cheaper than any other hot destinations, as Steve and I knew, having made our honeymoon choice very much based on our budget.

Kristin might have justified the frivolity of a Reading Week party trip by her devotion to Frida, and painted Frida-like work before the fact in anticipation of her vacation. I didn't think that would be quite enough, though, especially from a student in the visual arts program, where the need to express an artistic vision was required from each student as the work was being undertaken. If Kristin had been painting a la Frida, she would have laid the groundwork for that long before she had purchased a ticket to an all-inclusive on the beach for a week.

I looked up and realized that Steve was off the phone and working on his laptop instead.

"Would you be interested in some dinner?"

He looked up and smiled.

"So much for a weekend off, eh? My only consolation is that if I get this report in now, I think I can stay away from the office tomorrow."

"That sounds worthwhile. Why don't I whip something up while you finish off there, and we can binge watch something on TV?"

"You're playing my song. Am I in your way here?"

"No, having mastered the concept of cooking with very little counter space, I am still in awe of this island. You are safe there." I moved around said island and burrowed into the fridge to see what we had in stock.

In the freezer, I found a bag of green beans and some lean ground beef. I set the meat on a paper towel in the microwave to thaw, and hauled out the eggs and bread that had been in the fridge since before our trip, and a can of mushroom soup from the pantry. After crumbling up three pieces of bread in a bowl, I added the still very cold meat, a raw egg, some Worcestershire sauce, which we had noticed in Mexico was called *Salsa Tipo Inglesa,* and undiluted soup. I stirred up everything along with a pinch of salt, and popped it into a loaf pan, one of the few bits of kitchenware that had come with me, since Steve hadn't owned one, while I had two glass ones and a tin version.

I sliced some cheddar cheese into strips and laid them across my meatloaf and popped it into the oven. Steve had raved once about my meatloaf, a recipe I had learned in grade seven home economics, so every now and then I hauled it out to feed him what my mother would call "comfort food." I poured some frozen beans into a pot with a small amount of water and set it on the back of the stove, ready. I wouldn't start them for another forty-five minutes. I rummaged in a basket at the bottom of the pantry for a couple of baker potatoes, and scrubbed them up and poked them with a fork before popping them into the microwave and setting them to bake for ten minutes.

Having a microwave was a blast. There had never been room for one in my small kitchen, so I'd done without, but Steve had

a powerful one hanging above his stove, which had become one of my favourite tools. No more tepid coffee, no more waiting for one dish to be ready while the others wilted or cooled. The euphoria of the 1980s housewife was mine.

I set the table with the place mats and matching napkins Leo had sent us for a wedding present. They were red and had black moose walking along the top of the mats, and only one moose on each napkin. They were woven and designed in Newfoundland, where Leo taught, and were likely chosen with the price of postage in mind, but I loved them on sight, and was happy to use them. He had thoughtfully sent along five sets of napkins, so I could toss them into the washing machine and still match the place mats all week long.

I decided to go all in and pop candles into the crystal heart-shaped candleholders that Valerie had given us. Saturday night meatloaf by candlelight might seem silly, but it was still officially our honeymoon, and I wanted to mark it. Even though Steve's work had pulled him back early, I didn't want to lose it entirely. Monday morning would come soon enough.

Steve heard the oven chime to let me know the meatloaf was ready, cleared up his laptop, and padded off to wash up for supper. I served from the stove, and brought our plates to the dining room table. My reading lamp from the living room cast enough of a glow to make dining by candlelight possible, since it was already dark outside, and the lights across the river marking our city skyline were visible from the windows.

I don't think I would ever get tired of that view. Supposedly, television shows requiring a Midwestern city would often use our

Edmonton skyline because it was so attractive, shining against the big blue sky, or in this case, twinkling against the big indigo sky.

Steve snuck up behind me, standing with my hands on the back of the dining room chair, and put his arms around me.

"Happy honeymoon, Wife."

"Happy honeymoon, Husband."

"This smells divine."

"Well, dig in, and don't worry, there is more."

"That always sounds like a challenge, as well as a comfort."

Cooking for Steve was one of the most satisfying chores because he was always so appreciative. He smiled at me as he closed his mouth on a fork-full of meatloaf and reached for my hand with his free one. Romantic dining in Edmonton wasn't quite the same thing as on a moonlit patio in Mexico, listening to the surf on the beach and watching the sun set to opera music. Still, sitting with a good man across from me and good food before me was a lot more than most people could expect in life, and I was intensely grateful. Love was something one should never take for granted.

"So far, so good?" Steve's voice cut through my reverie.

"What? Sorry, I was drifting."

"I could see you clicking through our new situation. You were thinking about how different it is even though we have been eating together on and off for, yea, these many years?

"Does it feel different to you, too? I was thinking about the shift between the honeymoon and home, but you're right. It's like we've slid into a different gear, even though we've been driving in the same direction all along."

"Ooh, car allusions. What a great segue into what I was going to propose for tomorrow."

I perked up.

"What?"

"How would you like to go out for a drive and some snow-shoeing near Elk Island Park tomorrow, as long as it's not too windy?"

The thought of crisp snow, sunshine, hot cocoa in a thermos, and the possibility of seeing a bison or two sounded terrific. It was great to have a tiny National Park within an hour's drive of town, with trails and camping and picnic sites enough to allow everyone a taste of nature without too unwieldy a road to get there.

We watched a couple of episodes of a police procedural series that Steve found relaxing, because the anachronisms and inaccuracies made him laugh. Whenever DNA evidence would be returned immediately, he would make a bleating air horn noise to protest, and various set phrases the desk sergeant made would elicit guffaws. Thank god the condo was pretty well soundproofed or our neighbours would have started to wonder about us.

"I'm torn between wanting shows like that to be more accurate and wanting them to show slightly less in the way of educating incipient criminals on how not to get caught. Of course, it helps that the criminally-minded are generally not that bright."

"I've often wondered about that, too. My theory is that the police should set a watch on how many people buy shovels, hacksaws, tarps and bleach all at the same time."

Steve laughed.

"And we'd be profiling a lot of arborists and renovators."

"Right, I never thought of that. I'm too focused on the television body dump people."

We cleaned up the kitchen together, and headed to bed. I had already claimed my side of the bed on our years of sleepovers, but it was still so strange to walk around to the right of the large bed and see my book on the sidetable, and my slippers beside it.

We rolled over to face each other mid-bed, and Steve pushed my hair back from my face gently while I stared into his warm brown eyes.

"One more day, and then it's back to reality."

"Reality 2.0. I'll walk a longer way back from campus. You'll take a packed lunch with you on your shift. We'll have someone to immediately relate our day to every evening."

"You cut right to the essentials, Randy."

"I do my best."

"This has been a great adventure already."

"You mean our honeymoon accented by a murder investigation which followed us home?"

"No, I mean our life together, from the minute it began."

As I recalled, the first thing I had done upon meeting Steve was throw up in response to the news he had brought me, so the fact he was focusing on "from the minute our lives began" had a worrisome edge to things. I leaned in to kiss him on the nose and then the lips.

"Have you set your alarm for the morning? If we want to get out to Elk Island before the rest of the non-church going heathens, we'll need an early start."

"You're right. And yes, I did." Steve kissed me again, and rolled over onto his back. "Sweet dreams, love."

"Same to you," I said, just like my mother and father had always said to me, and each other, savouring the tradition as I settled into my perfect pillow and went immediately to sleep.

17

Alberta may be considered part of the Great White North and cold as hell in the winter, but one thing the prairies and aspen parkland offer in recompense is a blue, sunny sky that stretches for miles. Combined with the sparkling snow, the sheer brilliance of the day reminded me of noon hour on the beach in Mexico. I had used the tail end of my sunscreen from our trip to make sure my nose and chin didn't burn on our outing.

You wear sunglasses year round in Edmonton, first off because it's the second sunniest city in Canada, losing out to Calgary by an average of eight days, and because in the winter, that sun is positioned in the sky at an angle to always be right in your eyes.

Steve had packed the snowshoes and poles, and brought our winter hikers out from the back of the closet while I made cocoa, poured it into the big thermos, and packed it with the sandwiches, chocolates, and bananas in my backpack. I also

packed wet wipes in a resealable sandwich bag, and a small garbage bag for anything we might want to toss in one of the big bins near the picnic site.

Elk Island National Park was only about half an hour past the edge of town, but it seemed kilometres away once you swung into the entrance and slowed your car and your heartbeat onto park time. The park on the north side of the highway was the part which welcomed people, the rest was still a large animal preserve.

It had started out more than 100 years ago as a preserve for one of the last elk herds in the province and became one of Canada's twenty-two National Parks in 1930. There were two or three camping areas, one of which was even organized for people without tents and camp stoves of their own, and oodles of walking trails. There were some historic buildings of early settlers, preserved for mostly educational programming, and a small golf course and clubhouse tucked away at one end of the main lake.

A boardwalk out over the marshy end of Astotin Lake offered information signs about the fish and insects beneath, and a bison paddock let you drive slowly through an enclosure where you might be able to see and photograph accommodating bison. Chances were, of course, that you might come across a bison or two on the hiking and skiing paths, which a park warden had once laughingly told me the bison assumed had been created and maintained entirely for their pleasure.

In the summertime, we came out for picnics and to watch the sailboarders glide and splash in the lake. We never had camped

over; Steve and I had both agreed a long time ago that hell was being trapped in a tent with a mosquito. But we liked to come out for a day's enjoyment; hiking in the summer, and using the same groomed trails in the winter to snowshoe or cross-country ski.

I had found my sport in snowshoeing now that the new aluminum styles had been developed. They were easy to get into, and walking in them was pretty straightforward, rather than the wide-legged duck walk I had used when snowshoeing with my grandfather in the gut-strung elongated tennis rackets he purchased from a Dene trapper friend. While he mainly used them to maintain an eye on his fences and check the state of the stream that ran through his lower forty over winter, he would pull them out whenever we went out to the farm to visit, and my dad and I would usually waddle out in his wake, while my mother would laugh and take photos from the kitchen window where she would stay and visit with her mother.

Years later, when Steve had surprised me with snowshoes, I had cringed, thinking of my graceless progress over the snow, but within minutes of strapping the smaller aluminum ovals onto my boots, I had felt the freedom they brought. Displacing your weight meant that you didn't sink into snowdrifts, and you could walk with ease across snowy expanses, opening up the winter for exploration. We had done a trip to Marble Canyon the winter before, when we'd been staying for a long weekend in Banff, and strolled along amid small trees recovering from a forest fire some years before. It was only when we got back to the hotel and I was flipping through some postcards on the

rack that I realized we'd been strolling along about eight or nine feet above ground level and that those small trees were actually fifteen feet tall, not four or five feet as I had thought.

Elk Island didn't get that sort of snow, usually, and the trails were mostly maintained for skiers to get through, so we wouldn't be hovering above the trees anywhere, but it would be nice to make the journey without turning an ankle along uneven snowy paths.

We pulled into the small parking area for the Beaverpond Trail, which was one of my favourites because you didn't have to retrace your steps—it brought you back to where you'd begun. Even in the mountains, where the vistas were pronouncedly different from every angle, going back along the same trail made me a bit anxious since it always seemed we'd gone a lot further than I'd been reckoning.

Steve opted for a counter-clockwise trail, and since there was no one else in the parking lot, we could do as we liked. I pulled on my backpack after transferring the heavy thermos to his, and we strapped on our snowshoes, his blue and mine red. Soon, we were strolling along, listening to bird song and glorying in the morning.

"This time a few days ago, we were heading off to that food tour in shorts and sandals," Steve mused. "Hard to believe, eh?"

"Well, aside from a few layers of wool and neoprene, and a distinct lack of tequila, it's much the same thing. We're doing as we like, we're together, and the sun is shining."

Steve pointed across the pond, where a moose was walking in the snow, his long awkward legs looking much more graceful and purposeful as they stepped up and into the drifts.

"And the things we spot along our walk aren't dead," I whispered, although I doubted we would startle the moose. Animals in National Parks seem very aware that their protection is the primary concern. While I wouldn't want to get close to a bear or even an unpredictable moose or bison, from this distance I was happy to admire and leave him alone.

Steve paused to get a photo on his phone, and then stopped to read the messages he'd been ignoring since it was ostensibly his day off. He dashed off a couple of text messages and then, frowning, put his phone back in his inner pocket. Smartphones didn't do too well in extreme weather, and though it was sunny, it was still well below freezing. He popped his gloves back on and turned to smile at me.

"Trouble from work?" I asked, even though I didn't particularly want to hear the answer.

"Nothing that can't wait a few hours," he said, and on we walked to get to the bench near the beaver lodge, where I had planned to stop. We pulled out the sandwiches and cocoa, and ate and drank quickly, in order to get our hands back into our gloves as quickly as possible. The heat of the cocoa through the plastic mugs I'd brought along warmed the palms of my hands, and the sun on my face was welcoming. I heard Steve sigh beside me, and realized he was just as content here as he had been beside the pool in our hotel. I admired that about him, that he could find the pleasure of relaxation wherever he went. Maybe cops learned how to do that, to turn on and off their minds when they could, to preserve whatever peace they came across.

It didn't work that way for me. Even here, in this white and

pristine area so different from the sandy Playa de los Muertos, I was still mulling over the imprinted memory of seeing Kristin Perry lying there.

"Why do you think they killed her and positioned her where they did?" I asked. There was no need to explain to whom I was referring. I was betting those messages had been about Kristin.

"I don't know yet. But they've determined she was killed there. The blood loss indicates the body hadn't been moved and placed there. There were traces of a barbiturate of some sort, which probably means she was drugged, and placed on the beach, and then stabbed. Someone must have had the knowledge of where to pierce in order for her to bleed out without being a gusher. That would suggest some anatomical knowledge. The blood saturated her red bathing suit and the towel, which had been white. There were no trails away from the towel, so the perpetrator wasn't catching any blood spatter."

"Her hat was placed over her face, I presume really wedged on so it wouldn't fly away, and her bag was beside her shoulder, her water bottle was in her hand."

"Yep, she looked as if she had fallen asleep while tanning. We have no one who seems to have even noticed her before you took the photo of her, but then again, that spit is used only for amateur fishermen and children, so no one would have been there at dawn to catch anything."

"I had thought that she must have come from one of the smaller hotels or condos along the river, maybe one that didn't have much of a pool access or patio."

"But we know her hotel was well away down the beach. She

would have had to take a cab downtown to get there on her own, and none of the cab drivers recall a young woman alone early in the morning. In fact, that was one of the messages this morning. Inspector Rodriguez has been keeping me informed of their progress."

"So, you think she separated from her girlfriends the night before, and was drugged and laid out there and killed some time before dawn the following day, or at least before people started to walk the beach."

"It would have had to be before dawn. Apparently, there are beach cleaners for the bigger hotels who get out before six a.m. to smooth out the areas in front of their properties. There are regular joggers. And, the folks who run the kiosks on the island come from both ends to set up each morning. It would have been a risk to be out there later than dawn."

"And a risk to set up too soon beforehand, or she would look way out of place."

"Right. One thing is that placing her on that spit of land under the bridge allows for people to see her from the bridge, but not necessarily come upon her if beach jogging, since the water is pretty deep right there. They usually either turn around when they get to the River Cuale, or they head up to the bridge, and over, before heading back to the beach on the other side. So, situating her there was a carefully planned statement."

"If only we knew what they were trying to say, we might figure out who was saying it."

"Yes. Did they pick her specifically because she was Kristin

Perry, or did they just need someone who would fit into the red bathing suit?"

"You said a copy of the Frida Kahlo book was in her bag."

"Yes."

"Was it her bag?"

"Well, it had a change purse with her hotel key in it, and some postcards."

"Those are things that might be in her evening purse. Maybe they tossed those in to make it easy to identify her."

"Okay, so everything is purchased except the change purse and maybe the book."

"Why would she take a book on an evening's outing?"

"You take a book everywhere."

"Not everywhere; I don't think I'd take a book to a nightclub."

Steve reached over to my backpack sitting by my feet, and opened it. Rummaging past the bag of sandwich detritus, he pulled out a paperback copy of *Mary Russell's War*.

"This is not a nightclub."

We laughed at my feeble attempt to get out of my own argument, but I noticed that Steve was making a note to himself on his phone. Perhaps he would check with her roommates whether Kristin had bought or brought a book on Frida Kahlo with her when they went out on the town.

We packed up our packs and headed on the circle trail back to the parking lot. We passed and nodded to two clockwise skiers, and noted three more cars in the lot by the time we got there.

Steve drove us back to town, and I daydreamed in the

passenger seat, wondering how many of my students would notice the ring on my finger or detect anything different in my demeanour.

"What's that you're humming?" Steve asked me.

I paused to think, and then laughed and sang the words to the song from *Funny Girl* that had been accompanying my thoughts.

"Sadie, Sadie, married lady…"

Steve laughed.

"Looking forward to referring to your husband in sentences?"

"Exactly. What about you?"

"Oh, I have already mentioned that I had to 'get back to the wife.'"

"And what did anyone say?"

"They applauded," Steve admitted, blushing a bit.

I giggled.

"Are we too old to be feeling this way?"

"Nah, I'll bet people who get married in nursing homes feel the same way. It's normal to revel in the novelty of it all."

"That's the thing. I feel as if it's Christmas morning, and yet I also feel as if we've been together all our lives already."

"Well, that may be the secret, Randy. That may be the secret."

18

Getting back to lectures after Reading Week seemed anti-climactic, as if most of the term had already taken place. I handed back essays, gave a summary of things to watch out for, gleaned from the most common errors in formulating their arguments, and handed out the final essay topics.

"Some of you might think it would be kinder to wait till Wednesday before you got the next topics, but I can see from the depth of thought many of you put into the last essays that you like to make every moment count. The topics are all focusing on our final work, the Canadian novel *Hey Nostradamus!* by Douglas Coupland. I'm hoping you have managed to get the primary reading done, because we'll be diving right in next class. In the meantime, as per starting each new section, I'm handing out a pre-quiz to reward early readers, and get all of you thinking about elements to consider in our discussions ahead."

I handed out the quizzes, telling them they could leave once they had handed a completed one in. Most of them ran through

it in five minutes, meaning they'd either read the book over Reading Week as the break implied they should, or they hadn't tackled it yet and knew nothing.

I startled myself into recalling what I had meant to mention to Steve, and while someone waited by the door to get in for their next class, I quickly texted him to ask whether he had checked with Kristin's profs about assigned reading. Perhaps that Frida Kahlo book had been hers for a class back here. And if not, then it still could be hers as special interest reading.

If it wasn't hers, it scared me to think that whoever had staged her body had known her well enough to place an art book in her bag, over a novel or history book. That was the question that needed answering. Was Kristin Perry targeted because she was just a cute, blonde tourist? Or was she killed because she was Kristin Perry? Or was she the victim because of what she represented: a Canadian, an art student, a single woman? Who knew what went on in the minds of killers?

Before I had a chance to slide my phone into my satchel, I received a text from Denise asking me to come see her. Since her office was so much nicer than mine and I didn't have another class for three hours, I packed all the material I would require for my next class with me, and caught the LRT over to the U of A. After running the gauntlet of HUB Mall teeming with students, I headed into the Humanities Building and up the same concrete steps I'd been climbing for twenty years. Unlike the marble steps in the old Arts Building and South Rutherford Library, these steps didn't deign to show a groove where year after year of young scholars had

trod. I pulled open the door to the third floor and headed past the main office.

I could have been invisible for all the attention I got from the office staff, but to be fair, one of them was dealing with a student at the front counter and the other two were on the phone. Still, you would hope for a bit more spatial awareness from people, or maybe it was just me who would. After all, this was not the safest building I'd personally ever been in.

Denise's office seemed like a separate world radiating peace. The beech wood paneling that was similar to every other office somehow glowed more and I wondered idly if she had oiled the bookcases and the strips of wood under the windowsill. She had greenery along the window, but not a great deal, and I was pretty sure they were all plants listed as having beneficial effects on the air. Mostly, the place was decorated with books, as were all the offices along the hall. Denise's specialty being Shakespeare, she also had a set of Toby Mugs along the top shelf with different characters like Falstaff, Shylock, Richard III, and Lear represented. I am not sure how she managed to seem so serene, with all of them staring down at her.

"Randy! Want some tea? It's just steeping." She poured me a cup of fragrant Earl Grey and one for herself while I slumped down into her reading chair, a big overstuffed monster we'd dragged up with the help of one of her grad students a couple of years back one weekend. She had a regulation wooden seat for students across from her desk, and somehow managed to have her coat or a pile of books stacked on the reading chair whenever a student appeared for a meeting, but friends were allowed

to sit in it, unless they showed up by surprise while Denise herself was curled up in it.

"I did some asking about the art profs for you. I recalled that the Chaucer fellow, David Murchie, has been seeing one of the sculptors, that woman who always shows up to the Studio Theatre shows wearing all that turquoise jewellery, you know who I mean?"

"Sort of. Thin and long grey hair, and a long black coat?"

"That's the one. Her name is Briar Nettles."

"You're kidding me."

"Nope, apparently it is a family name, but it does sound like the family lives in a fairy tale, doesn't it? Anyhow, Briar is approachable and very interdisciplinary, which in this case means she connects with other profs and lecturers in other departments. Did you want me to arrange a meet cute?"

"Film studies rubbing off on you?"

"I suppose. It's the students, really, who have begun to merge the language between their classes. If I never read another essay discussing the 'beats' of *Macbeth*, I will be a happy woman."

"Or the filmic value of the heath in *Wuthering Heights*?"

Denise pretended to throw a book at my head.

"Exactly. I don't particularly mind the film gang being part of things—after all, they've really been part of the whole from the start when it was just Bill Beard teaching film studies against the world—what bugs me is the diminishment in the eyes of the rest of the university it seems to have. We used to be the bastion of rhetoric and style and interpretation of metaphor, and now we're only good for dissecting one particular culture

through words and moving pictures. On the whole, I think it's a plot to undermine the Faculty of Arts in the eyes of the funders. If it's not practical science and thereby worthy of mega-grants, It's of no value at all. Studying the arts will soon be equated with embroidery for the ladies of the court. Utterly non-essential, but it keeps our hands and minds too occupied to foment rebellion."

"I hope you're wrong."

"I do, too. The thought of having to fight our way out of the rubble toward a second Enlightenment just makes me weary."

I had never heard Denise quite so cynical before. Usually she was the one jollying me out of a funk. Of course, there was less at stake in the future of academe for me, because academe had never clasped me to its bosom the way it had Denise. From the distance I had been forced to maintain, the university game was just another business anymore. I got there on time, put in my hours, sat my requisite office hours, got my marking done in record time, and started all over again. I was getting to the point of wanting to just find a quiet retail job, or to snag an editing job for the City or the provincial government.

I made motions to leave and Denise wrote down the phone number for Professor Nettles the sculptor. We hugged and I left her to ponder the value of her life choices for about a nano-second before she remembered what a great path she was on. Meanwhile, I had half an hour until my next class.

I pulled out my cellphone and dialed the number Denise had given me for Briar Nettles. It seemed strange to be dialing such a person this way, rather than sending her a message by means

of a talking woodland creature, but she picked up on the second ring.

I introduced myself and stumbled through my reasons for contacting her. She was polite, if a bit cool, and agreed to meet with me at three-thirty for a cup of coffee in Hub Mall.

I went off back downtown to teach, managed to instill a bit more verve into my introduction to the new novel with that group, and gathered up the quizzes tossed on my desk on their way out the door. I had thirty minutes to reach the south end of HUB Mall, where I had agreed to meet the sculptor. Thankfully, none of my students wanted to waylay me to discuss their upcoming papers, and the LRT was sitting in the station as I jogged to it. With only five stops between me and my destination, I managed to stroll into the mall from the underground station handily in time.

I had just dumped my coat and satchel on a table for two in front of the coffee shop that had at one time been known as Java Jive when Briar Nettles appeared.

Apparently, the black and turquoise was a special costume for fancy events. Today, she was dressed in overalls, very sincere ones with ground-in clay in places and patches in others. Her blouse beneath the bib was colourful and woven, perhaps Peruvian in origin. Her grey hair was wound up in a bun on the top of her head, with a pencil shoved into it. The pencil looked like it had almost as much clay on it as the knee of her overalls. I wasn't sure she even knew the pencil was actually there.

I waved, and she came right over to me and stuck out her

hand to shake. I had a weird sense of déjà vu, as if I'd witnessed this scene before, even if I hadn't actually lived it.

"Randy? Briar. What can I do for you?"

"May I get you coffee before we begin?"

"Great. I drink it black."

She sat across from my stuff while I grabbed my wallet and went to buy us coffees, decaf with milk for me, and black for her. I also bought a muffin for us to share, and set it in the middle of the metal table. She looked up from her cellphone when I sat back down, and dropped it into the bib pocket of her overalls.

"So, you said this might be about a student of mine? Is it a mutual student?"

"No, and I'm not even sure she would have been your student, but she was in the Visual Arts program. I should backtrack a bit. I have become involved in a homicide investigation of a student in your department, mainly due to being on scene when her body was found in Mexico."

"Oh, Kristin Perry."

"Yes, Kristin Perry. My husband is with the Edmonton Police Service, and we were on vacation there when it happened. He has become the liaison between the police there and here, and I have been asked to read one of the books found in her bag to see if it could be of any importance to the crime."

"How could a book be of importance?"

I gritted my teeth just to hear those words, and from a creative artist, but pushed on.

"Well, everything else about the scene of the crime was posed, apparently. The police want to know if the book in her

beach bag was one she had, which the murderer just left there, or if it was planted there to create a message of some sort."

"And what was the book?"

"It's a book on Frida Kahlo. In fact, it was a copy of this book, the same book I had bought and was reading." I pulled out the Helga Prignitz-Poda book I'd shoved into my satchel that morning on the off chance I'd have a chance to read during my break. Briar Nettles reached for the book.

"I love a good art book," she enthused, and flipped through it reverently, or as reverently she could with her work-roughened hands.

"Do you think this would have been assigned reading for Kristin?"

"I doubt it. Most of the texts assigned are more theoretical than biographical. This would have been purely for interest, and I'm not so sure a BFA student would be spending time with a compendium of this sort. If she was being assigned something to do with Kahlo, it would likely not be something this mainstream. This looks more to the biography of the artist than her place in the movements of the time."

"Does it look like something an art student would be reading in her spare time?"

Briar Nettles wrinkled up her perfect nose in thought.

"I doubt it. For one thing, it's relatively heavy, and we are so aware of how much weight we have to carry, in terms of paints and canvases and notebooks and pencils, and how careful we have to be of our own skeletons."

"Wow, you sound like a dancer I know."

Briar shrugged.

"It's a fair comparison. To be an artist, you are at the mercy of your own physicality. As you move toward professionalism, you understand that more and more. One of the things I insist my own students do is enroll in yoga classes to keep limber."

"We English types just try to remember to put both of our backpack straps on."

Her smile was a bit withering.

"I'm sure you pay attention to your eyes, though, right?"

I had to agree with her. The one time I had been terrified enough to head to the Emergency of my own volition was the time I'd scratched my cornea. I couldn't imagine a world without sight.

"I'll pass your insights about the book along to my husband. If he requires you to make a statement, would that be possible?"

"I would be happy to, but I am sure he'd rather hear from Kristin Perry's own instructors? After all, I am just offering an opinion as to her free reading choices. I didn't know her. Is that all you wanted to talk about?"

"Actually, I really wanted to get a sense of your department and how she'd fit into it. She and her fellow students. This whole corner of the campus is relatively unfamiliar to me, except for the music library. I was hoping you could flesh it out for me a little. Did you by any chance teach—wait a second," I pulled my phone out of my satchel and flipped through the photos from the student gallery, "a Dana Woodfield, Cole Vandermeer, Austin Stauffer or a Gerry Bradley?" I threw Kristin's boyfriend in to the list to see if that might get a rise out of the art prof.

Her eyebrows shot up into her forehead, and for a second I could tell what sort of tiny little crone Briar Nettle would eventually look like. Apparently, it wasn't Cole's name that made her take notice.

"Austin Stauffer is one of my sculpture students. What do you want to know about him?"

"As I understand it, he was part of an art exhibit Kristin Perry was involved in. Could they have been involved personally, as well?"

"Well, I doubt it. Though it is not exactly common knowledge, Austin is married."

19

Briar filled me in at length on the discussions both she and the Dean of Fine Arts had gone through with Austin Stauffer, as they did with all students whose portfolios had made the grade, about the rigours of the coursework expected of them, and the time commitment entailed.

"I also tried to impress on him that the chances of making a regular wage as a sculptor were impossible to predict. It's not just a matter of how talented you are. It's about the commissions, and whether a client sees from your last work the possibility of what you could do for them. This is not necessarily the way to put your kids through college or even pay for orthodontia."

Austin had seemingly put them all at ease, explaining that he had been that unicorn of a mythical creature, a responsible roughneck. Instead of buying a new truck every year and blowing his money on his two weeks' home from the rigs, he had saved and invested and turned ten years of rig work into a nest egg that he and his wife could rely on while he took his BFA. His

wife was a licensed practical nurse who worked part-time at the children's hospital, while taking courses toward her masters in nursing.

From the way she spoke about him, Austin Stauffer sounded like a paragon of virtue and wisdom. That didn't mean he wasn't also a cheating asshole; it may have just meant he was better than most men at hiding that portion of his personality from at least his professors. I made a mental note to tell Steve about Austin as soon as possible. Meanwhile, there was one more thing I wanted to ask Briar Nettles before she got too incensed at my besmirching her student's reputation and stormed off in high dudgeon.

"I noticed in the shows at the Abernathy Gallery that several of the works in the last couple of shows owed quite a lot to Mexican traditions. Could you posit an opinion on why it was that Frida Kahlo and other Mexican elements would spark such enthusiasm in a bunch of Edmonton art students, all at the same time?"

"Ah, well, for that you'd probably have to talk to Diego." Briar's eyebrows shot up into the top of her forehead, indicating there was something possibly unsavory about Diego, whoever he might be.

"Diego, as in Diego Rivera?"

"Exactly, though not THE Diego Rivera, obviously. His name, originally, was Daniel or Darrell Rivers, or something equally white bread. He began to sign his name Diego in art college, and now Diego Rivers makes a living as an artist-in-residence, moving gypsy-like from one campus to the next, imbuing the

students with dreams of living in a beach shack in Tahiti and painting canvases that will eventually hang in the Louvre, or at least the Tate Modern. To my way of thinking, it's utterly irresponsible, but there you have it. The chair is funded by alumni and having one more person on faculty allows for students to have wider access to philosophy and technique. Our last artist-in-residence was an Inuit print maker from Aklavik and she was amazing, so it's swings and roundabouts."

I scribbled down Diego's name and number for Steve to consider, which Briar had in her smartphone, and thanked her once again for her time. She nodded, as if she was releasing me from a royal visit, and turned on her heel back toward the Fine Arts Building. It was the same direction I needed to take, but instead of prolonging our connection, I decided to take the stairs down to street level and walk home overland.

I walked through the block of campus housing and the subsequent block of old homes, some renting to students, others renovated to the max. The traffic along 109th Street streaming up off the High Level Bridge wasn't too heavy at this time of day, though rush hour was creeping earlier every year. Like it or not, Edmonton had turned into one of Canada's six major cities in the last decade or so. It was trying to manage traffic responsibly by paying major attention to rapid transit, bicycle lanes, and pedestrian friendly areas, but even with studded winter tires, sane bicyclists didn't risk freezing their lungs and skidding on ice during the stretch from December to March each year, when it was sort of hard to see lines painted on the road, anyhow, for all the snow and ice built up.

Having never owned a car, I wasn't so fixed on the need to drive fast and park cheap that many Edmontonians seemed to think was their right. I did think that it was good to have parking access when you were grocery shopping or for lugging home large items, but, then again, there were more delivery options springing up all the time, so perhaps that would cease to be a real argument soon.

I wished Steve's—or rather OUR, I corrected myself—place was closer to a grocery store. Aside from the K & K, which was great for liverwurst and German cheeses, the closest grocery was two buses away in Bonnie Doon Mall. Steve and I were going to have to sort out doing a major shop once a month, and I could supplement with a walk to the deli for eggs and milk. Maybe we could fit a small chest freezer into the storage closet. I would have to check on that.

Thinking and planning had taken me on autopilot all the way down Saskatchewan Drive and soon I was back up in the aerie, a term I had jokingly used the first time I had visited Steve's condo, and which he had liked and begun to use himself.

Steve had texted to say he would be late, and not to wait on him to eat. I hung my satchel on the back of one of the kitchen island stools and stood there, considering my options. All I had to grade were the pre-quizzes, and they would take all of half an hour to get through. My lecture notes were up to date for three more classes each, my clothes for lecturing were chosen and hung up in order in the closet, the condo was tidy, and I wasn't even hungry, having picked at the huge muffin I'd bought to augment the coffee with Briar Nettles.

I decided to do some research for Steve. After all, he had asked me to think about the book I was reading, to see if it held answers to who had killed Kristin Perry. Surely, the rest of what I had been doing fell under that umbrella, too.

I plugged my laptop into the extension near the electric fireplace, and curled up in one of the oversized leather chairs that flanked it. I pressed the button for the fireplace on the handy remote beside me on the small side table, and hit the other button for the drapes. While there was likely no one across the river training a set of binoculars on me, I felt cozier shutting out some of the darkening sky. Steve's remotes made me feel as if I was living in a Matt Helm movie, but I had to admire the way he had fashioned the condo to suit himself. He had organized the lights, stereo, electric drapes and fireplace to operate from multiple remotes, and from three or four places in the room you could control things without disturbing yourself from your cozy cocoon. I wasn't sure how he managed to stay in such good shape, when hibernating seemed to be his default mode.

I looked up Diego Rivers. Google asked me if I meant the more famous artist, assuming I was a mistyping dolt, as usual. No, I assured the program, Rivers was exactly who I meant. Three paltry items appeared, along with some Rivera sites, as well.

Diego Rivers was a muralist like his more famous namesake. While he hadn't been the artist who revitalized Chemainus, BC with their now famous murals, he had provided centennial murals to many small towns across western Canada as they each hit one hundred, and had developed a relatively

politicized manifesto to promote himself as an artist of choice. The research component of his work was shown to take two or three months prior to committing anything to sketch, and the final work would be unveiled no sooner than a year after he was first commissioned.

"To understand a community, one must live within its gates. One must read its history, drink in the atmosphere that shapes its people, and listen for the notes that set it apart from others— the chords that sound its individuality."

I grimaced at the hyperbole. Diego Rivers sounded like a huckster, selling a dream of a unique vision to small town councils, who would end up with a painting on an old brick bank wall featuring a wheat sheaf; several Slavic farmers; a train; a fur trader shaking hands with an Indigenous man wrapped in a Hudson's Bay blanket; an iconic bird like a Canada goose, trumpeter swan, or loon; a beaver; and two portraits of people in wire-rimmed glasses who were either famous and came from there, or not-famous outside of there.

That, in fact, was the sort of thing in his portfolio portion of the website. I had to admit, however, his people looked real, and the distribution of subject matter and overall layout was very well wrought. One's eye was drawn from one element to the next with ease. Perhaps there was more to mural design than I had first believed.

I clicked on the bio section to see if there was anything else to learn about the man. Apparently, he was happy to tell all. He came originally from Pousse Coupe, British Columbia, and had spent most of his life in the interior of BC, in Nelson, Vernon,

and Kamloops, before moving to Toronto. There was a picture set into the text on the page of Rivers and his wife. I stopped short, and then clicked on the picture in order to expand it to the full size of the window.

Diego Rivers was David Rivers with whom we had shared a food tour in Puerto Vallarta, and whose wife, Alessandra Delahaya, had been so dismissive when I had mispronounced her name.

I had a strong feeling that Steve was going to want to know that Kristin Perry's former art professor had also been in Puerto Vallarta the day she had been killed. I picked up my phone to text him. I figured I would hear back from him pretty quickly.

For fun, I opened a new tab and searched out some Diego Rivera murals. The previous spark of admiration I'd held for Rivers' work vanished as I noted what could be achieved in the imagination of a great artist. Rivera's command of huge spaces was unsurpassed; his work drew the eye from one grouping of people to the next, a central theme pulsing from every corner of the images, and used small wonders to hook a viewer into a more intimate relationship with the painting. I could see why Rivers would want to identify with such a master. But he was always going to be the pupil.

Was it ego or admiration that made him self-identify with this giant of an artist? I would like to have him answer that question. And it would be the best way to find out why it was that so many students connected to him were becoming fixated on Frida Kahlo, Diego Rivera, and Mexican themes like the tin milagros.

I made a note to myself on the pad of paper beside me. I still couldn't bring myself to work entirely from the computer and smartphone. I was still leery of losing everything into the cloud or a power failure, and I also still thought better with a pen in my hand, especially for editing. I wondered, if when my generation died out, all stationery shops would close up entirely.

The fire was warming me, and the efforts of the day catching up to me. I closed my laptop and reached for the television remotes. Searching Netflix, I found what I was looking for, the Salma Hayak/Julie Taymor movie *Frida*. We'd watched it when it first came out over a dozen years ago, but I had been hankering to watch it ever since we'd done our gallery tour in Puerto Vallarta. Now, with all the reading up on Frida and Diego, I really wanted to see it.

Steve walked in just as Frida was demanding they move her entire bed into the truck so she could attend her gallery showing, and he sat down silently to watch to the end with me.

"I take it this was research for me?" He smiled as I turned off the television and blinked toward him, coming out of the spell of the film. "And thank you, by the way, for the lead on Diego Rivers."

"You would not believe the research I've done for you," I answered, and proceeded to tell him about my meeting with Briar Nettles, her background on Austin Stauffer and Diego Rivers, and my recently evolved sense of mural art.

"You have been busy," Steve nodded. "You do recall, though, that all I asked was that you read and report on the book you were reading."

"Yes, and you are very welcome." I was a bit miffed. "It's not like I overstepped entirely. I asked Denise who would be the best person to talk to about students in the BFA program. It was Briar who put me on to Rivers. And I wasn't even really asking her about Austin, I just wanted to know if she was connected to any of the other students being shown in the gallery. I didn't mean connected romantically. Which I don't think he was, unless he was really smooth. It strikes me that Briar Nettles is a pretty astute judge of character, and she seems to think Austin is upstanding all the way."

Steve shook his head.

"We'll have to ask some of Kristin's friends about Austin, but I'll try to make it casual, so we don't blemish his reputation for nothing. It could just be the gallery owner making assumptions or enhancing the story for his own amusement, but when I spoke with him, he seemed to think they had a thing."

I wondered how much I did that, imagining secret lives for people I didn't know. Probably more than I was willing to admit to.

20

Once Reading Week is over, the rest of winter term goes into freefall. Students are constantly popping into office hours, trying to massage out an extra mark for a quiz or puzzle through an outline for a paper that is getting out of control.

My lectures were organized and our married life was settling into a pleasant pattern. Now that we actually cohabited, Steve and I spent less time discussing every element of our workdays to each other, and more time contemplating elements of the news we'd hear over the kitchen radio, or trying to amuse each other with funny things that had happened.

I had handed in my review of the Kahlo book, with the general negative interpretation I'd received from Briar Nettles of whether or not a student would be reading an art biography for a class. I hadn't heard much else from Steve about the case.

I knew that Kristin Perry's body had been buried in a family ceremony, and that the Mexican government had issued a statement that it was very safe for Canadians to visit Mexico, and

that this was an isolated case that most certainly had ties to the victim's life back in Canada. I wasn't totally sure of that, though the knowledge that she was an art student certainly spoke to it being targeted and not random.

If Steve was still in regular contact with the Puerto Vallarta police force, it was from the precinct and not from home. We had put the Mexican tablecloth into circulation with the other two we owned but it tended to remind me of death more than my honeymoon, so when it came out of the dryer, I folded it and popped it under the dishtowels in their drawer till the connection dimmed for us.

Denise had asked me if I'd checked out the art students, but it wasn't up to me to do that sort of thing, and I was pretty sure Iain and Steve had been all over that angle. They just hadn't found any boyfriend other than Cole, the fellow Kristin's roommates had said she'd broken up with in January, and he had the marvelous alibi of being in Edmonton during Reading Week, surrounded by roommates and poker-playing buddies.

There's an old police maxim that a case needed to close within a two-week window if it was ever going to close at all. We were well past that deadline now. I wondered if Kristin Perry's family was ever going to find closure, or if they were going to decide in their hearts that adventure had killed their daughter.

My own form of adventure, marriage, was taking up a lot of my time and interest, making me far less curious about the murder than I am sure I would otherwise have been. I was discovering all sorts of interesting aspects to my own personality I'd never bothered to examine. For one thing, while I've always

considered myself to be pretty tidy and clean in my day-to-day habits, I had nothing on Steve, whose compulsion to wake to a pristine home each morning meant that the last half hour before crawling into bed was spent picking up magazines and plumping pillows while he washed and dried stray dishes in the kitchen.

I was also fascinated to see how much more serene I was now that I knew Steve's pension would see us through our twilight years. With that sort of safety net below me, I was free to concentrate on doing my best work in the moment, rather than constantly fretting about what course or job or commission I could snag for the next term. I'm pretty sure I did my best teaching that term, reveling in the assurance that I was not going to starve the week after grades were turned in.

In that lovely way the world has of rewarding them that has, I was asked to stay on at Grant MacEwan University to teach an accelerated introductory English lit course for the spring session, and I had already agreed to teach a half-term summer session class at the U of A, so my summer was stacked up right till August. The phone calls from the chairs of the departments about fall teaching usually came around the middle of May, and for the first time in decades, it didn't twist my stomach in knots to be having to wait on the pleasure and whim of other people's scheduling to see if I would eat that year. Things were heating up politically with more light being shone on the plight of sessional lecturers, or "adjuncts" as they were called in the United States, but it felt inordinately calming not to have to worry, and for that, I was grateful to my handsome, clever, and caring husband.

If only the university administrations knew how easy it would be to settle down the sessionals. Just give them five- or ten-year renewable contracts, so they knew they'd have regular employment and wages, and they would likely feel grateful enough to tamp down their desire for pensions. After all, if you knew you had some regular money coming in, you could likely start budgeting your own RRSP. Just a touch of continuity would go such a long, long way.

Our May routine shifted a tad, because I was teaching three-hour morning lectures Monday through Thursday. I would talk in the mornings, mark through the afternoon, and head for home to rinse, repeat. Steve would get home right after I did, and the last thing I wanted to do was talk, so we watched movies and binge-watched television series, and went for long evening walks in the lengthening days. To fill the void of my previously incessant chatter, Steve began to talk more about his days. Without mentioning names, I heard about the cases he was working on, and nodded along while he laid out theories he and Iain were exploring.

It was interesting to think that Staff Superintendent Keller, Steve's boss, would likely be happier that we were married than when we had first been dating and I'd been caught up in one or two of Steve's investigations. Now, as just a sounding board, I was far less involved in the workings of the Edmonton Police Service, who were very capable of handling things without the aid of some aging Trixie Belden.

It wasn't until The Works, the annual visual arts festival, began to advertise, that my thoughts came back to the

Edmonton arts scene, and that was only because Diego Rivers was one of the featured artists. He was apparently commissioned to paint a mural that would hang on the back wall of Rogers Place, the huge new hockey arena, right across from the LRT station. Since the trains there always seemed to be stationary for minutes at a time, it would be nice to have something to look at while waiting.

I thought it was canny of the arena executives to demand it be a movable mural, just in case there were defamatory pictures of Darryl Katz, the owner of the Oilers hockey team, worked into the piece. After all, Diego Rivera had put Lenin into a mural that Ford had demanded destroyed, since Rivera refused to paint over it.

That night, after supper, Steve was regaling me with a visual story of Iain chasing a thief down Whyte Avenue on foot while Steve drove up to block him off at the end of the block.

"I had this older woman hitting the car bumper because I was blocking the crosswalk, so I turned the flashers on the car, to make her aware and get her out of the way. She looked shocked, as if she'd somehow turned flashers on with her cane. Meanwhile, Running Man spots the car dead ahead and turns to detour through a shop or who knows what, and he bumps right into Iain, who grabs his wrist, even as they're both falling down. Before I was even out of the car, Iain had him cuffed and was hauling him up on his feet."

"That's really impressive. I'm not sure I could even run a block down Whyte Avenue, let alone catch someone."

"Well, you know Iain. He stays in shape just for that sort of

thing. He is probably the only cop I know who didn't make plain clothes and automatically gain ten pounds."

I looked at my handsome husband, without a spare ounce on his muscular frame and smiled. Though they'd likely never admit it, partners in the police force developed such a close bond, that were Iain not so completely heterosexual, I might be jealous.

"How is that case coming with the young woman who was killed on our honeymoon?" I asked. "Has anything more come from your investigations into the art students here or have the Mexican police found anything?"

Steve slumped a bit. He didn't like open cases that dragged on. The longer it took to find the bad guy, the more likely you were never going to find the bad guy.

"The Canadians are holding off on issuing a travel advisory because our team is still investigating some open ends here. But they'd like to. Meanwhile, Miguel and his guys are checking leads, but things all seem to run into tourist trails for them, and it's next to impossible to trace some of the people because during Reading Week and Spring Break, kids come down and stay four or five to a room and all the hotels have is one name and address to link to the room."

"What do you think in your gut?"

"Oh, hunch policing?" Steve smiled. "I think it was someone here who deliberately went there to do the deed. I see this as a highly pre-meditated action; you don't get that level of staging of a crime scene happening on the spur of the moment."

"And what is the psychology behind that sort of staging? Is it

hatred for the victim, or is the victim incidental to the tableau being displayed?"

"Do you mean, could it have been anybody?"

"Yes, or did it have to be Kristin Perry?"

"That's the sixty-four thousand dollar question, for sure."

"Well, you recall me talking to that art professor, and her talking about the artist-in-residence?"

"Diego Rivers, right? Pretentious son of a bitch. We questioned him about his relationship with his students and his push for Mexican primitivism, and he shrugged it all off as if he couldn't be bothered to look up anyone's name on a class list, let alone recall anyone. And I am pretty certain he didn't even recognize me from that food tour, so he could be right about not paying attention to the students."

"So he didn't teach Kristin?"

"He thought he might have, but couldn't be sure. His mind was on larger things than naming conventions, or some such blather."

"So I take it you two didn't hit it off?" I giggled in spite of the topic at hand.

Steve smiled and shook his head.

"You should have seen Iain trying to hold in his disdain. No, Rivers was not a fave of ours, but he wasn't the only person we talked to over there that seemed vague. It's like they are more focused on their own work than that of their students in that faculty. And besides that, he had an alibi in Mexico from his wife and her cousin and his family."

"That can be the trouble with working artists, and it's the

same with some research scientists. You aren't always going to get the blend of academic, practitioner, and teacher that the university assumes every professor will be. It's a special combination, and sometimes it's the professors who study and admire, but don't practice the art or science they lecture on, who are the very best teachers."

"So you don't believe in an artist-in-residence sort of program?"

I shook my head.

"I didn't say that. It can be immensely important for a young writer or painter to connect with a professional working in the field, if only to measure themselves against the reality of the situation rather than some romanticized version of Kirk Douglas shearing his ear off."

"You think people go into art because they've watched *Lust for Life* at an impressionable age?"

"Well, it's not because they like the smell of turpentine."

Steve laughed and I remembered what I wanted to tell him.

"I just brought this all up because I wanted to let you know Diego Rivers is going to be part of The Works this month. He's been commissioned to paint a mural by the MacEwan transit station."

"Is he? That might be worth looking into. I wonder if he's going to have anyone apprenticing."

"I'm not sure. I am not even sure if he's going to be painting outdoors at all. The article stressed that it wasn't a permanent installation, so I don't know whether that means they'll just wipe it off the arena wall later or whether it will hang on the wall, to be taken away later."

"Interesting." Steve made a note in his leather-bound note-pad that was always with him, and which he set next to his keys by the door, and we moved on to other topics.

About a week later, I was finished teaching at MacEwan for the morning and answering a text message from Denise, who was suggesting lunch. I decided to head for the LRT station instead of walking, although it would likely have been less effort to walk to the U of A from MacEwan than to walk back to the condo, which I had been planning to do. After all, the High Level Bridge spanning the valley took away the need to climb down one steep hill into the river valley, across the lower bridge and back up the other side of the valley, which was the route home. Still, both routes would take me about an hour, whereas the LRT would get me there in approximately twelve minutes if I got the train immediately.

I texted her back that I could meet her within an hour, just to give myself leeway. This leg of the train circuit was notorious for being slow. I walked along with a small but steady group of students, through the adjoining buildings that composed the Mac-Ewan campus all the way to the east end, where we cut through a small parking lot toward a crosswalk. The path wound behind a block of apartment buildings that had to be really noisy to live in now that the massive arena had opened beside them.

Tucked behind the brushed aluminum behemoth of the arena was the LRT station, which was a chilly little station no matter what time of year it was, because the sun seemed to be perpetually blocked by the arena.

There was no train, meaning I had up to a fifteen-minute

wait, though it could be as short as two minutes. I purchased a ticket from the machine and went to stand slightly away from some rowdy students who were hitting each other with their binders.

Diego Rivers was at work on his mural. The wall had been whitewashed in a huge rectangular space, running at least twenty feet long and about twelve feet high. He looked dwarfed by his "canvas" and I felt suddenly how scary art could be.

He was taping a long roll of paper up at one end of the whiteness, as if he was hanging wallpaper. He wasn't at the very end of it, more like four feet in. I moved closer to see what he was doing.

Very faint pinkish dots could be seen on the first four feet, and once he was satisfied with the placement of his paper, I saw him reach for a pouch and what looked like a big sea sponge. He climbed back on his stepladder and began to hit the paper with the sponge, dipping it into his pouch hanging across his body. Pinkish dust went everywhere, though he was careful not to get it to the right of the paper.

Suddenly, I got it. He was transferring the pattern for his mural onto the wall by means of stencil. There were tiny holes in the lines he had drawn on the paper, and the pink dust went through the dots and created an outline of what he wanted to create. So that was how someone could keep perspective and lines happening accurately on a huge canvas. I pulled out my cell phone to take a few pictures of the process and the artist in situ. Who knows, Steve might find it interesting.

Just then the train arrived, and I regretfully pulled myself

away from the show. It occurred to me that Diego Rivers had met me. If he or one of his acolytes had killed and staged Kristin Perry, he might think I was spying on him, not just admiring his industry. Just then he turned and looked straight at me. It was as if he could sense I'd been photographing him, but that didn't seem to bother him. This was a man who craved an audience. And perhaps meeting me hadn't registered in his self-absorption. Or maybe he knew exactly who I was.

I shivered and leapt on the train.

21

Denise and I were delighted to get some time together, since she too was teaching a spring course, and our timetables had been overlapping. Being on different university campuses didn't help, either. Denise was pretty certain it was my newly married status that was making me incommunicado, but I assured her that it had more to do with my need to keep up with massive marking schedules than my desire to nest.

Nesting was fun, though. Steve and I had been rearranging things bit by bit, and I had to hand it to my mom: buying art together was a very good means of rethinking a space for two. We had added a couple of bookcases to the living room, making it automatically homier, in my opinion. If the truth was known, my idea of decorating was more books.

Denise's spring class was the survey course on Shakespeare that the theatre students all tended to take as their English option, even though some of the papers almost killed a few of them. She had a relationship with the Drama department

through a team course she had taught a couple of years back, and I could tell she enjoyed having practitioners in her class to shake up the focus of the students who were reading Shakespeare as if he was a trial to be got through.

"We had a big discussion about all the productions that bring the plays into different time periods and what that does to the interpretation, like Richard III wearing jackboots, or Titania looking like a hippie, and I could almost see a couple of heads exploding, because it had never occurred to them that directors and producers put their own stamp on things. Can you imagine being eighteen again, when the whole world contains glorious and magical surprises?"

"How do you feel about that sort of appropriation?"

"It doesn't bother me in the least, if it's thoughtfully done. Mostly, I see that sort of reinvention bringing people back to the immediacy and energy of the text. They are such great stories and such wonderful writing that they can withstand anything. And if putting everyone in Beatle wigs brings you anew to the Bard, I'm all for it."

I picked at the dregs of my poutine, and thought about the last few productions I had seen. She was right. The shifting of time periods helped to create the scene anew, so that plays I'd read and seen several times on stage or on film were always a new pleasure.

"I wonder why it is that I never mind seeing a new production of a Shakespeare play or an opera, and yet I whine about Hollywood remaking European movies or even redoing movies they've already done. There's something about the movies that seems set in stone, I guess."

"Well, it's there, to watch over and over again, whereas a live theatre production is always ephemeral, always changing."

"You can extrapolate to the visual arts, too. We get Van Gogh painting several versions of his *Sunflowers*, and instead of the art world saying, 'well, here's the best one,' or even, 'well, that's just him churning out a still life to make some grocery money,' we look for distinctions between the one in the Netherlands and the one in the National Gallery, even turning that into an art experience. And of course, what about Monet and his endless water lilies?"

"Or take it a step further. We have artists copying the great masters. We get forgeries. Or we get post-modernist takes on previous works, like Duchamp's 'nude descending the staircase,' or the various versions of *Le dejeuner sur l'herbe*. I like that one by the Cuban artist where it's a man who is naked and the women are clothed, but everyone has done a version of that Manet. So what makes that different from redefining the place and time for *Hamlet* or *Othello*?"

Something Denise said twigged something in my mind, but I wasn't totally clear, not enough to make a quick note and leave it for later. Distractedly, I made my farewells as soon as possible, and went home to pull out my art books.

Denise had been making comparisons to new ways of looking at Shakespeare with parodies of famous works of art. What if that was what we had been supposed to see when we looked from the bridge at Kristin Perry all set out on the shore, a parody or a reworking of a famous painting?

Was the book in the beach bag a pointer that we were to look

to Frida Kahlo to find our original? Or was that just another part of the setting? A book about an artist?

The thing was, it could indeed be Frida, because she had painted herself lying in bed or dying so often, being bedridden herself with all her back operations. There was one painting in particular I was recalling, made after her stillbirth, which I wanted to check against my memory of Kristin on the beach.

I had expanded my interest with Frida to include several books I'd found in secondhand stores, and had even indulged in a book of Frida Kahlo paper dolls. A black and white version of the picture I was recalling was in the original book I'd bought in Puerto Vallarta, the biographical guide to her work and life. It was called *Henry Ford Hospital* or *The Flying Bed*, and had been painted in 1932 after her miscarriage. I also had a colour plate of it in another book in my Kahlo library.

It showed Frida lying naked on an iron bedstead, with a distant Detroit in the background. There is blood on the sheets beneath her and tears running down her cheeks. She holds one hand to her stomach, and six red threads come out of her hand, tied to symbols of her situation. The stillborn baby floats above, her narrow, broken pelvis below, and a model of a uterus on a stand is yet another thing tied to a red thread. The others, an industrial vice grip, a purple flower and, for some reason, a large grey snail, were supposedly sexual images, according to the notations in the books.

The flower I got. I'd seen enough Georgia O'Keefe and Judy Chicago to understand the flower as vagina. I was also pretty sure the vice was tying the pain she had gone through to her

distaste for being in Detroit, or the United States in general. She had been longing to go home while Diego stayed to paint yet another mural for plutocrats.

But what was the snail all about? I would have to check that out.

There was another disturbing painting that I marked with a sticky note to show to Steve when he got home. It was called *A Few Small Nips* and was painted to depict a story Frida had heard about in the news, but was considered to be symbolic of her feeling of betrayal over Diego's infidelity, after he had an affair with her sister. In this painting, the woman on the bed is definitely dead, and her murderer stands over her, wearing much of her blood himself. She is cut all over, and is naked, apart from one shoe, and a stocking and garter puddled around her ankle. The phrase the husband used at his trial to excuse himself, "*unos cuantos piquetitos*" is written on a ribbon being held in the air by one white bird and one black bird.

The more I looked at Frida's paintings, the more they seemed like intricate clues to a painful revelation. The biggest problem was that the code was out of my cultural context. How odd that I could understand the intricacies of conduct and poetic references several hundreds of years extinct, from the literature I'd studied and absorbed, and yet just down the globe, on the same continent, I couldn't interpret the rebuses painted, and sometimes even labeled, in painstaking clarity.

It reminded me of the milagro lady down in Puerto Vallarta, telling our fortune on the heart we'd purchased in her store based on the little brass and tin figures that were hammered into

it. Each of those symbols meant something different, and not always what I would have assumed.

Perhaps Frida was using the same milagro symbol system? I wondered what a snail on our heart would have said to the woman.

I began to circle some of the notes I had been taking, to get things straight in my mind for discussing with Steve. As I did so, I sketched out the miscarriage painting, and then the little cuts painting. Then, for good measure, I went to get my cell phone from my purse and sketched a layout of Kristin Perry's murder scene as if it were a painting.

When you hear old-fashioned or clichéd phrases like "a goose walked over my grave" or "my heart stopped" you may not realize that they accurately represent an exact feeling of dread and clarity. As I looked at the three sketches I'd just made, I felt a pressure on my heart, as if my entire body was trying to impress on me the importance of what I was seeing.

Kristin's body had been laid out as if she was a character in a Frida Kahlo painting. Her left hand was placed exactly where Frida's had been in the Henry Ford Hospital painting. Her right flip flop was on, but no other shoe was in sight, and she was wearing an ankle bracelet on that foot, as well. This had to be a reference to the *A Few Small Nips* painting. And her belongings: the beach bag, the thermos, the sun tan lotion, the book and the pile of clothes; were all laid out in an arc around her, as if Frida had set them there to signify vital clues.

What was important about anything beyond the book, though? Steve and the officers in Mexico had been assuming

things were laid out to avoid suspicion for as long as possible. The body had been placed to look to the casual viewer like a sun tanner who had staked out a prime position, and was there for the day.

What if the murderer was saying more with that set up?

I was up to my elbows in research when Steve got home, and it was lucky I had tossed some beef chunks and potatoes into the stew pot the last time I'd got up to use the washroom, or he'd have gone hungry.

"Did you know that a bare foot represents happiness and health, but a boot signifies wealth?"

"Good evening to you, too, darling." Steve grinned and came over to kiss me and see what I was babbling about. By this time, I'd unearthed several sites detailing milagro ciphers. The little charms were quite elastic in their meaning, from what I had gathered. They could represent exactly what they were in some cases, like a horse meaning you would get a horse, or they could be symbolic in the extreme. That same little horse could translate to be a journey for another supplicant, or a solid business to someone else. The meanings could be fluid. One thing, though; none of the milagros spelled out misfortune for anyone. They were all seen as positives.

No one cursed others using holy elements. There was likely some other, darker system for that in ancient Mexico that I'd just never heard about. There always was something, like voodoo from the Caribbean, or herbal witchcraft from the Celts, or the painstaking ways to placate the *Julenissen* in Norway, or Baba Yaga in the Slavic countries. Eventually, after praying for a

miracle to lift themselves fell through, human beings would start to look around and try to bring others lower than themselves.

If Steve's instincts were right and this whole business had been a plot to deliberately kill Kristin Perry, then who knows what other symbol systems might have worked their way into the tableau. Maybe the killer hadn't managed to stick strictly to the symbology that Frida would have followed, but had imported some of his or her own social background.

Steve and I ate our dinner quietly, mulling things over and putting our minds to rest before a relaxing evening ahead. This was one of the things people rarely spoke about when they extolled the blessings of marriage, the glorious way you could be quiet together. Maybe it was a product of our long courtship, or even our relatively late middle-aged entrance to the union, but the combination of knitting our lives together was turning out to be a very easy pattern to fall into.

We went to bed around nine-thirty like the party animals we were.

"What are your plans for tomorrow?"

"Oh, I was thinking of staying close to home. I have a little bit of marking to do, but no reason to head out, unless you need an errand run?"

"I'm just wondering, would you have time to write up a little report on those milagros? There is something there that we should be paying attention to, I think."

"Sure, darling. You might want to ask Detective de Valle about them, though."

"I'd like to know a bit more about what I'm talking about

first." Steve rolled over onto his side to kiss my nose. "I don't want you to let this get in the way of your work, though. Let me know if your time is too tight if I ask these things of you, right?"

"You know me, research is my chocolate!"

"I love you, Randy."

"Mutual, I'm sure."

22

After Steve left for work the next morning, I tidied up the kitchen and put another pot of coffee on, only decaf this time. I took a shower and got dressed in yoga pants and a flannel shirt, my home wear, then hauled all the towels and our bedding to the laundry corner to get a load running. The sunny weather had me feeling spritely, so I pulled cotton sheets out of the linen cupboard and remade the bed. With the likelihood of cold weather still well into mid-May, I added a light blanket to the end of the bed, though Steve ran hot and our duvet was usually enough to keep me toasty.

A quick spray and swipe in both bathrooms, running a duster across all the hardwood floors and the vacuum on the living room area rugs, and I was done the weekly housework I allotted myself. Now I could feel all right about jumping back into the work I had promised Steve.

He wanted more information on milagros. I pulled together what I'd found on the Internet the day before, and collected a

few pictures. I also took a shot of our milagro-laden wooden heart to add to the dossier. It wasn't enough, and I'd likely need to head over to Rutherford Library in the afternoon to check out more about folk symbols of Central America or even Spain. Perhaps the milagros had come over with the conquistadors. Just to be safe, I sifted through my collection of pamphlets and papers from our trip and found the handout about Huichol peyote symbols, like the ones embedded in the Malecon in Puerto Vallarta.

I poured myself another cup of decaf and thought over what I'd been working at the day before. Were we supposed to be reading this as art or as happenstance? I stared at the picture I'd drawn of Kristin Perry's murder scene, and flashed back in my mind to seeing her lying there on her lonely beach blanket. It seemed too specific to be random, but I wasn't certain I wasn't layering that on with all my reading about symbols.

I wasn't equipped to view this picture, but I bet I knew who would be. My knees crackled as I rose to find my old address book. This sort of symbolism called for an anthropological specialty and if anyone would know to whom I should talk, it was likely going to be Nancy Gibson.

Nancy, whom I'd befriended through various literary events we'd both attended over the years, had done her PhD research in Africa, comparing local and indigenous medicine to western procedures. I recalled her meeting with several witch doctors during her research, and I wondered if she had pursued any of that further while she was writing up.

I checked the clock on the wall before I called her number.

No one wants to be called on the lunch hour, even if they're retired or work freelance. It had only just turned ten o'clock, which surprised me. I had been more efficient than I'd thought in my *putzfrau*-ing. I pressed her numbers on the keypad of my phone, realizing I had never actually phoned her before. Normally, we had met at the university by happy happenstance. I only had her mailing address and phone number from a stint of marking I'd done for her when she'd been saddled with a massive intro course and not given a TA. We'd worked out a quiet deal which had involved me receiving a farm share of vegetables all that fall from her husband's hobby farm. It had been a good trade-off.

"Nancy Gibson!" Her cheery voice rang down the line at me.

"Hi Nancy, this is Randy Craig calling…"

"Randy! How great to hear from you, it's been ages! I heard through the grapevine that you and your lovely fellow got hitched. How is married life treating you?"

We discussed the wedding, my feelings about whether marriage was adhering to the patriarchal system or whether keeping my own surname struck a blow for a new dynamic, all the sort of interesting blather you get into when talking with a cultural anthropologist.

I then asked her how retirement was and we went off on another fascinating tangent. She sounded busier than she'd ever been working in the department, with her boards and reports and interviews she was doing in the far north for a project she'd been working on for years, sort of like Michael Apted and the *7-Up* films.

"But you didn't call just to catch up, did you?"

I smiled into the phone. Nancy was so shrewd, she probably knew the minute she picked up the phone that I had an agenda. After all, why would I call her up out of the blue?

"I do have a question for you. I have been looking into various symbol systems in Mexican art and customs, starting with the milagros…"

"Those little metal charms they nail everywhere?"

"Yes! Do you know anyone who works on that sort of thing?"

Nancy paused for a moment.

"I heard someone give a talk on them, not that far in the distant past. Now I just have to think who it was. I was wearing my green suede skirt, because I could remember brushing it up and down on my leg to shift the pattern while I listened, so that must have been the year that CASCA was in Laval…" She broke off her mental reverie. "Do you do that, too? Recall by visual stimulus? It's not quite the same as Marilu Henner, but I find I seem to take mental photographs of my world and then work backward from that."

"I'm not sure I'm quite at that level, but I do tend to recall where on a page material is that I've read, you know, upper left page, or middle right page. It makes going back for footnotes a lot easier."

"Yes, I know that feeling. I wonder what makes some people connect with their environment in that fashion while others have no spatial connection whatsoever."

While it was an interesting point to consider, I had to bring Nancy back to the topic at hand.

"So, the paper you heard in Laval?" I asked, cringing at how bluntly I was commandeering the conversation.

"Right, right," Nancy laughed. "This is how academics retire, not with a conclusion so much as a trail of endnotes. Back to the point, I was in Laval at CASCA listening to someone speak on the collision of religious symbolism, with an emphasis on the Virgin of Guadalupe, and he mentioned those milagros as evidence that European influence had shaped what had been a pre-Christian symbol system which was pretty basic: small clay foot equals praying for a healed foot, clay ear equals bringing back a person's hearing. They turned them into metal, and here's where it got cloudy. I think the idea was that it was a nefarious plot to determine the sorts of mining possible in the areas, but on the whole I recall the strength of the paper being in twinning an indigenous folk story with the Virgin Mary."

"So, I'd find milagros in Spain?"

"You know, they almost seem more likely to come from the sub-continent. The Parsee, as I recall, have some sort of prayer offering of wax body parts to pray for the relief of suffering of their loved ones in their fire temples. But of course, there is a Brazilian practice of bringing wax bits to church, which end up hanging from the ceiling in their ex-voto rooms. Maybe the milagros do come from a South American influence originally?"

"It would be nice if we could blame them on Marco Polo, wouldn't it?" I laughed.

Nancy laughed, too.

"Yes, what can't we blame on him and his wandering ways?"

We went on to talk about what she and her husband John

were doing these days, and she wouldn't let me off the phone without a thorough description of our wedding ceremony. In her case, I felt as if I was being interviewed for a future article on 21st century rituals, rather than just curiosity about the day.

We said our goodbyes with her promising to call before she and John popped back into the city next, so we could get together.

I looked at the doodles I'd scribbled on the notepad in front of me. In the middle of a lot of small hands and feet was the name of the conference Nancy had been at when she'd listened to the milagro researcher.

I looked up the website for the Canadian Anthropology Society to see if I could find anything that would lead me to the paper. Nancy had warned me that their periodical, *Cultural Anthropology,* was notoriously slow about getting to press, with reviewers being tardy to respond, so the chance of something she'd heard two years ago being published already was remote. It was worth a try, though.

I trolled through a variety of sites, looking for milagros, and anything else that hinted at cultural blending and appropriation in Mexico and Central America. It was slim pickings unless you wanted to read about the Virgin of Guadalupe and the overlay of Spanish Christianity on indigenous Mexicans. According to the novelist Octavio Paz, Mexicans believed in only two things: the Virgin of Guadalupe and the National Lottery.

I sent off an email to the Society, to find out if a paper along the lines I was vaguely defining was in the works. While I wasn't sure I was any further ahead than before, I wrote up what I

had discovered about milagros to date, and tied in as much of the Frida Kahlo symbology as I'd unearthed, as well. If Steve wanted more, he'd have to wait till the anthropologists deigned to respond.

All of a sudden, I was ravenous, never a good thing in my experience for ending up with a well-balanced meal. I opened the pantry door and then the fridge, looking for immediate sustenance. In minutes, I was sitting down to a pathetic looking plate of rice cakes slathered in liverwurst, with some sweet gherkins and grape tomatoes alongside for vegetables. I read a couple of chapters of the new Nino Ricci novel, marveling yet again on the wild distinctions of what it meant to be a Canadian, based on location and ancestry. His Niagara peninsula Italian-Canadian experience was so remote from the stories of W. O. Mitchell here in Alberta or Alistair MacLeod's Maritime stories, or Eden Robinson's *Monkey Beach* out on the West Coast, which I'd happened to be rereading the week before in order to teach it next on my spring syllabus. It was extraordinary that we could articulate a Canadian identity at all. Not that we'd succeeded at that very well. The only way in which we managed to identify ourselves as Canadians was in relation to our neighbours to the south. We were gentler, more polite, and we had health care. And we all still mourned the passing of Stuart MacLean.

I recalled the joke from tour guides when we were in Mexico that we were Northern Mexicans, somehow conferring an honourary status of fellow sufferers on us.

That thought brought me right back to Steve's conundrum over the Kristin Perry case. Was this a Canadian crime

committed while on vacation, or a tourist who had stumbled into a Mexican crime scene by hapless accident? Steve was right; the only way we'd discover the killer would be if it had been a targeted crime. It was like solving for "x" in some convoluted algebraic equation. We had Kristin Perry, so if she was a meaningful integer, we could uncover "x". If she was an arbitrary marker, we had fewer known elements, making the equation that much more difficult.

Thoughts of math were hurting my brain, so I rinsed my dishes and popped them in the dishwasher, and tidied up the kitchen island. Then, on a whim, I changed into a sweatshirt and exercise leggings and headed down to the bike room to get out my bicycle. A pedal through the river valley would clear my head and rid me of the need to do a cardio workout.

I was glad I'd pulled my windtunnel band over my head before clipping on my helmet, because the mild breeze from the balcony became a bit brisker as I rode along. The band covered my ears, and I tried to pick up the pace to warm up. Soon, I was feeling a bit of sweat sliding down the middle of my back. I made it to the outer ring of Hawrelak Park within twenty minutes, and decided to turn back the same way I had come rather than crossing over the footbridge to the dog park on the other side.

It was a fair slog uphill once I got past the new Walterdale Bridge, but the bike path was graded to be manageable, and I came up out of Skunk Hollow winded but triumphant not to have had to get off and push. I swear, they ought to have medals for the little triumphs of the world, like the Brownie badges

of old, that you could pick up whenever you conquered a tiny, homely challenge.

By the time I was showered and dressed again, Steve was home. Since I had been out enjoying the mild spring weather instead of thinking ahead to dinner, nothing was planned. Steve suggested we go out for something to eat. My feelings on our budget were that we should try to rein in our eating out, but my self-control was pretty low, so I agreed to something simple.

We drove down 99th Street to Huma, a Mexican restaurant on a busy corner that was even busier since the popular restaurant had opened. After all my research that morning, I was tickled to see a votive candle to the Virgin of Guadalupe behind the till, and several milagros nailed to a picture frame which held a photo of a rustic farm scene.

"Where is that?" I asked our waiter, who looked to be about fifteen.

"That is the family home of the owner," he smiled.

The menu, while not as replete with seafood as we'd been used to in Puerto Vallarta, had an authenticity to it that spoke of recent immigration on the parts of the owners. The fact that we could overhear Spanish being spoken at other tables added to that authenticity. Steve ordered the platter, and I settled for tortilla soup and tamales.

Over dinner, I told Steve about my conversation with Nancy and her suggestions about where to look for milagro research. I promised that if and when the anthropology journal got back to me, I would flip it immediately to him. Steve was complimentary in my detection skills, and I basked in the glow of his

inflating the little I had done to help. It was very likely a mechanism for not telling me anything more than he needed to about the case, but we take it where we can get it.

When the sopapillas came for dessert, I closed my eyes and brought back the vision of the lovely city of our honeymoon with the first bite.

Steve smiled.

"You're thinking about that little restaurant by the bridge, aren't you? Where the old musician played the electric keyboard?"

"Ten points for Gryffindor. That's exactly what I was thinking about."

"It was a magical week."

"Most of it."

"Yeah, I guess I've been compartmentalizing, trying to sheer those last three days off into their own memory bank."

"What would have happened if we hadn't been there? Would you have been just as tied into this case?"

"Probably not. In most cases, the family back here would be hiring a private firm to check into what had occurred, but relying on the consulate and the Mexican authorities for any information and updates."

"So it was lucky that we were there, for Kristin Perry's family."

"I guess."

"You don't suppose the killer factored in the whole Reading Week element into things, do you?"

"What do you mean?"

"Well, the probability of there being more than one person

from the University of Alberta down there that week was expo-
nentially higher than either the week before or after."

"Go on."

"So, if the statement the killer was trying to make, with the
symbolic layout of the scene, was meant for someone at the Uni-
versity of Alberta, then that would be the week to do it."

"So, this wasn't a case of targeting Kristin Perry herself,
but Kristin Perry, U of A student, as some sort of messenger
pigeon?"

"Maybe. I'm just spit-balling, going on the line that if there
is a symbolic message being delivered, it must be anticipating
someone to whom it is delivered."

Steve looked at me, with alarm.

"What did I say?"

"Well, if you're right, what happens when a message goes
undelivered, or the sender doesn't receive a reply?"

I suddenly saw why Steve looked concerned.

"They reach out and try again."

23

Steve was up and out early the next morning, so I didn't have time to make him a lunch and put some gooey love note into it for him to find and read. Not that I would have done that. I got up with my alarm, which likely went off ten minutes after he was out of the parkade. By the time I had showered, dressed and poured a cup of coffee from the machine which Steve had set the night before, my husband was likely already in the precinct. I knew, though, exactly what he was going to be doing, because we'd discussed it the night before.

Steve's plan was to go over every name associated with the Fine Arts Department that had showed up on the airline lists they had collected from flights in and around the past Reading Week. Even the cancellations would be of interest because he was looking not just for a killer but also for witnesses. While they'd already tried to find connections to Kristin Perry, he was now looking for a broader context.

Patrons, I thought. That's what an artist would call those he

or she wished to appreciate and admire the art created. What if this was supposed to be an instillation, rather than a murder? That was almost more gruesome to contemplate than a murder itself. To be a victim of hatred or envy or rage would be a terrible thing for Kristin Perry, but to be a random piece of material for a piece of art would be even worse. Then your entire identity would be erased. Instead of being the *Mona Lisa*, you'd be *Semi-nude #17*.

I was trying not to get wrapped up again in the sad thoughts of the night before and to put myself into the game of discussing the Eden Robinson novel my students were expected to have read by this morning. I made an executive decision to walk to the LRT station at the university, which took me past the High Level Diner, where I could buy a cinnamon bun, thereby making all my walking a zero sum game.

The campus was nearly deserted, with only professors and spring term students about. This was always such a magical time on campus and hardly anyone saw it. I regretfully dropped out of the green and shiny morning into the stairways to the chilly deep, where the LRT would whisk me downtown to the MacEwan campus.

The bulletin boards in the terminal had been replaced by the video sort that they had in Central Station. I supposed that made sense, since this was a highly congested area most of the time. I watched the screens flip from an Alberta Health Services ad about STDs to a travel agency ad showing first a mountain trail and then a rodeo, and then an ad for The Works, which had just begun. The ads were starting around again and I shook my

head to stop from watching them all again, mesmerized. I had to pay attention so that I didn't get on the wrong train. Nowadays, one train went to Clareview Station, by way of the Commonwealth Stadium and the Exhibition grounds, while another cleaved off at the downtown Churchill Station, taking students to MacEwan and NAIT, and shoppers to Kingsway Mall. The last thing I wanted was to end up in Northeast Edmonton when I was supposed to be in front a class I'd read the riot act to on punctuality.

I got on the right train and off at the right station, but I was almost late, anyhow. Diego Rivers had been hard at work at his mural in the time since I'd seen him before the weekend. Now all the pink lines were pounded onto the white area of the fresco, and some of the painting had been roughed in. I wasn't sure, perhaps he had hired other painters or students to help him, but the outer elements of the mural were coloured in with a pale undercoat of what they would look like, on either side of the mural.

Two or three disgruntled students pushed past me, muttering, jolting me out of my communing with art. I hurried off to my class, and made it with time enough to get in the zone.

It was not as hard as I had thought to move into the world of discussing the plight of Indigenous peoples trying to maintain dignity and culture in a modern, colonizing worldview. Here in Canada, we were only now seriously considering the damage done and reparation that could be achieved. In Mexico, there were similar issues, but it was more difficult for an outsider like me to assess, since the only distinction a visitor could see was

something overlaid like the Huichols' traditional dress to distinguish Indigenous populations from colonially-rooted Mexicans.

My students were eager to discuss *Monkey Beach*, and I gave myself a little internal pat on the back for having chosen a thought-provoking novel they could connect with and be dazzled by. There were no Indigenous students in my class, but there were three Asian students who expressed solidarity with the narrator feeling stigmatized for looking different in Canada. Since they seemed very shy, the fact that they had spoken up at all was a minor miracle, and I silently blessed the brilliance of Eden Robinson's writing. In many ways, my class were reacting to this novel the way I had reacted to George Ryga's *The Ecstasy of Rita Joe*, many years ago. This was the magic of the written word, to inspire readers at the same time as making them uncomfortable as hell. And that was exactly what I wanted my students to come away from my class with—the knowledge that literature is meant to provoke and deal with the awkward and unspoken issues of society around it, not just to entertain. If they caught onto that, and the ability to write a strong five paragraph essay, I would be happy.

We had two more three-hour classes to deal with the intricacies of the novel, but I was delighted to watch students walking out still discussing things. I cleaned up the white board, organized my satchel, and set off for the LRT station. I had no need or desire to trudge up the stairs to the office I shared in the English department, since my office hours were Wednesday afternoons only.

Rivers had been working as hard as I'd been. The whole mural

was under-painted now, and I was able to see a pale version of his ultimate vision.

I stood there, staring at what looked very familiar: a central large image with a series of smaller images surrounding it. I grabbed my phone and took photos of the mural, and sent them to Steve.

The mural seemed to be organized along the same principles as that famous "little cuts" painting I had linked in my mind to the death of Kristin Perry. Milagro-shaped glasses, a cowboy boot, and a mitten were dotted around the outside of the mural, along with similar-sized icons representative of the tourist attractions in Edmonton: I could see the pyramids of the Muttart Conservatory up on the left, and the Science Centre below it. At the bottom left, the brown square was probably going to be Fort Edmonton.

Along the right side of the mural was a swirling art gallery, a circle of tents representing festivals, I assumed, and a trail through the river valley with the new Walterdale bridge gleaming alongside it. I wasn't certain what the centre of the mural was going to represent, but it seemed to be one or two large seated figures. Was this a paean to tourism? I thought I could see the Legislature in the background, though it might become the dome of one of the orthodox cathedrals in town.

It would take more than a graduate course in Mexican sociology and anthropology to make me understand all the nuances that were possibly at work in this mural, or the political art I'd seen in Puerto Vallarta, or at the student show. However, if it was a simple symbol structure at work, there was nothing like an English major for winkling it out.

Was it a huge coincidence that Rivers was creating a mural with an organizing principle based on a Kahlo painting that had also been an influence on a murder in Mexico a few months earlier? What sort of relationship had Kristin Perry had with the artist-in-residence? I was certain that Steve and Iain had all of the answers to these questions locked up in their notes and reports.

What I wouldn't give for a husband who talked in his sleep.

I had timed things properly by sheer good fortune, and dinner was ready as Steve walked in the door that evening. He looked tired, and it occurred to me that maybe I didn't want to hear what he held in his head, and kept out of our shared space.

We spoke about the news, which was depressing, and some gossip about Myra McCorquodale's cousin, whose daughter was in the battle rounds of some reality singing show on television.

"Is that the way people have to start their careers in the arts now? By competing on reality TV? What about apprenticing, and studying, and singing in choirs, and playing in pub bands before being discovered? What about keeping those manuscripts that will never see the light of day in your filing cabinet and sending that one you believe in out over and over again until it finds the publisher who sees the potential? What about the artist who paints in the garret and does greeting cards to pay the heating bills until that first big commission or the breakout gallery showing?"

"Now it's a contest—you appear at the beginning rough at the edges, and if you have a dead parent who believed in you, all the

better, and the coaches choose you, designating you worthy, but it's the vox populi who decide and your career is at the whim of who is watching NBC and bothering to tweet out a vote."

"And what even happens to the winners?"

"One of them won a Grammy, and a couple of those early winners on those other talent shows are churning out records. Sometimes it's the runners up who have the stronger careers, too. Adam Lambert is singing with Queen now."

I shook my head. It was probably the academic in me longing for more recognition of study, refinement, and practice, but it might have had something to do with a program I'd seen about the crazy reality shows they ran in Japan where they broke into your house to shock you, and humiliated you on screen to the delight and entertainment of the television audience. To me, these reality contest shows were just a short step away from that sort of spectacle.

"Anyhow, Myra's cousin's girl is hoping to stay in the contest long enough to get a car. The last five or six get a car."

"More power to her. And she has a career to fall back on, right?"

"Sort of. She's a music teacher for elementary school. With funding as it is, music classes could be the next thing to be cut."

I sighed. This world was just getting meaner and meaner about all the things that made us a civilization. Wasn't it Churchill who had said that if they cut funding for the arts, what were they bothering to fight for?

"Speaking of arts, I have some pictures for you." I went to my satchel to get my phone, and showed Steve the snaps I had taken of Diego Rivers' mural in the making.

"These are really useful, Randy. Can I get you to keep taking shots throughout the process? I'll get someone from the unit to go take some pictures, but they won't be able to do it daily, and will look far too obviously official with all the freaking lenses they bring for their cameras."

"Remind me again about where this guy lands in terms of Kristin Perry's world, if you can. I know he was in Mexico at the same time as us, he was helping organize the student shows in that house gallery we went to, and that he is last year's artist-in-residence. Was Kristin actually in one of his classes, if that's how it works?"

Steve did that arch looking over his shoulder that people should actually do before gossiping in restaurants, but which just looked silly at our dining table.

"I likely shouldn't even be sharing this much, but seeing as how you were actually the one of us to spot the victim, I trust your insight. And besides, it has been three months and even Iain doesn't want to talk about this case with me anymore. He keeps on saying 'what happens in Mexico should stay in Mexico' but you and I and Kristin Perry's parents know that isn't the case."

I nodded. That hadn't even occurred to me. If I was curious and unable to let this go, what must that poor girl's parents be going through?

"We got the manifests of every plane out of Edmonton and Calgary direct to Puerto Vallarta for the seven days before Kristin's death, and everything back to Edmonton for five days after, under the assumption that would cover most permutations of a week's booking. Interestingly, few people book two or three

week vacations that intersect with Reading Week. The snow-birds who are there for two or three months suffer through, but most vacationers know to avoid it."

"Sounds like a lot of names."

"You wouldn't believe it. Apparently, at Christmas, the city really fills up but we were there during a high point, and it never felt crowded to me in the least."

"You're right. And you would think that when those cruise ships came in it would burst the streets, but we never even had to wait for a table in a restaurant."

"So, anyhow, we matched all those names to addresses and backgrounds, and came up with about seventeen cross-matches to Kristin Perry. There were her friends who were there sharing a hotel suite with her; two of her cousins from Calgary, who didn't know she was there too, if they're to be believed; Diego Rivers and his wife, whom we met—Rivers apparently has a reputation for being something of a Lothario with the undergrads; Kristin's former roommate from her first year at U of A, who apparently had no idea she was down there; Austin Stauffer—the fellow that gallery organizer mentioned as her possible boy-friend—and his wife, who were down at the same time, but staying in Bucerias; Ellen Chorley, an actress who did life modeling for drawing classes that Kristin attended, but says she didn't see her down there; Kristin's former Grade Two teacher and her husband, who are now devastated to know of her death; and five other students who were enrolled in classes with her: Anatomy, Art History, Literature of Greece and Rome, and Spanish 100."

"Wow, that is amazing work."

"Thank you. We don't just eat doughnuts and set up speed traps."

I ignored Steve's jab because he knew I didn't have a clichéd vision of his work. My concept of policing wasn't comprehensive, in that way that no one really understood the ins and outs of any of their friends' or families' occupations, but I did know that the Edmonton Police Service, and my husband in particular, were diligent, forward thinking, and thorough. Sometimes, though, when a murder happened so far away, even if all the players were from here, it took time to put all the pieces together. And that was assuming that all the players really were from here, and that the crime was motivated by a real desire to remove Kristin Perry from the world, rather than a random act of tidy violence on the part of a Mexican National or other unconnected tourist visiting Puerto Vallarta.

I closed my eyes. It made me tired just to think of the possibilities. And then something Steve had said worked its way back to the front of my mind.

"You say that Diego Rivers had affairs with undergrads?"

Steve smiled.

"I wondered when you would latch on to that. Yep. And yes, Kristin Perry had taken part in a workshop with Rivers during the fall term, and been part of his curated show in the student gallery. There was some hint that they had connected for a week or two before Christmas, but the girl I spoke to was hazy about the details. So, he's on my watch list, for sure."

"And this Austin fellow, whom Briar Nettles was so adamant about defending—how did he connect with Kristin?"

"Kristin was apparently his shoulder to cry on while he was going through a trial separation with his wife. He's about fifteen years older than the rest of the cohort, and his wife is a nurse who is funding his midlife shift. Too many life model classes and late nights at the studio were getting to her, and they split up between first and second year. That is apparently when Austin and Kristin got together. She and he were inseparable during second year, and then he went back to his wife the beginning of third year. This trip to Mexico was purportedly a second honeymoon for them, and everything seems rosy. They were staying quite a ways away in Bucerias, which is in the neighbouring state of Nayarit, in a condo up the hill that a friend of hers owned, but as you know, nothing is that far away, and you can catch a cab or a bus to pretty well anywhere."

So Kristin had been in a town with an ex-beau and his wife, an art prof she'd had a fling with and his wife, two friends, a few classmates, and a model who might be harbouring a grudge if Kristin had drawn an unflattering portrait of her.

"Two men you've had relationships with in one place," said Steve. "That's twice the number of suspects we usually need."

"Don't underestimate the women, though. After all, the lay out of the body is the same as the painting by a woman, not a man."

Steve smiled.

"Oh, I promise I will never underestimate a woman. Didn't we put that in the vows?"

I smiled at him and for a minute lost track of what we'd been talking about.

"All right, then. I'll take photos of the mural every day for you, and thanks for letting me in on what is going on with your case."

"If it were up to me, I'd bring you in on more of it. I see so many elements of symbolic messaging, the sort of thing we need a trained reader to be noticing for us. But you know the drill, and I really appreciate your understanding of the pressure I am under not to share more."

"When it comes right down to it, Steve, the less I have to think about that young woman bleeding out on that sandy beach, the better. I wonder what they did with the sand that was stained with her blood."

"The forensic team digs it up and transports it to the lab under hazardous waste conditions, and then it's disposed of in the same manner."

"But is there a hole in the beach now?"

"Apparently not. That bar of sand tends to move around with the tides, so it's unlikely anyone would be able to pinpoint the spot where she was now."

I shivered with the thought of impermanence and that lonely beach.

"Randy?"

"Yes?"

"Did you say there was dessert?"

I came back to earth, to our dinner table in our condo in a blossoming spring Edmonton, and my loving husband.

"Coming right up!"

24

Spring session went on, and every morning I took a picture of the mural and every afternoon, I took another. Rivers seemed to have lost his crew, or sent them away, because the detail work was being done by him, alone. My students handed in their *Monkey Beach* essays and started reading scenes from *Much Ado About Nothing,* one of my favourite Shakespeare plays to teach.

Steve and I were back on our art hunt, too. With the bookcases up along one wall, we decided to balance them with a large painting opposite, above the low credenza that held the television and Steve's minimalist but excellent sound system. Two tall towers of DVDs stood to one side, and I could imagine a large landscape or a triptych balancing them. Steve was more of the mind to group several smaller works there, but whatever the choice, we had no paintings at the moment.

Before we leapt at a single painting, Steve wanted us to wait for the Art Walk on Whyte, which had been bumped up a month

this year due to a conflict with some city building and repair work that had to happen along Whyte Avenue. Artists had been annoyed by losing their close connection to the Works Festival, and I had read that some were feeling the pinch of not having enough inventory on hand to make the weekend of sitting at a windy stall worthwhile. Still, it would be worth walking up and down the avenue to see what might be on offer.

My class didn't meet on Fridays, and Steve managed to wrangle a swap of schedules in time to make hitting the Art Walk during its first hours a reality. I was all for walking over, but Steve pointed out that we might be carrying a large piece of art home with us, so we took his car to the lot on 83rd Avenue, where the polite young men in the booth taking your money and offering you a ticket always seemed to be pausing from a philosophical argument or discussion of political theory. It was as if Chekhov cast and populated that booth.

The concept of the Art Walk was to allow artists who didn't always get gallery shows to have access to a larger audience. They rented space for booths, which were sometimes covered tents with three walls, and sometimes, just a patio umbrella perched above a table holding boxes of prints. There was one block cut off to traffic, but the majority of booths shared pavement space with pedestrians all along Whyte Avenue, from 99th Street at the eastern end, to 106th Street, where it petered out. There were booths near the Fringe area of the gazebo on 83rd Avenue, too, but that wasn't the prime area. It seemed there was something desirable about admiring and haggling over art on the sidewalk, with the rest of Edmonton

pushing by you on their way to a secondhand bookstore or gastropub.

Steve and I started at the blocked off area on 105th street where there were two rows of stalls, and worked our way around. There was a mix of everything from bright primitive portraits to highly stylized landscapes, with some metalwork and wood-carving thrown in. Steve was drawn to a bright depiction of our river valley from almost the same vista as our balcony. We could think about it in several sizes, in print form, or as an original acrylic stretching about four feet long and two feet high. I purchased a postcard-sized version, so that we could compare it along our way.

We craned our neck down to the west, and decided to head east for more diversity. I bought another postcard-sized print of little birds sitting on telephone lines, looking like music notes, for my office bulletin board.

We paused for a long time at the booth run by Maria Pace-Wynters. I loved her series of paintings dealing with dress forms and corsets, but couldn't imagine Steve being keen to look at dressmakers' dummies on his wall every evening. She had a couple of her trademark huge poppies in both print and canvas form, and I was rather smitten with the blue poppies. I turned to ask Steve, but he was engrossed in a conversation with Maria's husband, Chris, who was both a well-known musician as the lead of the local band Captain Tractor, but also the organizer of a summer music festival, which was how Steve knew him. They had connected to make security at the Interstellar Rodeo a thing of beauty, where both on duty and extra-curricular cops who

happened to love music were on hand to keep the rowdiness at bay.

I tugged lightly on his sleeve, and made him look where I pointed. Steve was equally taken with the blue poppies, and Maria happily set about wrapping the canvas up for us in clear plastic while Steve and Chris went back to their conversation.

"I'm not painting the poppies so much anymore, but I love this combination. The blue Siberian poppy is the symbol of the U of A Botanical Gardens, you know."

"Oh, is it indigenous to Alberta? I had no idea. I just love the lushness of what I know is such a small flower in the grand scheme of things."

"That's why I started painting them, because they're everywhere in the older gardens, and they pop up in cracks in the sidewalk, like dandelions. I wanted to look at something so ordinary and find the beauty."

"You've made the dressmakers' forms beautiful, too."

"They are necessary before the fashion can begin."

I nodded.

"I've been studying a lot of Frida Kahlo since we went to Mexico for our honeymoon, and her corsets were essential to her. They must have been connected to such pain, and yet she painted them so exquisitely."

Maria smiled.

"One of my art teachers a long time ago said that you either painted something to ease your own eyes after seeing it, or to rip out someone else's eyes so they could see it afresh."

"That's exactly the way I think Kahlo painted, putting things

right in your face. But she also had a sense of symbolism that I'm not sure I'm catching in its entirety."

"Oh, I did a paper on allegorical symbolism in the Renaissance back in my BFA days," laughed Maria. "The whole language of objects was great, like if you were to put a cat on the lap of a great lady you were painting, it actually might be saying that she was secretly having an affair, because cats were a sign of illicit love. And lemons were so expensive that if they were falling out of the bowl, the owner might be overly extravagant or showing off with his money."

"That's amazing. So, are there books detailing that sort of symbolism in art?"

"There are loads of them. Of course, I think you need to take it all with a grain of salt, or an understanding that any code is only useful if there is a key to which more than one person subscribes. The artist and the viewer have to be in agreement as to what the symbols stand for. Otherwise, it's a crapshoot. And, once you've bought the painting, you can decide whatever it means yourself."

Steve and Chris were shaking hands, and I had finished the transaction with Maria and her smartphone gizmo that read my credit card, so we said goodbye and headed down the street.

"So I gather the large landscape idea is no more?"

"Nope, you win. I say we work with the concept of this blue as something to join things together. We could have another biggish painting and one or two smaller ones."

"Well, we could still afford that smaller river view, the evening skyline. And then keep an eye out for another small painting?"

"Sounds good. Do you want to carry this to the car first? Or take it with us to match with?"

"Let's take it with us. That way, we'll look like serious art buyers, and they'll clear the path for us."

I laughed.

"Oh yes, we look like art moguls for sure."

In the end we bought Steve's river valley view, a stylized vision of Whyte Avenue, and two funky little pictures of birds, which I had to assure Steve didn't make us hipsters.

"It was a good thing we did bring the car," Steve said as we wove his car blanket between the canvases and linked the car seat buckles together to hold them secure in the backseat.

"I'll say. I think this will all look amazing, though."

"Let's hang the bigger ones and hold off on the birds till we decide whether or not we're going to buy frames for them."

"Sounds like a plan."

As plans go, though, it fell through, because Steve got called in to deal with something he and Iain were working on, so I lined the paintings up against the living room wall and went to put the kettle on.

As soon as I had a cup of tea in my hand, I curled up in the corner of the sofa with my laptop. Ever since my talk with Maria, I had been eager to do some research into visual art symbols. Maybe the killer had been saying something with the way Kristin had been laid out on the sandy spit.

You can find pretty much anything on the Internet, but you have to be prepared to wade through a lot of dross to get there. I suppose it was the same with any sort of research, except it was

far less likely that you would stumble on porn in a university archive while looking for the Renaissance.

Finally, after watching about seven or eight online videos of Sister Wendy, the charming nun whose razor sharp wit and slight lisp had made her the darling of the middlebrow art world, I found my way to a site that listed a variety of symbols, including cats representing infidelity, as Maria had mentioned.

I opened two windows on my laptop, one with the website on it, and another of the photo I had taken of that lonely sun tanner on the beach. Mine was the photo the police were still using, even after all the forensic team had been through, and it gave me pause to think I might be the artist's keenest appreciator.

Kristin had her hat over her face. It could mean the artist was obliterating Kristin herself, which of course, as a murderer, he was. But it could mean that it wasn't Kristin that was the target so much as what Kristin represented.

She had a large bag with her in place of a purse. Did that mean she was to be seen as rich, or as a tourist? Or that she had capacity to carry more than she did, or, in other words, was vacuous. One shoe on and one shoe off. Did that mean she was careless in her travels? Or that she was not quite so elite as how she would like to present herself?

Sometimes you just have to go old school. I unfolded myself from my cozy corner in the living room and went in search of my own meagre art supplies. Back at the kitchen island, I lined up my computer, my book on Frida, and my phone, with my old sketchbook, a gummy eraser, and a soft pencil—holdovers from when I had taken a drawing class through the Art Gallery of

Alberta evening classes. In my sketchbook, I outlined a picture of Kristin on her beach towel from my enlarged photo, trying to capture every element that might or might not be deliberate. Carefully, I drew her large beach bag, her shoes, and her hat with its circular maze design. I enlarged the photo I'd taken of her as much as I could and even tried to trace in the shadows and edges of what I now knew were bloodstains, but which I hadn't registered at the time.

I recalled Steve telling me that Kristin's blood had sunk down into the sand rather than spreading evenly through the towel she was laid out on. She had been killed on-site, but had likely been drugged into submission. The forensics team, urged on by the tourism police, had dug up and carried away almost a ton of sand.

I stared at the lay out, looking down on it from above. Then, I sketched it again, as if it was being presented to be seen from the bridge, in the same perspective as Frida's little cuts painting. I still didn't see anything that jumped out as a statement symbol. As I was drawing Kristin's legs, with one shoe hanging off her toes, it occurred to me that it felt totally unlike the life drawings we had done in the art class I'd taken. Even though the model we'd been sketching was still in her poses, there had been something about the energy in the tensions of her muscles that let you know you were capturing an image that would be changed at a moment's notice. Drawing Kristin Perry from the photograph on my phone, I realized that I was seeing her as a still life, a grouping of objects displayed together. I had likely sensed that as I was taking the picture. After all, why had I been moved to shoot a picture of a solitary tourist on the beach?

This was a painting, replete with symbolic messaging, laid out on the morning sand for the world to see and understand. What was the message, though? Without a real sense of what the key to the code might be, I was helpless.

I wasn't sure whether it was frustration with not being able to read what might or might not be a message in a crime scene, or the idea that I was veering close to sounding like a character out of a Dan Brown novel, but I found myself pushing aside my sketchbook in irritation. It slid off the island with a flurry of pages. I reached down to pick it up before the expensive paper of the pages became creased or folded, and shook it out before setting it to rights.

The sketchbook had flipped back several dozen pages into the studies our teacher had made us do of a large brocaded purse, reminiscent of the carpetbag Mary Poppins carried in the Julie Andrews movie. It had slumped on the table with loads of folds and creases, making the flowers and leaves turn in on themselves, while the wooden handles stood upright.

I had been intent on making the designs on the outside of the bag appear accurate, and the shadows created by the folds. My teacher had put a hand on my shoulder and said to me, "Your job as an artist is not to record every thread of the brocade on the outside of the bag. Your job is to make the viewer wonder what is inside the purse."

I stared at my stupid purse studies. While I understood what she had been saying, I didn't have the skill or talent to translate that into pencil strokes. There was nothing of interest in that carpetbag the way I was drawing it.

On the other hand, as I started to flip forward to the more recent sketches I had just been making, there was another purse to think about.

There, on the oversized towel, with one dead hand near it, one lost shoe close by, and the other hand of the corpse resting on her abdomen and pointing straight toward it, was a beach bag that made me want to know exactly what was in it.

25

It was going to be difficult to get Steve to give me the content list of Kristin Perry's bag. I did know she had a copy of the same book on Frida Kahlo that I had bought at the little bookstore near the plaza in Old Town, because that was what he had asked me to make notes on. He had also mentioned a change purse that held her ID.

But, if I was going to follow the idea of the murderer as artist, then one of the things I was meant to wonder about was things on display but deliberately hidden, and that amounted to Kristin's face and the contents of her beach bag. Those were the only two elements of the presentation that weren't laid out for immediate view.

It could be the obvious symbol of big bag meaning conspicuous consumption, or some sort of tirade against tourism, but I didn't think so. After all, this was a rather small woman, and a very tidy spot, and the whole ethos of Puerto Vallarta was one of gracious welcome rather than irritated tolerance for tourists.

Kristin could stand for foreigner, or tourist, or Canadian, or she could just be an anonymous woman. She might also have been chosen for being exactly who she was, with all of this being an elaborate cover up for what might be a very petty, personal revenge. I mustn't forget that angle, though to my mind, that was probably what the police were pursuing, so I could likely put that one on the back burner myself.

The beach towel was commercial, likely bought back home or in Puerto Vallarta at the Coppel or Woolworth's, nothing indigenously woven, so maybe that was a comment on imposing anglo-values into the natural scene. Or maybe it was just a handy towel.

The shoes were flip flops, and nothing like the lovely leather sandals Steve and I had purchased in the huarache store only blocks away from where the body lay. Again, this could be a comment on commercialization. Or it could have been easier shoes to dress a corpse with, or it could be nothing. Lots of Mexican nationals wore flip flops.

The bag, though, that was where my eye kept returning. This was no commercially processed bag. She had either bought it from a beach vendor or at the market. It was a large, woven bag that stood upright with woven handles on either side of its maw. Holding it closed, though, was a flap of fabric covered in embroidered flowers that reached between the handles and was secured with a turning mechanism. This was the most Mexican element of the entire still life. Some of the flowers matched the deep red of the girl's bathing suit, and others matched the bright yellow of the crown of the wide-brimmed sunhat covering her

face, the white brim extending like a halo reversed in front of her head. The hat, seen from above, looked like a sunny side up egg, which was probably not the effect the designer had been going for. However, you usually didn't see hats from directly above. Unless you were a bird.

Was the colour-matching deliberate between the hat and the bathing suit and the flowers on the bag? And if it was, was it deliberate on Kristin the art student's part, or was it an overlay of choice made by the murderer? That was the trouble with it being an art student who was murdered. Where did the general style and artistic choices she'd made when alive merge with the designs made by this audacious murderer?

Steve surprised me, so intent was I on staring at enlargements of the photo on my screen.

"I thought you might have gone to bed by now."

"Is it late?"

"By your standards, it is." Steve laughed. "But I could use a drink, if you want to stay up and keep me company for one."

"I'll have a cup of peppermint tea alongside you. Right now, a drink would probably rev me up rather than calm me down. How was your evening?"

"Less eventful than Iain thought it was going to be, which is a good thing. What about your evening? Were you drawing something?" Steve nodded to my art supplies strewn across the kitchen island.

"Sort of." I took a deep breath. There was no point in hiding anything from Steve about this. After all, I was trying to help him, not go behind his back on any of this.

"I got thinking about the concept of symbols and codes in painting, like what I'd been discussing with Maria earlier. So I started looking for any obvious symbols in the lay out of the body of Kristin Perry."

"You think this murder was actually supposed to be some sort of art installation?"

"That sounds creepy, and I'm not sure I want to go that far, but I do think there is something deliberate about the placement of the body and the layout of the items on the beach. This is something that was done by someone with an eye for symbols and placement. Maybe we're looking for an artist as a murderer, because I believe that this murder is seeped in the language of visual art. And in order to understand what is in front of you, you have to speak the right language."

As the kettle boiled, I went on to tell him my epiphany about the beach bag, and my need to know what was inside the bag.

"I don't suppose there is any reason why I couldn't share that with you. We did let you know about the book, and while I should check with Roberto to see what they are withholding as nonpublic information, I'm pretty sure I could share the list with you. I like the idea of what you are saying. I'm not so sure there's going to be much pay-off from what I recall from the purse contents, but I'm certainly willing to check it out through that lens."

"Really? That would be great. If there is any message we should be getting, I think it all points to the bag."

We sank down in opposite corners of the sofa, and I stuck my toes under Steve's thigh, to keep my feet warm.

"Do you talk a lot to Roberto about things still? Is there much going on down there on the investigation?"

Steve shrugged.

"It's hard to say. Part of it is the language barrier, of course. My Spanish is schoolbook clunky and Roberto, though he's better in English than I am in Spanish and, for that matter, much better in French than I am, maybe doesn't catch the nuance of everything said over the phone. We end up waiting for Ana Maria here to translate things to read out, and that loses any spontaneity of conversation. Or maybe Roberto just doesn't want to connect. After all, this is a blot on their reputation that they are really hoping can be traced directly back to something Canadian that just happened to occur between Canadians while they were on a vacation outside of Canada—something that could happen anywhere, and unfortunately happened on a Mexican beach, completely by happenstance. The last thing they want is the idea that murder on the beach is a regular occurrence. Puerto Vallarta is considered the safest city in all of Mexico. That's a strong reputation to maintain."

"So, how are you keeping connected with the folks down there?"

"Define connected. We have a conference call with Iain, Roberto, and that chief of theirs every Thursday morning, but oftentimes we lose the connection and I don't think the materials we sent down to them by post have even arrived yet."

"What is it with the bureaucracy of Mexico and the Central American countries? Everything else is state of the art, everyone there speaks two or three languages, and most of them have lived

in Europe or elsewhere on this continent, the Wi-fi is strong, the mix of veneration of history and push to modernity is beautifully balanced, and yet you cannot feel secure about something actually arriving by post from just one country over?"

Steve laughed and nodded.

"It's driving Iain crazy. He wants to send things via some sort of Dropbox method, but Roberto's boss doesn't believe it to be secure enough for transmission. Meanwhile, who knows where the mailbag containing the files we sent them has got to?"

"The other thing I was wondering was, did you get confirmation from her friends or relations as to whether those items actually belonged to Kristin? The bag, and the hat and the bathing suit and flip flops? Or was she dressed by the murderer?"

"That, I can tell you right now, because I recall how weird I thought it was. According to her roommates on the trip, Kristin did have a red bathing suit, and they thought the sandals were hers, but they had never seen either the bag or the hat she was found with. She apparently wore a pink Edmonton Oilers ball cap when she was with them, and we even found a photo of them all on the pirate ship with her wearing the pink-billed cap."

"Wow, that's very interesting. I'm not sure why, but I think that may be important."

Steve smiled.

"Well, what is important to me is aiming us both toward the bedroom."

"You wanting to get to bed at a decent hour tonight, is that it?"

"We're married now, so any hour is a decent hour, I would think."

"Oh, Mr. Browning!"

It was my turn to smile.

26

Steve was gone to work by the time I woke up on Saturday, but, true to his word, he had emailed me a list of the contents of the bag found with Kristin Perry when she died. I was determined not to equate it with her, now that I knew that her roommates didn't recognize it as hers.

There had been the Frida Kahlo book, the same one I'd picked up at the local bookstore, where there had been a stack of five or six copies. There was a small zippered bag containing some pesos, her hotel key, her Alberta driver's licence, her UPass, and both a debit and a credit card. There was a small tube of sunscreen, with all the directions in Spanish. And there were three art postcards listed: one of Frida and Diego on their wedding day; one of a fried egg on a piece of toast; and one of Edvard Munch's *The Scream*. I knew that the wedding portrait was in the San Francisco Museum of Modern Art. I wasn't sure about the egg. Was that an Andy Warhol? And one of Munch's four paintings had been stolen a few years back, but was apparently back in Norway, wailing away.

I looked the list up and down once more. It seemed obvious to me that this was a deliberate set of items, not what Kristin might actually have had in her own bag, and just transferred.

Her passport had been locked in the hotel safe along with those of her roommates, so it wasn't surprising that it wasn't in the bag. Also, the very few cards weren't a surprise. Kristin had probably left a wallet back home filled with store membership discount cards, old sales receipts, and Canadian Tire money, bringing only her essentials. Perhaps the girls had ridden the LRT to the airport shuttle bus on their way to the airport and were planning to return the same way, hence her bringing her UPass.

Whoever had killed her wasn't looking to empty her bank accounts or run up her charge card, or they'd have taken them. Of course, they had targeted an art student. Perhaps they were aware that the monetary pickings would likely be slim. Or they were aware of how easily law enforcement could track their movements if they were to use the cards.

There had been no fingerprints found on any of the items in the bag, which also spoke to the idea of it being staged. Steve had included the file of notes I presumed Iain had made of the bag.

He had checked with Vallarta police to determine that the bag was available at two stores in The Flea Market, and one stall in the market on the island in the river. It was older stock, but sold well enough, and no one could recall anyone unusual buying one.

It could have been a man or a woman, and no one would

have noticed. It wouldn't have seemed odd for a man to be buying a purse in a tourist destination; vendors were probably used to people purchasing items as gifts to take home as much as for personal souvenirs.

The book had already been traced to the same bookstore where I'd purchased my copy. Again, no one had any recollection of who had bought it. They were more focused on noting patrons who were bringing in secondhand books for a discount on others, than on recording every new purchase.

The art cards were noted, and while I was pleased to see I had been correct in guessing the provenance of the Kahlo and the Munch, I'd been wrong about the fried egg. It wasn't Warhol, and Iain hadn't been able to determine who it was. He had "Etsy?" written in his notes.

The idea that Iain McCorquodale had been aware of Etsy, the online craft emporium, amused me. It also brought me back to that student focused art gallery Steve and I had visited on our 124th Street art amble. Etsy might be the sort of place students were selling their work, even while in school. I wondered what the protocols were for students to be selling art while in school, and whether anyone bothered with that sort of distinction anymore. If a housewife with crafty ideas could whomp up some cutesy craft and decide it was worth selling on Etsy, why shouldn't some aesthetically minded student find some way to augment their student loans?

The postcards bothered me. They were so easy to lay out as some sort of pictorial sentence or comic strip. If only one used the right order.

Egg on toast, *The Scream*, Frida and Diego's wedding. Perhaps that was a commentary on special occasions. They all start like a regular day with breakfast, then tension and nerves, even the happy ones.

The Scream, the egg on toast, the Wedding. There is tension and fear, then a toast, as a metaphorical toast to celebrate, and then a wedding, the happily ever after ending.

Frida and Diego. Munch's *Scream*. A fried egg on toast. Frida meets Diego, or in this case, Kristin meets her murderer. There was a scream because she was frightened and killed. And then there was a fried egg. What could that mean at the end of that scenario? The killer ate breakfast? It happened in a diner?

I flicked from the fried egg postcard picture, to my photo of the scene of the crime.

The fried egg was the last word. It looked just like the sunhat on top of Kristin's face. And underneath that egg, Kristin Perry was toast.

27

I took a photo of the layout of the postcards and added my photo of Kristin on the beach, and emailed it to Steve, with my thoughts. He called almost immediately, sounding excited.

"This is the first thing that makes sense to all of us. It adds a strong plus to the column that says this is a murderer who is definitely dabbling in the fine arts."

"Have there been any others prior to this, do you think?"

"Other murders?"

"Yes. This seems very tidily done, with nothing out of place. But surely there were messier versions, sketches leading up to the big work of art? Even the great masters all did their practice sketches."

"It could be anything, couldn't it? A bit of graffiti, some refuse set out in a particular way. We might even have overlooked signs at other murder scenes, though there aren't that many that pop up without a clear line on who was involved and why. It's a thought though, and I'll take it to the group. Thanks, Randy. Every new nugget helps."

I smiled into the phone.

"Glad to bring you a nugget."

"I'll be home by seven."

"See you then. I'll make a casserole."

"Make that six forty-five."

I tidied up my books and notepad, and bustled into the kitchen to find ingredients for my casserole. That was the great beauty of casseroles; one only had to find three to five interesting things to pop together, and then set them in the oven for an hour, and poof, you had a meal that indicated you had put thought and energy into it. I checked the fridge crisper for salad fixings and then went off to the bedroom to have a shower.

With my hair damp, but feeling a lot fresher in clean jeans and an embroidered blouse we'd bought on our honeymoon, I set the table out on the balcony. It was a beautiful clear evening, and the sun wouldn't set for another three hours or so, making it basking weather up on our concrete aerie. The heat was absorbed by the grey wall, but seemed to warm the whole area. I had set a couple of rag rugs out on the tiled floor of the balcony, making it cozy underfoot. I set the heavy silverware on top of the napkins, to assure they wouldn't fly away in a sudden breeze, and went back into the kitchen for the salt, pepper, and hot sauce Steve insisted on putting on everything, another find from our honeymoon.

With the salad under a mesh cover, and a trivet ready to accept the casserole dish, I was finished setting the table, and I stood gazing out on the river valley and beyond to the north side of the river. The lights in the baseball park were on, indicating

Janice MacDonald

a game was about to take place. We would be able to see the action, but not hear the crowd from this distance. A trolley went over the top of the High Level Bridge, and at the same time, an LRT train went the other direction on its own bridge just beyond. The white bow of the new Walterdale Bridge gleamed at the river's edge, closer to us than the huge black bridge that spanned the entire river valley. I saw people kayaking down the river. I heard joggers below me along Saskatchewan Drive. It was like one of those Richard Scarry double-pages in a children's book of everyone on the move.

Maybe I was turning into a visual arts person, seeing everything in framed images. That is what I had read somewhere; that an artist wasn't someone who could draw or paint exquisitely. An artist was someone who knew where to draw the frame around something to make the rest of us really see it.

That thought brought me back to Kristin on the beach. What had we been meant to really see?

"Hey honey, I'm home!"

I turned toward the interior of the apartment. It was impossible to see in from out in the sunlight, which I took comfort from, even though at our height, very few people would be able to peer in. I stepped back into the living room to see Steve dumping his keys and service belt into his drawer in the kitchen island.

When he saw me, he smiled the same smile I had seen when we took our vows and my heart did a flip in my chest. I was still having a hard time believing this was real life now.

"You look as great as the kitchen smells."

I moved in for a kiss.

"My theory is that any food smell you come home to, meaning you didn't have to cook it, is the best food smell ever."

Steve laughed.

"There is something to that, I'll admit. Does it work if you set things up and then go for a walk?"

"That only works for pot roast."

Steve laughed again, and I shooed him off to wash up for supper. I popped on oven mitts and pulled the bubbling casserole out of the oven. It was a bit of a wriggle to get the screen open with a hot dish in my hands, but apparently that is why elbows were invented. By the time Steve reappeared, I was pouring wine into our Mexican glass goblets. Steve sat down and dished himself some salad while I got on an oven mitt once more to take the lid off the casserole. I served us both, and then popped the lid back on, more to keep bugs away than to keep it warm. Steve had told me bugs rarely made it up past the fourth floor of a building, but I was taking no chances. There was enough protein in that dish already.

"Mmm, this is amazing." Steve was the most appreciative person to cook for. We had bonded early over food, which to my way of thinking was a good thing, even though it boded that we'd end up both being at least twenty pounds over our standard approved weight in life.

Once we had settled into our meal, and were proceeding to clear our plates at a leisurely pace, our conversation turned to the Kristin Perry murder.

I was eager to know what other people on his task team had said about my rebus pictorial message idea.

"Roberto thinks it is a genius idea. Iain said it made sense, but he couldn't figure out why she had to look like an egg on toast at the end. And Garry, our art expert because he owns two Sylvain Voyers, thinks that may be the best lead we have so far. He's now searching back through crime scenes over the last three years that had any pictorial aspects to them, to see if there is any linkage that can be done."

"Why three years?"

"The thought was that it would capture anyone who was in fourth year of a BA or BFA now, or anywhere in between. We needed to start somewhere, with a small enough catchment to allow for a prediction."

"I love it when you talk analytically."

"Remind me to median your base line later. But first, seconds!"

Steve dished out more casserole for himself. I declined another portion, but made a note that there would be leftovers for lunch tomorrow.

When he had cleared his plate a second time, Steve stood to clear the whole table. I wiped the table clean with our napkins and then took them both to the washer, along with the wine bottle which went into the recycle bin in the same utility room. I dished the leftovers into a container while Steve filled the sink with sudsy water, foregoing the dishwasher.

We bustled about the kitchen together, quietly and harmoniously, and then settled in to the living room with tea and the television. We were catching up on a magnificent series starring Liev Schreiber called *Ray Donovan,* which explored the relative

morality of a family of transplanted Boston Irishmen out to Los Angeles. Steve considered it to be on a par with *The Sopranos* for cinematic exploration of the humanity of criminality.

"Aren't you supposed to be watching *Law and Order* or something else with cops as the heroes?"

"Why would I want to watch a fictionalized depiction of what I do every day, except to laugh at the magical timelines? No, I think it is important for me to understand the humanity of it all, because we paint things so black and white every day. We need to remember there are infinite shades between."

"Do you notice we're talking about morality and philosophy with art terms? Did we always do that, or is it dealing with the Kristin Perry murder that has us speaking with visual arts metaphors?"

"And looking for metaphors everywhere we look?"

"How do you reconcile that on a day-to-day basis? As you move more and more into a case, does everything begin to look as if it belongs?"

"I think that's why most Superintendents run their crews with a three case load format. You juggle three different puzzles, keeping you fresh to possibilities and not tied into one rabbit hole that makes everything look like a clue. Sometimes I think those huge task teams dealing with a particular crime or killer get very blinkered."

"Are there a lot of task teams?"

"Once again, magical thinking TV, mostly. If you can afford the space, you devote a wall to a case, but there are several going on in the same area. Actually, that's not as much of a traffic jam

as it sounds. And sometimes it leads to interconnections you wouldn't have thought about otherwise."

"As in, the murderer you're looking for on this wall may be the same person who is murdering people on that other wall, in a whole different manner? Aren't murderers supposed to stick to a pattern?"

"Normally, they do. But sometimes they venture out, or connect with other malfeasants, or simply stumble over an easy opportunity to do something slightly different. After all, why stab someone if you can push him out a window?"

By this time, we had slid past the last possible time to begin a new episode without consciously admitting we'd be haggard the following day, so Steve turned off the various devices with their corresponding remotes, and I gathered up the teapot and mugs and rinsed the tidied things away in the dishwasher.

"So you're telling me that someone as obviously message-driven as our murderer in Mexico is going to just happily defenestrate someone if the opportunity arises? I'm not sure I buy that at all. I think this guy cares more about the message than the medium, and by medium I mean victim."

"I think you're right, and it's the conclusion most of us have come to, although Iain is still pursuing Kristin Perry's background to see if there was anywhere it intersects with someone who took umbrage with her to the point of following her on vacation and doing her in."

"So, we're looking for victims with art connections, or with symbolic patterns at any rate."

"Right."

"In the last three years."

"Yep."

"And how many unsolved murders have there been in the past three years in Edmonton?"

Steve smiled wryly as he pulled the coverlet back on our bed.

"Well, if you factor out the body recovered from the river that hasn't been claimed since 2004, and several bodies not discovered until at least a month after they had died, making it very hard to sign off on whether they died of natural causes, there are three."

"Ooh, no wonder they call us the Murder Capital of Canada."

"I know, right? A little localized gang flare-up every now and then, and the news media goes wild. Honestly, Edmonton on the whole is a pretty safe city, if you don't count getting knocked over by a cyclist on the sidewalk."

I didn't particularly want to think about inner city gangs as a way to lull myself to sleep, so I tried to think soothing thoughts about some of the paintings I'd been studying earlier.

28

Maybe it was my mind still hooked on my art and picture framing thoughts from the day before, but I decided to make toad-in-the-hole for breakfast, rather than just egg on toast, as I usually did.

I cut a circle out of four pieces of bread, buttered them and set them into the big frying pan, and then carefully cracked an egg into each hole I'd made. The perfect circles were certainly tidier than the art card version they'd found in Kristin's beach bag, but there was something connecting the more British recipe to the image in my mind, and I was going with this.

It had been my grandmother who had made toad-in-the-hole for us on vacation mornings with her. My mother had stuck to poached eggs in their little aluminum cups, or soft-boiled eggs in egg cups with toast soldiers for dipping. I knew there was another recipe with the same name, using sausages and a cheese bake, but to my mind, toad-in-the-hole involved an egg and a piece of toast.

Steve appeared, all clean-shaven and showered and ready for work. He kissed the back of my neck just as I was pouring him a cup of coffee, which could have caused a rather awkward explanation at the Emergency if I hadn't been quick enough to shift the carafe away. I shooed him to the other side of the kitchen island and set his nursery food in front of him, along with coffee and half a grapefruit.

"What's this?"

"My grandmother's version of toad-in-the-hole, which is what has been somehow on my mind since seeing those art cards in your evidence list. I really do think there is a message in those cards. Maybe Kristin's beach hat was supposed to replicate the egg message, too. It's just that I'm not certain what it is supposed to tell us."

"Well, it's tasty, if a bit regimented."

"I know. When I was little, I really appreciated how defined the egg became, cooked in the middle of the toast. Now, I am not so sure why it was so essential to rein it in."

"Tidy is good."

"Spoken like a true detective," I laughed, and handed him over more conventional toast, without an egg in the middle. He reached for the peanut butter I'd put on the counter along with the butter and the hot sauce we'd brought back from Mexico.

"That hat could have been the first hat the murderer had on hand. It could be absolute coincidence that it looks like your toad-in-the-hole."

"You hate coincidences."

"That doesn't mean they don't happen."

"I guess, but given the rest of the visual aspects to this, I wouldn't discount anything as coincidence."

"But neither can we discount coincidence."

"Your job is really complicated."

"Thank you for noticing." Steve jammed the rest of his toast into his mouth and chewed with satisfaction for not nearly the requisite number of times before swallowing and smacking his lips. "I have to get to work now, but that was a wonderful breakfast."

"I wish you didn't have to work Sundays."

"You know it's not every Sunday, just once a month. I have to say I've been more grateful these days that we do rotate, to give all us family guys a chance of getting the most full weekends with our peeps."

"Look at you, Steve Browning, family guy."

He pushed away from the island and slipped off his stool to come around and hug me, pulling me almost off the ground as he did so.

"It's nearly our four month-a-versary, and it still makes me melt a little to think about it."

"I suppose it will eventually get old, but I'm glad it's not. I waited long enough for you, Husband."

"I hear you, Wife." Another squeeze and he set me back to rights.

"So, what are your plans for the day?"

"I'm getting my week together. I teach tomorrow and Wednesday, but lucky for me I have nothing to mark on Tuesday. I'm not sure how I managed that, but it's a tiny miracle gift I

gave myself when cobbling together the two syllabi. I am think-ing of heading off to the library to do some research."

"Research for me or for you?"

"For you. I'm still wondering about the milagros, and the whole symbolic form of painting, and hidden messages in paintings. Nancy Gibson gave me some ideas of where to look for research on the topic, but I still haven't heard back from that direction, so I'll have to start looking for myself."

"Thanks for this, Randy. Who knows; Keller may even be more gracious about things if it comes in a report from you rather than delivered firsthand, too. As a police expert, I mean."

"You can use the material without my name on it if it makes things easier. I just feel as if I'm in this, and appreciate the chance to do my bit. I can still see her lying there, all alone. Even though I know she was already dead by then, it pains me to think we just walked on by."

Steve grimaced, as he salted his wallet, badge, and keys about his person, readying himself to head out.

"Well, if we can put this case to rest, maybe we can get you past that image, too. And that would be worth it in my books."

After he left, I cleaned the kitchen and went off to sort out the bedroom. Steve had already made the bed, but I picked up laundry items and started a load going before heading into the closet to ponder my outfits for the following week. Being nearly summer, it didn't take too long, and I soon had three outfits organized: a blue and red sundress with a red cotton blazer to wear over it on Monday; a white blouse with black and white peg pants for Tuesday at the library; and since the temperature

was predicted to soar this week, the way it often does in Edmonton in late May and early June, my peach capris and striped peach and cream mega-tee from our honeymoon. I didn't bother sorting out past Wednesday, because I didn't have to appear in public the rest of the week, and that to me meant I could laze about in my stretchy yoga pants with elephants on them and one of Steve's plaid flannel shirts until someone pried me out of the aerie.

I checked on the laundry, transferring some of it to the dryer, and shaking out and hanging three of Steve's dress shirts that purported to be no-iron magical shirts. I had another load of washing, this time including towels, the bath mat and a tablecloth.

I pulled the balcony window open to let in the warm air. It had rained overnight, and everything seemed to sparkle as if it had just been through a car wash. On a day like this, it seemed impossible to think that there was anyone in this world that could inflict pain or suffering on another. I knew better, of course, but the fresh-washed blue of the sky and the quivering of the aspen leaves in the river valley below me all seemed to indicate the promise of a world that now knew better. I could hear bird song: sparrows chittering, and robins setting their nesting boundaries with piercing cries.

The condo seemed a bit dim after having been out on the balcony, so I decided to go for a bike ride. I grabbed my small backpack for my keys, wallet, and glasses case and put on my bike helmet with the help of the hall mirror. I remembered to leave a note for Steve, just in case he looped back for lunch, but I was pretty sure I would be crumpling it up before he ever got home.

I decided to head east for my jaunt this time, rather than west. I wound my way down past the Old Timers' Cabin and across the mishmash of roads winding to one bridge or another, till I was down by the riverboat dock. *The Edmonton Queen,* which had gone up and down the river as a tourist ride and party boat, had been docked for a couple of years, finally sold and now was sailing the North Saskatchewan in her new incarnation. I had taken my parents on her once when they had visited and we had enjoyed ourselves; and Denise and one of her boyfriends had been on an evening dance cruise that she had raved about for days. I stopped by the pier, straddling my bike, wondering how much it cost to ride her now. It was wonderful to know she wasn't going to disappear, especially just as the City was really exploring ways to make the river valley more than just a nature preserve.

They had built up the multipurpose walkway under Louise McKinney Park across the river to be very nice indeed, and while we were all waiting to see what the new LRT bridge would be like, we had to make do with not being able to connect to there without a long detour. I biked back up along the pathways toward the pyramids where we had got married four snowy months ago, only to realize the pedestrian pathway across the main road had also been removed for the LRT construction. I got to the corner, and became a vehicle proper, waiting for the light to change.

Although it seemed silly to go indoors to see plants on a sunny summer day, there were very few cars in the parking lot and it struck me that it would be nice to wander the Muttart

Conservatory pyramids without a crowd of people to navigate around. I locked my bike up at the nearest stand, and clipped my helmet to my backpack, letting it bounce lightly on my butt as I went.

The four pyramids were linked together by a central area, filled with tables and chairs. At one point, there had been a small concession in there, but now there was a full gourmet restaurant at the front of the pyramids, so this area had become part art gallery and part school field trip hands-on area.

After wandering through the tropical pavilion, I took a look at the art on the walls. One side was photos of Edmonton outdoor art from interesting angles, like from underneath the big blue legs of the structure in Borden Park or up close and self-reflected in all the chrome balls piled up near Fort Edmonton. There were a couple of murals included in the shoot, and I wondered idly if either of them were Diego Rivers' work.

Tallied up and photographed, it became obvious that there was a whole lot more public art in Edmonton than I'd realized. I wondered if we had as many statues down Jasper Avenue as Puerto Vallarta had on the Malecon. That might be an interesting project to undertake. All it would take would be an afternoon of my time, to walk the length of Jasper Avenue from 97th Street to 124th Street. I already knew that I could count the DREAM statues on the side of the Convention Centre, commemorating the site of the old Dreamland Theatre for old-time Edmontonians.

So, that is where I started, after biking home and making myself a liverwurst sandwich. I caught the bus downtown and

started at the Convention Centre, photographing and documenting every bit of art I could find.

There was an inukshuk just past the convention centre to the east, and a statue of Robbie Burns in front of the Macdonald Hotel on 100th Street. A twisted set of what looked like huge vacuum cleaner hoses sat in the wee park by the ATB building. There were chrome birds flying along a wall of a parkade, visible through the park on the corner of 102nd Street. The inscribed benches between 100th and 101st Street told the story of Canada geese in the centre of the city. Meanwhile, a running poem by Cadence Weapon, a former poet laureate of the city, appeared on banners hung from every lamppost from 100th to 109th Street, the length of Jasper Avenue that was considered downtown proper. An aluminum sculpture of straight and curved lines stood on the corner of 103rd Street. On 105th Street, in the Beaver Hills House Park, there was Lynn Malin's interactive statue of bicycle seats and wheels, which looked like fun, but I never had caught people on it. More birds flew along a wall between that park, along with the name in Cree, and the tiny Michael Phair Park, honouring tiny Michael Phair, former city counselor. On 108th, they had recently put up a tribute to David Thompson, the map maker and explorer, that looked like three aluminum canoes on their ends, joining in the middle, with a sextant on top. There was engraving all over the canoe hulls, with pictures, maps, and segments from his diaries.

Waiting to cross 109th Street, I recalled that there used to be a wind statue with pipes that played according to the weather, but it had apparently been moved somewhere else. On 112th,

there was a bronze statue of a cow or possibly a bull. I wasn't sure if that was City art, or if it belonged to the restaurant beside it.

Continuing down Jasper Avenue into the more residential end, there was a representational horse statue in front of a different restaurant and a more abstract metal horse nearby. I wasn't sure why the horses were such a theme, and there was no one to ask.

I went a bit further, seeing corners painted to denote how the city was going to add in resting stops, but the art seemed to peter out before Jasper Avenue turned into the arty 124th Street, aside from the mosaic on one of the older apartment buildings. So, counting the birds further back, that made only three or four murals downtown. I knew there were a few more in Old Strathcona, the trendy neighbourhood across the river where the Fringe Festival took place in late August. Murals had started as, and had somehow become, a small town concept in BC and the prairie provinces, not the art of a metropolis. On the other hand, I had heard that Winnipeg had something like 600 murals, part of the city's attempt to curb graffiti. So maybe the further east you headed, the more cosmopolitan murals were considered.

I bused back from 124th Street down Jasper Avenue, getting off at 109th Street. I had a vague notion of walking south to the High Level Bridge, and then home along Saskatchewan Drive. Just as I made the turn south, my phone buzzed with a text from Steve, asking where I was and did I want to meet up for dinner somewhere.

Relieved, because frankly I had walked enough for one day,

I texted back the suggestion of The Common, a great restaurant that had the added cachet of being only one block from where I stood. Steve agreed to meet me there within fifteen minutes, so I walked into the cool interior and asked for a table for two. The smiling hostess ushered me into their second room, which was pretty empty at this time of the day. The lunch rush of government workers didn't happen on Sundays, and the dinner and happy hour crew wasn't yet on board. I opted for one of the booths in the window, and asked for an order of their truffle popcorn while I waited for my husband.

Steve was good to his word, and arrived only ten minutes later, so he was also able to taste a few handfuls of their decadent popcorn appetizer.

I had been examining the menu while I waited and opted for the steak salad, and Steve ordered the lobster pot with fries. Once the waiter was gone with our order, we could catch up.

"You look like you got some sun," Steve remarked. I touched my nose, which always gets red when I wear my sunglasses.

"Well, I've been art-trekking." I explained my quest of the afternoon, and listed my finds, showing him the photos of all the art on my phone at the same time.

Steve looked impressed, if a bit mystified.

"And you decided to do this why?"

"I was thinking about public art, a category which murals fall into, and wondering how much public art Edmonton maintains. I know of other installations, in parks and plazas, and elsewhere around the city, but I thought I would check our main drag, to see how we would look to a visitor."

"And that's important why?"

"There are two threads that keep pulling at me about this case of yours: tourism and cryptic art. Did the murder have to happen in a tourist mecca? Does the murder layout have an art connection at all besides the victim being an art student? With those postcards and art book in her bag, was it somehow part of the message the killer was sending? And if it was about sending a message, who was the recipient of the message supposed to be?"

Steve looked at me with admiration. "That's a very good point. If you remove the possibility that the killer is toying with the police, trying to prove his or her cleverness, then there's a second audience. And if we can figure out who the audience is meant to be, that may offer us a clearer link to the killer."

I tried to look appropriately clever, but Steve had taken those limber leaps all on his own. It made a great deal of sense, though. Find out who the message is meant for, and you're far likelier to find out who sent the message. Now if only we knew what the message meant.

Our food came, and we were soon tucking in to delicious flavours, in plentiful but not overly laden portions. I demurred when asked if we wanted to see the dessert menu, and we were back on the street and moving toward Steve's car just as the first push of drinkers was headed in.

On the way home, along Saskatchewan Drive, I noted very little in the way of public art, but there were several benches and lookouts onto the beautiful river valley, so perhaps nature trumped art in this situation and the city forebearers knew it.

29

The next day was a Monday and one of my teaching days.

We were just diving into *Much Ado About Nothing*, a play I loved to teach because there was enough humour to jolly students along into really wrestling with some of the more problematic issues like whether or not we want a doofus like Claudio, who believes everything he hears, marrying Hero after all. I also liked the idea that a girl could be named Hero, even though I was much more of a Beatrice fan.

After I was done teaching, I took the train across the river to the University of Alberta's Rutherford Library. I had planned on going Tuesday, but just couldn't wait. I wanted to look up some more things about secret messages in art and maybe find something by the fellow Nancy had mentioned. The LRT fed into HUB Mall through a spacious walkway, and I clattered down the much-less-busy-than-usual mall to the next walkway, which attached HUB to the dark brick building which was Rutherford Library, North and South. The walkway was an upper balcony

of a covered breezeway or atrium linking the original building to the new addendum. To my mind, it was one of the best architectural points on campus. Occasional art displays happened in the atrium and it meshed the limestone of the older building's façade to the darker brick of the new building with a ceramic tiled floor, which was broken into a series of stairs and ramps to conform to the levels of each building. While I had a certain history with Rutherford South, and still loved the grand staircase and study hall, it was Rutherford North I needed today. The main entrance was on the second floor, at the end of the walkway I was on from HUB, and I went through the turnstile and past the check out counter. Lucky for me, summer means fewer people hogging the computer terminals, so I was able to get to one immediately.

I did a search first for symbols and codes in art, then for articles in *Canadian Anthropology Studies,* and wrote down a few titles. I then headed to the reference desk, because if there is one thing I have learned about libraries, it is to take advantage of their secret weapons—research librarians.

The fact that it was a slow Monday was probably to my advantage. Spring and summer session students didn't hound librarians, for the most part, mostly because they were having too much trouble making it through the reading requirements for their courses without adding to their loads. I sidled up to the desk and put on my sunniest smile.

"May I help you?" asked the woman behind the desk, who looked as if she never had to consciously put on a smile because she was just naturally beaming. Her nameplate said "Carol Wright," and somehow I knew I was in good hands.

"I hope so. I am looking for some books on hidden messages in works of fine art, and symbols and signs in Middle American art."

"Oh my goodness. Did Janet send you over here as a joke?"

"Uh, no. I'm totally serious. Why?"

"Because my own thesis was on reading the messages in the visual arts."

"You're kidding. So, in that case, does the library have a copy of your thesis?"

"I'm afraid not. I did my masters degree at York. But I can point you to some good source material and give you an overview of my argument, if that would be of use to you. You're absolutely positive this isn't a joke?" She scanned the vicinity, looking for some prankster friend, I suppose, or James Cordon.

"Absolutely positive. I don't know, I guess sometimes coincidences work in our favour. And anything you can tell me would be spectacular, Ms. Wright."

"Call me Carol."

"Thank you, Carol. I'm Randy. Randy Craig."

I pulled up a chair to the side of her desk, and for the next hour, Carol Wright listed a variety of books on the subject of symbol and message in the arts, both secular and religious, including one which had an essay that sounded an awful lot like the talk Nancy had pointed me towards. She also walked me through the meaning of the various milagros with which South and Central American religious icons were bedazzled.

"Are you working on a paper, or is this for your teaching in some way?" she asked, having ascertained that I was indeed an academic of sorts, working across the river.

I admitted that my interest was partly personal and partly as research for the police as a civilian specialist.

"And the crime is one of art theft? Or some sort of art puzzle?"

"Not really. It's more that a murder scene had some art elements to it." I figured it was okay to say this much, though I was trying to be as circumspect as possible, knowing that Steve would wince and Keller would kill me if they even knew I was discussing things this much.

"Well, you should probably add De Quincey to your reading list, in that case," Carol nodded to herself.

"Thomas De Quincey, the opium eater?"

"One and the same."

She pulled up the call numbers on her computer and scribbled them down for me on a note pad.

"His essay, *On Murder Considered as one of the Fine Arts,* is all about the argument that one can appreciate the aesthetics of a murder, given the attention to details a murderer presents."

"Wow. Yes, that sounds like something I should read."

Carol passed me the paper, and smile. "I hope I've given you something to start on. It's been fun talking shop again, as it were."

"Do you paint, Carol?"

"No," she shook her head, "I dabble occasionally with watercolour pencils when I'm on vacation, but I certainly don't transcend the level of applied doodling."

I thanked her again and went off through the stacks to see which of her suggestions I could find. After about half an hour of searching, I had a sizable number of books to haul home with

me. I looked for Carol when I was back on the second floor, checking out my books, but she must have gone on a break or have completed her shift for the day, because a rather sullen-looking younger woman was now manning the reference desk.

I thanked my lucky stars I had been in the right place at the right time to meet up with Carol Wright, popped my books into my backpack, and headed for the bus bays to grab a bus that would take me down Whyte Avenue. Walking in five short blocks from Whyte Avenue with a heavy backpack sounded a lot more appealing than trudging twelve long blocks along the river valley, no matter how nice the view was.

I was soon home, and once I had peeled out of my teaching togs, and back into some capri leggings and a T-shirt, I set out a roast to thaw before popping it into the oven with root vegetables. Only then did I unload my backpack onto the coffee table.

I had two books on the Symbolists, most particularly Redon and Gaugain, with Munch, Klimt, and Beardsley bringing up the rear. Symbolism apparently was a push against the literal representation of works, or what we'd call photorealism, and aimed for a purpose beyond capturing the vision itself. They moved back to the mythic, and looked into death and lurid sexuality as topics for their work, as well.

I also had a book on hidden messages in famous paintings, which I'd pulled for curiosity more than research. Another book Carol had suggested, *The Metaphoric Interpretation of Paintings*, might or might not be of use. And then, topping it off, a small red book with a gold embossed title, *On Murder Considered as one of the Fine Arts and other essays* by Thomas De Quincey.

I suspect it was his opium-eating essay that had turned me off De Quincey as an undergrad, where I had been introduced to him in a half-term course on Regency and Victorian Essayists. There was an archness to his writing about addiction, and I could feel it here, as well, in his overblown gentlemen's club discussion of murder.

I just about dropped my pen when I got to the third page of the essay, though. The main character at his murderers' appreciation club was known as Toad-in-the-Hole, supposedly for his gloomy attitude about modern life.

Toad in the hole. Could it be a total coincidence that the egg and toast picture which had been included in the beach bag at the murder scene? Was her white and yellow beach hat supposed to lead a viewer back to De Quincey and an aesthetic argument for murder?

Steve had once said that police officers understood that coincidences did happen, but that they hated them. So, he wasn't going to think it was a coincidence.

I sent Steve a text to call me as soon as he had a chance, but I had been so wrapped up in my reading that I hadn't realized the time. He texted me back saying he was in the elevator, and he walked in the door just as the oven buzzer signaled that dinner was ready.

It was all a bit garbled in my mind, and I didn't want to lose the thread, so I turned off the oven and made him sit down and listen to my findings.

His eyes got wider for a bit, and I wasn't sure whether that was amazement or disbelief, so I suggested he look through the

books and computer histories of his suspects for a copy of the De Quincey essay.

"That's amazing, Randy. And exactly what I was hoping you'd uncover with your research. I'll get on this first thing tomorrow. I might even see if the university library system will give up who may have checked it out in the last year or so."

"You'll end up with me on that list, then. I've got a copy sitting here on our coffee table."

"I think we can eliminate people who took it out after February of this year."

"I think eliminating people is what it is all about."

"Figure of speech."

"That's the thing. What we take as shorthand, symbols, figures of speech, someone out there is seeing as literal concepts. It's as if someone brand new to the codes of a culture, like an alien or a baby or a tourist, is coming in and reading them as utterly literal. Or someone very immersed in symbolism is playing with its potency."

"Can we narrow it down to not being a baby or an alien?"

"Okay, if we must. But I think you really need to look at the artists in this case: the teacher Diego, and the married sculptor guy. Both of them are visual artists. Hell, add in the ex-boyfriend, too. Maybe he got to Mexico somehow without our knowing it. All of them had an axe to grind with the victim, all of them play with symbols."

"And you still think this art installation was meant for a particular audience?"

"That I'm not sure about. Unless it was you and me."

"You think the killer knew we'd be there?"

"Not us personally. But Edmontonians on Reading Week break, yes. I think it may have been meant to ruin our vacation, to present us with a vision of foreign tourist, set out as attempting to approximate fitting in—hence the Frida allusions—but showing how little we do, how anachronistic we are when set apart from the rest, how invisible we become. Hell, I'm not sure what the message was meant to be, but I am certain it was supposed to convey something to us Canadians escaping our winters by invading sunny shores."

"You could be right. Listen, I'll take this to Iain and Keller, and see if we can get warrants to search for the De Quincey circulation history, and we'll see what we pull up, okay?

"Terrific."

"So can we eat dinner now?"

"You bet."

30

The next morning, Steve left me drinking coffee at the island, promising he'd let me know what the thought was on the symbolic angle. He kissed me on the forehead and was gone. And with him went my sense of being of value on the case. All in all, it seemed pretty small potatoes, especially given that it was I who had first seen the body.

I tidied up the rest of the books, suddenly tired of looking at anything that reminded me of Kristin laid out on the sand, and spent an hour organizing the shelves under the bathroom sinks, which was obviously an area that Steve had no use for, and which I liked tidy. Our tacit agreement seemed to be that if something bothered you enough, you should be the one to deal with it. So Steve washed up dishes sitting in the sink and vacuumed every morning of a day off, I dusted and organized shelves, and whoever got out of bed last made it.

We were getting the hang of this combining of our lives just fine. I only panicked every other month, and only for a minute or

two, about the finality of it all. Then I zipped my mind through a catalogue of my life without Steve, and bucked up again. With our schedules, we managed to get enough private moments for me to feed the introverted aspect of my personality. I hoped Steve felt that way, too. Did he ever feel as if I had just invaded his space, leaving him no down time without me draped over the arm of the chesterfield like some patchwork quilt? Most of the time I could quell these thoughts, but sometimes it haunted me. Would Steve ever get tired of having me around, and once I was so entwined into his life, what would that do to me?

Was this how murderers felt about people? Did they get tired of them? Not that I could ever imagine Steve as a murderer, but one of De Quincey's lines came to mind: "For, if once a man indulges himself in murder, very soon he comes to think little of robbing, and from robbing he comes next to drinking and Sabbath-breaking, and from that to incivility and procrastination. Once begin upon this downward path, you never know where you are to stop."

Could that have been the sort of impetus that led to Kristin's death? Did someone feel she was in the way, or intruding? Were they just tired of her and turned her into material for their next project, like the pile of odd parts in the corner of the studio?

Odd parts in the corner of the studio. That thought reminded me of the offhand offer Briar Nettles had made me to look around the fine arts studios. I knew that Steve and Iain had been all over there, questioning everyone who had known Kristin, but maybe I could find something that pointed to a more symbolic sensibility after all the reading I'd been doing.

Before the impulse died down, I had grabbed my backpack, phone and keys, scribbled a quick note for Steve to say I was heading to the university to check on things, and I was out the door.

I was immediately glad I had decided to get out. The air was warm and redolent of honeysuckle and early roses from the gardens I passed. I strode along purposefully, taking deep breaths and wondering why anyone ever considered going somewhere else than Edmonton in the summertime. In the winter, sure. The combination of cold, short days and icy roads and sidewalks, not to mention the fifteen extra minutes you needed to bundle up or disrobe any time you wanted to go somewhere, made it easy to see why so many retirees became "snowbirds" and headed south each November. But summer in Edmonton hinted at its approach with a hot week or two in May, made you deliriously happy in June, serene in July and somewhat guardedly nostalgic in August, as you saw the days begin to shorten.

I reached the Fine Arts Building with a short detour into Remedy to get an iced Kashmiri Chai to go, and was soon happily sipping the final dregs of it and looking for a waste receptacle in the foyer of a building I hadn't really set foot in since the summer I'd worked at the Centre for Ethnomusicology on the second floor. I was aiming for studios on the main and second floor, I figured, but I wasn't certain which. The Drama Department was on half of the third floor, with the Music Department housed in the other half. There was also a theatre on the main floor and some recording studios, so it wasn't tremendously clear where one aspect of the arts left off and another began.

The thought of that made me happy, but it didn't do much for my sense of direction at present. I decided to go with basic arithmetic and start with the first floor. I popped my empty cup into a waste bin and went through the double doors leading toward the south wing of the building.

I was immediately treated to the sound of whining machinery, and a sign pointing to Sculpture Studio A let me know I was on the right track. Huge twelve-foot-high doors toward the end of the hall were propped open; the sound was coming from beyond them. I crooked my head around the doorway to get the lay of the land before venturing in.

Large sculptures took up space in five or six areas of the vast room. Along the walls were work benches covered variously with power tools, buckets of paint, what looked like the entire grill of an old Chevy, and a collection of pop cans and used coffee cups. There was a boom box covered in paint plugged in and blaring something electronic, which seemed fitting.

Canvas sheeting covered one area, making a little Everest in the middle of the room. I still hadn't spotted a human in the area. I ventured in cautiously, feeling a bit timid since the invitation had been so offhand and long ago.

The machine noises I had heard from the hall weren't audible anymore. The only sound was from the boom box.

I passed a metal sculpture that undulated wavelike in one direction and formed jagged edges along the other. Another area was filled with welded pieces of bicycles and mixing machines.

I had thought the area extended along the south face of the building, but hadn't realized that it was an L-shaped room,

turning along the east edge, as well. From the windows, I could see the small courtyard amphitheatre between the Law Building and the Fine Arts Building. There was no one outside the windows on this lazy summer day.

In the far corner of that shorter wing of the room, I saw something familiar. A family of white figures, partially wrapped like mummies with gauze, partially hollowed out so you could see the chicken wire form underneath. They were grouped in that triangle that I had learned in my overview Art History class so long ago, was classical balance: one sitting, one leaning toward the seated figure, and the third on the ground looking up to the seated figure.

The bench near the figures was tidier than some I had passed. There were boxes of gauze, the sort you'd find in the first aid shelves of the drug store; huge bottles of white glue, a couple of old department store catalogues, an anatomy colouring book like the ones med students bought to learn all the body bits and bobs; and tons of photos and pictures taped to the wall behind the bench. There were several of a pretty young woman with a baby; a bunch of hand studies, gripping different objects; and two or three art cards—*American Gothic,* Alex Colville's *Binoculars* staring ahead, and Munch's *The Scream.*

I pulled out my camera to take a photo of the pictures on the wall. Munch's *Scream* had been in Kristin's beach bag. Of course, it was quite possible that it was just here coincidentally. A lot of people probably had a copy of *The Scream* up on their walls. I'd even had one on my bulletin board for ages, sent to me by my cousin, the symphony cellist. Of course, in that version, the

fellow behind the screamer was obviously playing the banjo—a comment from him to me on my choice of musical instrument.

Anything and everything might be of interest to Steve, though, especially because I was pretty sure this corner belonged to Austin Stauffer, who had been featured in the same art show as Kristin Perry in the student gallery on 124th Street.

"Can I help you?"

I jumped. While I had been focusing on the pictures on the wall, the noisy music had run its course, and the silence was profound, except for the echo of the question just asked.

The fellow not quite four feet away from me didn't look exactly belligerent, but he didn't look all that friendly, either. He was about the same height as me, but his arms were ropy and muscular, and I had a feeling that if it came to physical combat, I wouldn't have a chance. I also had a feeling I had seen him before.

"Is this your space?" I asked, rather inanely.

"Yep. And you are?"

"My name is Randy Craig. I had an invitation from Professor Nettles to look around the studio, and thought I would take her up on it."

He seemed to take his level of antagonism down a notch or two at the mention of Professor Nettles. Here was someone who had been questioned recently by the police, after all. He probably had not enjoyed talking with Iain and Steve, and I was getting the brunt of that.

"Are you a sculptor?"

"Not at all. I'm an English lecturer over at Grant MacEwan."

"And why do you want to know about art studios? Are you teaching some story on artists?"

"Have you read *My Name is Asher Lev*?" I asked, happy to be offered this alibi, and proffering the first art-focused title that sprang to mind. "I would like to see how much art students today might identify with that novel, which I found quite profound when I was in university."

He shook his head.

"Never heard of it."

"I think I've seen your work displayed in a gallery on 124th Street, haven't I?" I asked, aiming to change the subject and with any luck get out of the corner I'd hemmed myself into, literally and figuratively.

"Last term? Yes, we had a student show at Abernathy's. You saw that? What did you think of it?"

"The juxtaposition of the reality of the hearts and other organs, in the hands of what were so obviously mannequins, really stuck with me. It made me think of questions of what makes us human or real."

The sun broke out on his face as he smiled, and I could see why Kristin Perry could have considered having an affair with this man.

"That's exactly what I was going for. You've got a keen eye. Maybe it's because you look for symbols in literature so you're tuned to looking for them in art?"

"Maybe. When you think about symbols in art, though, do you use them the same way as they are used in literature, to magnify a concept that is being played out in the actions of the

plot? Or do you use them as a code for special viewers only, like in the Reformation or other times of upheaval?"

I was trying to ease my way closer to the window so that I could stroll past the bulk of Austin Stauffer without seeming to be running away.

"For instance," I said, pointing to the jagged to smooth metal statue back toward the larger part of the room, "is that combination of harsh angles and smooth sine waves symbolic of warring elements in the same psyche? Or is it meant to indicate an argument between two people? Or is it a vision of youth to old age? Or is it supposed to mean anything beyond angle and wave?"

"Symbols cover a lot of ground, artistically," Austin replied. I think you need to talk to an art historian rather than a working artist to really get a bead on things. Sometimes it isn't until a critic begins to write about a work, or a curator assembles an exhibit, that elements of a piece start to be understood."

We were now walking together back toward the doors of the studio, and I wasn't sure whether I was escaping or being herded. Whatever the case, I was relieved.

"So a work of art can't exist on its own, out of an external context. Is that what you're saying?"

"There will always be references and predictions, sure."

"And do you find yourself influenced by other art you see?"

"What do you mean?"

"Well, say your trip to Mexico. Did seeing all the indigenous art, or the revolutionary paintings, or murals, influence your present work? There is so much talk of appropriation these days.

It makes me wonder if somehow we're ignoring just how much we're influenced by the world around us and our experiences."

"My trip to Mexico?"

The belligerence in his voice was back. I stumbled over my next few words, trying to recover equilibrium.

"Yes, didn't you say you had been to Mexico?"

"I don't think I mentioned it, no."

"Ha, maybe it's just that having been recently myself, I think everyone must have gone to Mexico! I'm sorry. That must have been confusing for you."

"Actually, we were in Mexico recently, my wife and I. During Reading Week."

"That's when I was there, too. On my honeymoon," I said, flashing my ring at him in some odd Victorian throwback, as if I was going to drop my handkerchief, or get him to kiss my hand.

"Congratulations. Or do you not say that to women? I forget the convention."

"I'll take it. I feel pretty lucky."

"Anyhow, your question about appropriation is an interesting one. And I'm betting there isn't an artist or writer out there who isn't thinking about it these days with so many issues in the news. We did see a lot of art in Mexico, and I liked some of the more stylized paintings, but the sculpture didn't do all that much for me, except for the older ones on the Malecon over in Puerto Vallarta. I really dug those little nuns on the ladder."

"Oh, so did I. The Sergio Bustamante ones. I went to his gallery, too."

"We lost a fellow art student down there, you know. She was

killed on the beach." Stauffer seemed like he was baiting me, trying to determine just how much I knew. Or maybe it was my guilty conscience making me think that. I figured I'd better stay on the right side of the truth.

"Yes, I did know that."

"Is that why you're here poking around? Are you with the police? They questioned me when we got home."

"I'm not with the police. Just sad and curious, I guess. I think I saw her."

"Kristin? Where? Was she with someone? Did she look scared?"

His concern was obvious. Whether or not they really had been intimate while he and his wife were taking a break, Austin Stauffer had obviously cared for Kristin. I wondered if he was a good enough actor to put on this sort of show for me. I didn't think so, but I wasn't going to bet my life on it.

"The police think she had already been dead some hours before I spotted her. I just thought she was sun tanning."

"You saw her body?"

"Yes. I'm sorry." I suddenly heard myself from his point of view, how callous it must sound to be speaking of his friend as a corpse, not a person.

"That's my only connection to the police. I promise."

He slumped a bit, but then seemed to realize I was still standing there. I figured I had better make my goodbyes before I got into anything stickier about why I was there asking questions.

"Well, thank you again for the discussion. This has been very interesting."

"No problem." Although he regained an approximation of his friendly guise, which had appeared when I had seemed to get his work, I had a sense that it was a mask, and that I hadn't yet seen the real face of Austin Stauffer. I did feel for sure, though, that I was really not welcome in that studio.

No problem for me. As I exited through the high studio doors, I felt as if I had somehow escaped something I didn't want to name.

31

The painting studios were on the second floor, and there was far more activity happening there. I explained to one of the first young women I met that I was there at the invitation of Professor Briar Nettles and there didn't seem to be any problem with me wandering through a similarly laid out room, though it was broken into much more segmented areas.

There was a wall midway on which hung myriad canvases of all sizes, painted by a variety of hands. I wandered near to it, to examine them. There were a couple that looked familiar, and I noted with a frisson of excitement that the initials K.P. were painted in white in the right lower corner. These had to be Kristin's work.

I wondered how much more of her student work was in this building, and how much was still with her roommates, Andrea and Jeannie. And, I wondered, had Steve and Iain catalogued it all? And who would be the ultimate owner of her work? Did artwork automatically increase in value when the artist died,

even if it was a student artist? Or did the artist have to slice off an ear first?

All the painters I saw around me had both their ears. In fact, some of them were sporting interesting earrings or extended holes in their ears. To them, anything was a canvas, I guess.

I took a couple of covert shots of Kristin's paintings, and then headed out of the studio. It was almost one o'clock, and while Denise might still be on campus, it felt like a long way down HUB through to the Humanities building when I could head home through the Law Building pedway and the student housing village.

As I walked the quiet corridors, past the musicology centre and through the double doors to the Law Building, the back of my neck began to prickle, and I got the sense that someone was watching or following me. I couldn't hear anyone else's footsteps. I couldn't even really hear my own footsteps, since I was wearing rubber-soled shoes.

I decided to pick up the pace a bit, so I could get to where other people might be around. There was no one in the halls of Law, nor in the first block of housing for students, though why there should be on a summer afternoon, I wasn't sure. The university did seem to settle into a somnolence that I usually found reinvigorating, but at the moment found quite eerie.

Walking down the middle of the student housing with hundreds of windows looking out at me, I couldn't stop and turn around to see if there really was someone. It was the middle of the day. I would look like an idiot if there really was someone there, innocuously walking in the same direction I was. I was looking

right then left before crossing the street, because even if it was a one-way, cyclists in this city didn't seem to think traffic rules pertained to them, when a hand reached out and grabbed my elbow.

I screamed.

The hand pulled away sharply, and behind me Briar Nettles gave a startled little shout, too.

"Oh god, I'm sorry to have scared you. I was trying to get your attention without causing a scene." She laughed. "So that went well."

I laughed, too, still shaken and a little nervous. Even though we were out in the open, there was no one on the quiet street, and the heavy summer air made the trees feel even denser around us.

"I didn't want to call out to you while we were passing the student residences, because I know a lot of students live there and might recognize my voice, and I don't think either of us want that much focus on us at the moment."

She did have a distinctive voice, though I wasn't totally sure what she meant by 'focus.'

"Are a lot of art students in residence here?" For some reason, I had sort of assumed they'd be doubled up in basement suites, saving money for Gauloises and canvases. They were probably all spending their allowances on gym memberships.

"Quite a few. The proximity to the studio from here attracts them, and the high windows allows for good sketching at home. I know of at least three who are in that building alone." She pointed to the complex of student apartments next to the historic Emily Murphy house a few doors from where we stood.

"Sorry I screamed. I was sort of caught up in my own head." That wasn't true, but I couldn't admit that I was scared that someone was following me and I hadn't turned to confront them.

"Isn't that the curse of the artist and academic?" Briar laughed. "We walk through life seeing other worlds."

I had the feeling she was quoting someone I was supposed to know. I just nodded and smiled, trying to fake my way through this awkward conversation.

"I heard you were talking with Austin just now. I ran into him in the hallway just after, and he mentioned it. Then I caught sight of you in the foyer on the second floor as I was about to unlock my office door, so I thought I would catch you up and touch base. You have a very long stride."

I looked down at her petite feet in their high-wedged shoes, and considered that there was more weight to this conversation than Briar Nettles was willing to admit.

"The police are going to be back, aren't they? Talking to all the students, taking up studio time?"

"A girl was killed," I said. "These things happen until they have all the answers they need."

"But she was killed in Mexico. Surely that all has nothing to do with us here."

"Several people she knew were there at the same time, along with their significant others. And she was killed with art motifs in mind, albeit a few of them seemingly Mexican. Why would a Mexican national pick her out of thousands to coincidentally create a still life on the sand? It only makes

sense if it was someone from here who followed her down, or lured her down."

"Lured her? You think she took the trip to meet up with someone in order to be killed?"

"Not to be killed, but to connect, sure. Or even to create an art installation. What if she didn't realize she was going to be killed? What if she thought she was participating in something like when Tilda Swinton slept in the art gallery?" I was getting excited with this train of thought. I wanted to get away from Briar Nettles and text Steve.

Briar Nettles looked startled. The idea had bizarre merit with her, too, I could tell.

"Or maybe it was her idea, but someone took control of the situation?" she pondered.

"Whatever the case, it all keeps pointing back to art, and, unfortunately, to your department."

"I can see that now." She shrugged, and held out her hand to shake. "I'm sorry to have startled you again. Let me know what I can do to help. This can't be allowed to be forgotten."

I watched her turn and walk back toward the university buildings.

32

Steve was interested in my talk with Austin Stauffer but still reamed me out for going into a situation like that alone.

"There is a murderer out there, you know. One of the people you flit around talking to is going to decide that shutting you up might be healthier for them."

"But he wouldn't have talked to one of you in uniform like he talked to me."

"True, but we're not that much further ahead, except that we know he still seems to have carried a torch for Kristin."

"And there's the whole idea of murder as art installation, that Kristin was complicit in. I wouldn't have got there without talking to him and Briar."

"That sounded like a weird conversation for sure. Why would she follow you so far out of her way to talk to you? Why wouldn't she want to be seen talking to you?"

"Do you suspect her? I don't think she was even in Mexico."

"As far as we know. She may have another name and passport.

Janice MacDonald

This might be her artist's pseudonym. After all, it's like it came out of a fairytale, right? It's not like it even sounds like a real name."

He made a note to ask Iain to check the plane manifests for Briar and any name that sounded like it might connect.

"If I was creating a pseudonym, it would be nothing like my real name."

"And that is how you'd be caught out. Good criminals know to make their names similar enough that they will respond naturally when someone calls out. The initials will be the same, or the beginning of the name will sound the same. You, for instance, could be Rachel or Rhonda. Rhonda Carmichael, international spy. I could be Sean Bean or Simon Le Bon."

"I think those are already taken. Or do you think it would cement the name in peoples' minds if you were constantly saying, No, I'm the other Duran."

Steve laughed and reached over to tickle me. By this time we were lying side by side in bed, mostly staring at the ceiling, but holding hands.

"I see what you mean, Simon. But how are we going to prove that some Brittany Nickerson who went to Puerto Vallarta is really our Briar Nettles?"

"Good old policework, that's how. You pull the manifest, you see if it was a charter, and work backward to the ticket to find out if there was a connection to a particular hotel. Then we send one of Roberto's men over to the hotel with a photograph."

"That seems like a lot of work."

"Police work is a lot of work. That's why in England they refer

to cops as plods, I think. One step in front of the other. If you don't arrive at the crime scene and find the perpetrator standing there with a slick knife over the body, then you know it's going to be a long haul."

"It's that whole twenty-four hours thing, isn't it?"

"You mean, if we haven't arrested someone by then, then it will be unsolved forever? That's not quite accurate, as you may notice from statistics."

"But that first amount of time indicates that it is a slamdunk, obvious crime, and you can tell immediately who the killer is."

"That's about right, I guess."

"And it's been months since our honeymoon."

"Are you saying the honeymoon is over?" Steve's mock pain made me laugh. "Don't worry, Randy. We'll catch whoever did this. The odds are in our favour. The number of Edmontonians who had a connection to her who were in Mexico at the same time is not an infinite number. We just have to make a case for the right one."

"Well, that sounds simple when you say it like that."

Steve yawned, and it made me yawn. I checked the alarm clock to realize it was past eleven. I had to teach the next day, and of course, Steve had to keep Edmonton safe and free. I reached over to turn off my sidelight, and Steve did the same on his side of the bed.

"I mean it, though, Randy. Someone out there doesn't want you showing up and nosing about. Please promise you'll be careful."

"Of course I will. Don't worry."

I rolled over, thinking he didn't need to know about my plans, which would likely come to nothing. Maybe I would tell him in the morning, or maybe not. There was time enough to talk about it if something panned out.

We woke at the same time the next morning, and I padded out to put the coffee on while Steve had the first shower. By the time we were clean, dressed, and fed, it was time for Steve to leave for work. I kissed him and handed him his lunch bag, feeling like someone posing for a Norman Rockwell painting. This buying into the monogamous, matrimonial hegemony was so easy to do, given that so much of our culture reflected it back at us. It was more of a wonder that I had known how to be a single woman operating on my own for so long. After all, there was only so much tossing of one's beret, à la Mary Tyler Moore, that one could fit into one's daily routine.

I packed my own tiny tin of tuna, crackers, celery sticks, and an apple, and was soon out the door myself, on my way to the little-university-that-could across the river. MacEwan University had expanded its downtown campus, but divested itself of its satellite campuses in the west end and out in Mill Woods. I was impressed with its growth, and more than happy to teach there. I had finally realized that I was never going to be offered a fulltime job at any of the universities or colleges in town, and had acclimatized myself to being grateful for work at all. Sessional friends I knew were having courses dropped at the last minute here and there, while the institutions scrambled to fill classrooms to the max and focused only on profit.

Everything was a business. Once you got your mind wrapped

around that concept, living in the western world became easier to navigate. Not easier to bear, but at least you understood the game.

Thinking about business made me think about money, which brought me back to thinking about my plan. I almost forgot to change trains at Churchill station, but popped off just in time not to be driven all the way to the northeast end of town when I wanted to swerve west of downtown to MacEwan station.

As I waited at the station, I noticed signs pointing to the Art Gallery of Alberta, situated just above the station, across from City Hall. I hadn't been there in ages, which was a shame since I had fallen hard for the new building, which seemed to be made out of one long ribbon of chrome, all swirled about. Now it seemed you could enter the building at the basement level from the LRT station.

Edmonton really was thinking like a bigtime winter city should. Major attractions were all connected by pedways or underpasses and now there were LRT links to three of the institutions of higher learning as well as two hospitals, three malls, a library, the art gallery, and the new museum.

Making a vow to come back and tour the art gallery soon, I popped onto my train for the short but ponderously slow ride to MacEwan Station. I wondered when they were going to finally get the bugs out of that route.

Diego Rivers was nowhere to be seen at the MacEwan Station, but he might as well have been there. His mural was finished, and full of eyes looking at those of us looking back from the platform. Tourists, old time Edmontonians in gaudy

Klondike gear, including a darkhaired Klondike Kate, a blond Shumka dancing couple, a trapper, the old town crier who used to wander Jasper Avenue, former alderman Michael Phair in his cool glasses and pink hat, our very tall mayor wearing the beaver-pelted chain of office, and various people I didn't recognize were all part of the crowd at the centre of the mural, gazing in all directions at the sites posted along the edges of the painting. Some of them seemed to be looking at us, too, implying that we regular Edmontonians were tourist attractions, as well?

I stood with people streaming around me, impressed as all get out by Rivers' vision and talent. This huge mural was as intimate a work of art as my *Sunflowers* photo print by John Wright, and yet it was more than a dozen feet high and even wider. No wonder Kristin had been taken with this man. It was one thing to talk a good line, but to be able to deliver this sort of a punch made me think the man was a visionary.

Briar Nettles had been dismissive of Rivers' talent and hold on the younger students. I wonder if she'd been jealous? Or maybe she too had been attracted to the artist-in-residence, and found that attraction annoying in spite of herself? Or perhaps she'd been rebuffed? The man Steve and I had met on the food tour had seemed nice enough, and completely devoted to his wife, almost to the exclusion of the rest of us on the tour. In fact, the face of the Klondike Kate—the most glamorous woman in the mural—resembled his wife, Alessandra, now that I thought of it. Had he been like that at his first meeting with Briar, and made her feel rejected? That could certainly account for her sneering attitude.

Or maybe it was just that my appreciation for art wasn't as high-toned as hers. The way I saw it, this mural was everything public art should be: bright and engaging, provocative, well articulated, and beautifully crafted. If I were on the Works board, I'd be looking for a way to make this a permanent installation somewhere.

I took a couple of pictures of the mural for Steve's collection, thinking it would make a good short stop motion film if I strung them all together for him. I could give that Cole Vandermeer a run for his money with his stop action art.

My second class of *Much Ado* was more successful than I could have hoped. There was some real pushback against the Prince's idea of tricking Beatrice and Benedick into falling in love from a couple of students, and they made the leap of comparing it to Don John's tricking of Claudio into thinking he wasn't in love with Hero.

"So royalty plays with the peons for their amusement, and you just have to hope you have a good Prince and not a bad one. Is that what Shakespeare was saying?"

"If that is what he was saying, why didn't he just come right out and say it?" asked another student, who was obviously firmly in the camp of not enjoying anything written in metre.

"What do you think would have happened to Shakespeare if he were to come right out and say such a thing?"

"He'd have his head chopped off!" one of them called out, a little too joyously for my taste.

"They weren't still chopping peoples' heads off by then."

"Actually, they were," announced a fellow proffering his

smartphone as proof. "The last person was beheaded in England in 1747."

"And *Much Ado* was written when?" I asked, trying to regain control of the discussion.

"1600!" chorused out several of those students far more comfortable with the recitation of facts and figures from other classes. I tried to give them a few of these dates and formulae in the way of important quotations to hang on to and make them comfortable in this world of symbols, and motifs, and unreliable narrators.

"Right. So we have a play that purports to be a comedy along the lines of *A Midsummer Night's Dream*, where unlikely lovers meet, overhear things and change their determinations as a result, overlaid with the makings of a tragedy, where a malicious prince decides to ruin a woman's life on the grounds that he feels slighted by the man she agreed to marry."

"No one seems to take her situation very seriously, do they?" asked one of the quieter young women who sat along the back row of the class. "They just want her name cleared for her father's sake and for her to be married off, to the same fellow who blew hot and cold the week before."

"And there would be the kernel of a great term paper, on whether or not you can claim Shakespeare as a feminist." There were groans, but their trigger word seemed to be term paper, not feminist, so I still had hopes for these kids.

"Next week, we have your late mid-term exam. Remember, you are being examined on whether you have read and understood the materials assigned, what you have taken from the class

lectures and discussions, and what you might extrapolate from what you've learned. It's only worth ten per cent, the same as your first essay, but in a way, the midterm is a dress rehearsal for the final exam, so you'll be prepared for the sort of exam I set. Read over your notes and pay attention to what we focused on in class from the words we read. You may see a poem you've never seen before, but you'll be asked to discuss it in the way we dealt with other poems in class."

Some of the class looked stricken, though most of them had been attending every lecture. Spring session classes were like that; you made the commitment to screw up your summer, so you took it seriously. I tried to lighten the mood a little. I usually slated the midterm later into the session, in the same way I tried to fit it into mid-January in regular full term courses, so they'd have a chance to write two papers prior to sitting an exam. I truly only used the midterm as a test-run for the final, so they could rehearse for the exam that would make up 30 per cent of their mark.

"I have no doubt you'll do fine. The class discussions have been really on point in this class, and I can tell you've been keeping up with the reading. My advice is just to review what we've covered, because we've covered a lot already."

A few students stuck around to ask questions about the exam, and another few continued the *Much Ado* conversation, mostly to vent about how much they detested Claudio. I shook them all off after about twenty minutes and made my way up to the English office to see if there was any physical mail for me. Most things came electronically these days, but I liked to check mostly because it made me look like less of a slacker to have an

empty mailbox than one stuffed full of junkmail from publishers' reps and college-wide flyers.

I ran into Valerie, who wasn't teaching this spring, but was training for a marathon and had decided to include the campus in her practice run. She had popped in for water and to find out if the bookstore had ordered her novels for the summer course she was teaching.

We walked down the wide stairs together, me feeling slightly overdressed in comparison to her singlet and shorts, under which she was wearing tighter bike shorts.

"How is married life treating you?" she grinned.

"So far, so great. We've settled into a routine of sorts and we've bought enough things together to make his place feel like ours now." I told her about my parents' gift of art money, and she nodded approvingly.

"That's so clever. Those joint decisions are the building blocks of a good marriage."

"Maybe that's what I should have told my students earlier, when we were discussing the marriages in *Much Ado About Nothing*."

"I don't think I would ever trust marriage advice from someone who willed his wife his 'second-best bed,'" laughed Valerie. "And now, I'm off. I have to make the last ten kilometers in less than fifty minutes. See you next term!"

Val jogged past some students blocking the sidewalk, stretched out, and began to run as she crossed 104th Avenue with the lights. She would probably make it to the southside before I did.

That was okay. I couldn't afford to work up a sweat. I was about to become a patron of the arts, and I needed to look both rich and arty. And the rich don't sweat.

33

I had done a check of all the A. McManuses in the directory, and finally found the one that corresponded with K. Perry's address. My sense was that a call ahead would net me nothing; Kristin's roommate had probably learned how to say 'no' on the phone after dealing with reporters for the last four months. But if I were to show up, and spin enough of a good story to see some of Kristin's art, maybe I could find out who was holding on to most of her work, and whether or not it had all gone home to her family.

The girls hadn't lived in the block of attached townhouses Briar Nettles had claimed were full of art students. Instead, they were a few blocks east, in a small walk-up apartment in Old Strathcona. I rang the bell at the front door, and when a metallic "Yes?" sounded, I asked for Andrea McManus.

"Who is it?"

"My name is Randy Craig, and I'm an art collector," I said, which wasn't entirely untrue, given that we'd just bought four pieces of art in the last three months.

There was a long pause, and then the voice said, "It's 402." The buzzer rang, and the door lock clicked. I pulled the door quickly and stepped inside the apartment building. There was no air-conditioning in this building, like most of the three-storey walk-ups in the neighbourhood. The air smelled of various cooking odors, none of them unpleasant.

I walked up the rubber-covered stairs in a front stairwell that was open glass on one side, and a series of fire doors at each level on the other. The basement level must have been the 100s, because 402 was on the top floor. I stood at the top of the stairs to catch my breath, hoping my art collector persona was still intact.

I pressed a button in the middle of the door of 402, creating an immediate buzz. Andrea must have been waiting for me, because the door was opened almost before I could pull my finger away.

"Are you thinking that Kristin's art is going to be worth something because she was murdered? Because I think that's ghoulish."

I held up my hand to ward off what seemed to be a pre-planned diatribe.

"No, Ms. McManus, my interest in Kristin's works is to see what sort of influences were at play in her most recent paintings. I'm working from a hypothesis that all artists are swayed in some way by what is important to them at the moment they are painting, and I would like to understand that in terms of her work."

She wasn't buying my line. Frankly, I was not sure I was, either.

"Are you some sort of reporter, doing a true crime piece?" I shook my head forcefully, both because I was telling the truth and because I could see that an affirmative answer was going to have her pushing me back through the portal. Andrea McManus had some strong opinions.

"Okay, then, are you working for the police?"

"I did some research for them in terms of this case, which is mainly how I heard about her, and saw some of her work. But I'm not here on behalf of the police, I promise you. I am here to purchase art if it is yours to sell, nothing more."

This somehow seemed to calm her down.

"Kristin's parents did leave some of her work here. I don't think they liked her more recent stuff, and it's not like they have that much room to hang all her student work. Her mom told me to let her classmates use whatever canvases they could salvage, and to deal with the rest for them." Andrea shook her head, sadly. "As if anyone would touch her stuff, but I'm not sure where we can keep all of it."

"May I have a look?"

"Yeah, sure. It's still in her room. We've cleaned a bit up, since we have to rent out the room soon to make this place feasible for us, but we haven't put up an ad yet. Kristin had paid up till the end of June, anyhow, and her parents didn't seem to care about that."

Andrea walked me down a long dark hall. One door was open, leading into a cheerful room full of bookcases, a daybed with drawers and colourful pillows, and a hanging skeleton with a feather boa around its neck. On one wall hung a cheery portrait of a smiling girl with dark, straight hair.

"That's Jeannie's room. She's in med school," Andrea said, obviously contextualizing the skeleton for the visitor in a practised manner. "She is actually in class all through the summer, so I almost never see her except around dinner time.

"And here's Kristin's room," she said, opening the one closed door in the hallway. There was a slight mustiness that was mixed with linseed oil. I didn't think that door had been opened all that much since they'd got back from Mexico.

Kristin had also lived with her work surrounding her. She had a double-sized mattress and box spring on the floor in the corner of the room. There was an Indian cotton spread over the mattresses, but it looked as if the bed had been stripped beneath. The louvred doors to the closet were opened, and there were only hangers where there should have been Kristin's wardrobe.

A dresser sat inside one side of the closet, leaving the rest of the room clear to contain a standing easel and a worktable, on which once must have sat all of her paints and brushes. There were splotches of colour all over the top of the worktable, but it was clean otherwise. Likewise, there was nothing on the easel.

Along one wall, though, canvases were stacked, about four rows of them and some of them at least six or seven canvases deep.

"We've cleaned up the rest, after her mom came and packed up her clothes and paints, and I was asked to sell the easel on Kijiji for them," Andrea said from the doorway. "But we're still not sure what to do with the paintings. Would you like a chair to sit on while you go through them?"

I accepted her offer gratefully, and Andrea rolled in a desk

chair from her room that was further down the hallway. I thought, half-curious, that it would be interesting to see the personality described by her room, but mostly I was taken with the task at hand. I set my satchel onto the workstation and rolled myself up to the left stack of canvases.

The first one was a study of a hand against a blue background. The veins on top of the hand were beginning to pop, and one of the knuckles was much bigger than the others. This had to be a hand portrait of someone much older than Kristin herself.

There were a couple more body parts on solid background colours: a foot, pointed and arched on a red silky sheet; and a shoulder with a small tattoo of Saturn in front of a green curtain.

The next row of canvases seemed like more exercises. I counted two still lifes, and an interesting collection of poses on one canvas of the same model in what had to be a life class.

The third row had the canvases turned back to front, so I had to pull each one out and turn it, instead of flipping through them like vinyl records in a store bin. I immediately recognized the model for the first one I turned.

It was a portrait of Diego Rivers, looking more like the man I had briefly met in Mexico than the strutting artist I'd been watching at the mural site. I also realized he was the dark-haired man in the other painting of Kristin's I had seen in the gallery. Talk about personal and public personas; this version seemed far more civilized, private, and pleasant. Did he think that made him vulnerable? Or was painting something that required him to amp up his personality to eleven?

Whatever the case, Kristin had been privy to the man he

showed to his wife on their vacation. I wondered if that was the teacher they had all seen, or whether that was especially for outside the art world? I took a shot of the painting with my phone.

The next painting was of another young woman, who wasn't looking directly out of the painting, but off the side and down, as if she was reading a book propped on a table. I set it to the side and took a photo of it. Maybe Andrea would know who she was.

There was another painting of the three men that Kristin had entered in the art show on 124th Street. I could tell it wasn't the same, because they were all clothed this time. And this time, having met two of them, I could tell who the subjects were. Austin Stauffer's red hair was applied with a palette knife, making the curls tangible. Diego's cheekbones were almost a caricature, they were that sharp. And the blond man's eyes were visible this time, an intense blue, so that they were the only thing you looked at even though the rest of his face was fully realized. I wondered if this was Cole, the time-lapse photograph artist. Collars of shirts were roughed in, but melded into the rough background of the painting. Was Kristin trying to decide between the men in her life? Was this a class exercise? Was she recording a friendship between the three of them? Were they the only men in the studio to sketch as a studio in masculine form? Had they all come together to kill her?

I was getting fanciful now. Surely no one except Agatha Christie would take a group of people on a trip and make them all responsible for someone's death. I took a photo and went on. There were more paintings of fingers and toes, and then several

studies of plants. I took photos of them just in case the plants were somehow only found in Mexico, but I didn't think there was much to that.

The last row of paintings were self-portraits, for which Kristin seemed to have an affinity. Perhaps she, like Frida, had been drawing herself all her life, and knew her best subject inside out. She seemed to be concentrating on a different element of the portrait in each. One was focused on the hair, bringing several shades of blond and gold into play to make the texture of strands of hair read across the room. The second one had Kristin looking directly out at the viewer, as if she was checking out a new subject to paint. There was something a bit eerie about being judged by a dead woman. I moved quickly to the third where she was actually painting, sitting at the easel. I couldn't quite tell what it was she was painting, for her shoulder hid most of the canvas but a corner of red showed. I took a photo of this one and set it to the side.

I was taking a photo of the last portrait, Kristin looking into a mirror, with a sort of Colville sensibility to it, when Andrea came back into the room.

"Just coming into check on you, see if you needed anything."

"I was just about done, good timing." Andrea looked a bit askance at the mess I had made by setting some of the paintings out of their tidy rows.

"I was wondering if I could buy three of these paintings from you, for say seventy-five dollars a piece?" I could see Andrea adding things mentally.

"Double that, and I will wrap them up for you as well."

I had hoped to gauge Kristin's monthly share of the rent correctly and offer about half, to make Andrea feel she was negotiating for a better price. I had nailed it. For four hundred and fifty dollars, Andrea could squeak out another month without a roommate search, and the nearer she and Jeannie could get to September, the easier it would be to pull in a fellow student. I agreed, setting out the painting of the three men, the one of the young woman reading, and the one of Kristin painting. Andrea went down the hall to retrieve a roll of brown paper and some twine, and I obliged her by pushing her chair back down the hall the other way to her room.

Andrea was obviously a sports enthusiast. A hockey stick leaned in a corner of her bedroom, along with a lacrosse stick and a tennis racket. Her desk had a book hutch on it, containing texts on kinesiology and a portrait Kristin had painted of her that showed Andrea holding a medal up proudly, as if she'd just bitten it to prove it was made of gold.

I pushed the chair up to the desk, and turned back to the doorway. Over the bed hung a velvet sombrero, probably Andrea's only happy souvenir of their Reading Week trip. I wondered if she and Jeannie were getting any counseling. After all, if Kristin's death had made such an effect on me, who had never met her; what had it done to two girls on their own in a foreign country, being questioned by the police and harangued by parents back home for not being the one who died?

Or maybe they were well-adjusted enough, buoyed by that glorious egoism of youth to think it didn't really concern them, and had no lasting damage. How could anyone know what did

or didn't affect a person's psyche, until it twisted up so much inside that they acted out in unexpected and violent ways?

I met Andrea back in Kristin's room, who by that time had already wrapped one painting. I asked for her email address and made an e-transfer of $450, then called a cab to help me get my purchases home. Andrea helped me carry them down the stairs to the lobby, and stood with me to wait for the cab to arrive.

"I hope you picked these because you liked them, and not because you just thought these would be the best investment."

I shook my head.

"I never think of art as an investment. I have to want to look at it for the rest of my life, or at least a good portion of my life, or what's the point?"

Andrea seemed to agree, though as a sports-minded person, I wondered if she and Kristin had ever had that much in common. Perhaps it was the drive in their own field that made them understand each other, without having any real overlap in each other's interests.

"Were you friends?" I asked, impulsively.

Andrea took her time to answer, and I automatically liked her better for that.

"I didn't really get her to begin with, but we got along okay. She was a very good roommate, very fair, cleaned up after herself, stayed out of your business. But after a year or so we got into a rhythm, and even though she was sort of messed up in her personal life, she was always really professional with her studies and her painting, and you have to respect that."

"You mean messed up with men?"

Andrea nodded.

"She had a couple of flings with married men, and I had a hard time with that, and so did Jeannie, who comes from a very straight-laced family. We asked Kristin not to bring them here, and at first she laughed, but then she saw our point and agreed."

"Did you tell the police all that?"

"They didn't really ask what I thought of her. After all, we were all three on vacation together, I guess they just assumed we were all best friends."

"How did you come to be travelling together?"

"Kristin wanted to go to Puerto Vallarta for Reading Week, because she heard of some other people doing it, and that there was a good deal if we split the room three ways. Jeannie really needed to get out of her own head and take a break, and I figured what the hell. I had enough Christmas money and it seemed like the right thing to do, to go someplace warm for break, you know? Normally, I go skiing with friends, but this was going to be our last year together and I guess I saw it as a box to check in university experiences."

"So it was Kristin's idea?"

"It was all Kristin's idea. She had our tickets and hotel booked and two or three outings purchased before Jeannie or I had even googled PV. We just went along for the ride." Andrea smiled. "And she was right, it was a beautiful place, full of really nice people." Then her face crumpled. "Of course, that was before Kristin…"

I reached out to pat her arm, but just then my cab arrived and she used the diversion to shake herself back into shape. She

opened the door for me, and I lugged the three parcels out to the street. The cab driver was solicitous enough to flick open his trunk for me to place the paintings in, but he didn't get out of the car. I shut the trunk and turned to wave at Andrea McManus, but she had already gone inside and up the stairs. I got a glimpse through the front hall windows of the upper fire door closing.

I got into the back seat of the cab and gave him our address.

Steve and I really were becoming quite the art collectors.

34

I had the three paintings unwrapped and leaning against the coffee table before Steve got home, so that he could walk in and get the full impact of Kristin Perry's artistic vision. Or message. I wasn't sure which was supposed to be most prominent. I still wasn't sure whether art was supposed to be revving up the brain or cooling it down.

I had folded up the brown paper wrapping and wound up the twine, and put it all on a back shelf in the pantry. You never knew when you were going to need some good wrapping paper, and you never got paper bags at the grocery store anymore. This was probably the first sign that I was going to turn into my grandmother, who had lived through the Great Depression and could never bring herself to throw anything away.

To her credit, she had found a use for things, rather than just hoarding them away. Her garden had been full of odd but effective scarecrows made of old straws, bread clips, and shiny coffee can inner seals.

From what I had seen at the art studios yesterday, Grandma could have been a collagist if she'd lived today. Some of the junk piled up there wasn't anything she couldn't have found a use for.

I was in the bathroom when Steve got home, so I didn't see his face reacting to the paintings after all. What I did see was his back, tensed and still, as he stood in front of them.

"Where did you get these?"

"I bought them from her roommate, Andrea."

"You went to the apartment?"

"Yes."

"You do realize that Keller will tear a strip off me for this?"

"I didn't think it would be seen as interfering. Andrea understood that I was someone who felt an affinity for her because of having been there when she died, and that I was a collector of art in a small way, anyway."

"Did you tell her you were connected to the investigation at all?"

"I don't think so."

"Don't think or don't know?"

"I'm not sure why it matters."

"It matters because these are going to have to go into the station as evidence and I'm going to have to explain how I came to obtain them."

"Why? I just thought it would be a useful thing to know who she'd been painting."

"It's very useful. Do you know who that is?"

"It's Diego Rivers, and Austin, and, I think, Cole. The men in her life. And of course, the self-portrait is Kristin."

"Not them, the reading girl."

He was pointing to the one picture I'd bought because I'd actually been taken with it, not because I thought it would inform the case.

"No, I just liked that one. Are you saying you know who that is?"

"Yes. That's Marta Gainer, an art student from U of A, who just turned up dead this morning in the water park at West Edmonton Mall."

35

I sat abruptly, my eyes glued to the painting I'd been drawn to earlier in the day. Steve continued to talk.

"She was laid out in a similar fashion to Kristin, with the towel over one of their lounge chairs, the beach bag, the sun-hat, the art cards including the toad-in-the-hole fried egg. There wasn't any blood, probably because it would have dripped onto the sand painted floor and alerted someone. Some early morning mall walkers spotted her from the glass wall upstairs and called us. We got there before anyone had opened up the park and disarranged the scene. I'm not sure why no one had found her during the evening clean up the night before, but that place is run by teenagers and shift workers on minimum wage, so who knows."

"How did the mall walkers know she was dead?"

"What do you mean?"

"Well, the mall used to have statues of people all over the place. Remember the cop and the streetwalkers at the opening of their Bourbon Street wing?"

"These people walk the mall three times a week. If there had been a statue in the water park, they'd have seen it every time. This was new enough to catch their eye. Honestly, with the rest of the place empty, the crime scene really does stand out."

"How so?" I was feeling a sense of jealousy, that this was not a scene I could feel associated with, not having seen it myself, as I had Kristin.

"Her bathing suit was splattered in blood, not completely soaked. It looked like a striped white suit with odd splotchy bits on it. There were thumb tacks and tiny nails poked into the suit, though most of them hadn't really pierced the skin. They're not what killed her. That was a very thin knife right into the heart, which didn't bleed out so much as fill her chest cavity with blood. Coroner thinks it would have killed her almost instantly, but that she had been drugged pretty well beforehand, in any case. The crime scene folks are all over the place, checking for prints or signs of a skirmish in a dressing room. The murder didn't begin right out there on the beach; she was probably walked out there solicitously, as if she was feeling under the weather, and placed on the chair. We have someone going through all the mall cameras to see if they can plot the timeline.

"So, I guess Roberto and his boss are going to be happy to hear that the murderer really was imported."

"We can't rule out the possibility that someone came here from there to commit a similar crime, but it seems unlikely. The team is concentrating their efforts on everyone from Edmonton who knew Kristin from an art perspective and who were also in Vallarta. It's going to be all go from here on."

"Have I got you into trouble, buying this painting?"

Steve shook his head.

"You've probably saved us a step. We can now link Kristin to Marta. If we can figure out when and where this painting was made, we may be able to narrow the circle even more."

"So you're going to take it with you."

"I'm going to take them all. What can I wrap them in, do you think?"

"Don't worry, I have everything you need right here."

36

The news media was all over the murder of Marta Gainer, and were quick to make the connection between the two deaths. I learned from the CBC that Gainer was originally from a small town in BC, and that her family had not wanted her to pursue a career in the fine arts.

"It's not as if doing a BFA is going to automatically get you murdered," I muttered, turning off the radio.

"The odds are going down, though."

Denise was over at our place for coffee and danishes, which she had brought with her. Steve, of course, was out. I had seen very little of him in the days since Marta's body had been discovered.

I snorted with a gasp, that sort of laugh when you get startled into reacting to something politically incorrect. Denise shrugged.

"They take in, what, eighteen students a year? Twenty? And two of them are murdered in the space of a few months?

Compared to the larger intake and, of course, zero murders of students in other faculties."

"But is their enrollment the reason for their death?"

"Perhaps their enrollment is what put them in proximity to their killer," Denise mused. "That would make the faculty more dangerous, if it was harbouring a killer."

"And it likely is. But is it another student or a member of the faculty?"

"That's what Steve and the gang are looking at?"

"Well, it's not for me to say, and I'm not all that sure I know exactly where their investigation is aimed, but they took my paintings, all three of them, including the one of the three men in Kristin's life. My sense of things is that it's one of them. Everyone says she had relationships with each of them, and two of them are married, which made Kristin seem less favourable to her roommates, and perhaps some of the other female students in the fine arts stream. But if there is another victim, maybe she, too, was dallying with a married man."

"And don't forget that married men come with wives, who may be vengeful."

"But would the wives be aiming to make an artistic statement with the layout of the bodies?"

"They might, especially if they were artists themselves, or trying to pin it on other artists—like their ne'er-do-well husbands."

"And what do you make of the fact that Kristin had done a portrait of the latest victim, Marta? Should that mean something?"

"I would think that has less to do with precognition and more to do with availability of models. It costs a lot to get models to

pose for you, and if you have to produce 'x' number of portraits for an assignment, they probably spell each other off and pose for each other."

"That makes sense, but it still creeps me out a bit that hers was the portrait I was drawn to."

"Well, that I can make sense of for you, too. She was posed reading, and you related to the posture as an attractive one, because you validate and privilege reading. And speaking of reading, I think you're reading a lot more into this than you need to. The main facts are scary enough: there is a murderer targeting students in the Visual Arts stream of the BFA program. That should be enough to go on, don't you think?"

Denise was right. I was going off on crazy tangents. Thank goodness I wasn't leading the investigation. Steve was probably minutes away from discovering and arresting the killer.

"So, who was the unmarried man she was fooling around with?"

"His name is Cole Vandermeer. Why are you thinking about him more than the other two and their possibly vindictive wives?"

"For one thing, because there's only one of him, making him stand out. And for another thing, there might be more ego at stake if Kristin was breaking it off with him, than with the married guys. They might be breathing a sigh of relief, if they weren't planning on leaving their wives, you know? After all, if they were conducting a clandestine relationship; how long could it go on before someone who knew the wife recognized them together and told?"

"But if the married man was an instructor or another student, it would be perfectly natural to be seen together at work, or having coffee."

"But maybe not out for dinner or drinks, or posing for each other outside of class assignments." Denise shook her head. "No, the longer a tryst runs, the more capacity there is for it to blow up in everyone's face. And the married person always has more at stake than the unmarried liaison. Of course they would be saddened momentarily, but, more likely than not, also relieved. My money is on the lonely heart who was spurned."

"But do we know he was spurned? Maybe he did the spurning, after finding out that she was also dallying with the teacher, or another student?"

"Do we think she was playing them all at the same time?"

"They've run in the same circles for three years now, from the beginning of their second year of studies, when Diego Rivers came in as the artist-in-residence, through to this spring. There was plenty of time to date one after the other. It would be really interesting to know the order in which Kristin's love life unfolded, though, wouldn't it?"

"Who would know that?"

"Not the roommates. They put their foot down right away. Of course, they put their foot down because she was seeing a married man. So perhaps that was Rivers?"

"Why not Stauffer?"

"Because I think that marriage was a lesser-known fact. When I suggested that he was a boyfriend, Briar Nettles shut me down on that, as if she had insider information. If she thought she was

imparting a secret, would Kristin's roommates, or even Kristin have known right off that Austin was married?"

"Well, that sounds like an interesting string to pull on. Why was he keeping his marriage a secret?"

"He's not someone I'd want to ask. I got cornered by him when I was poking around in the sculpture studio and felt really intimidated. Not just by his size, but by his intensity."

"Maybe I could call up Briar and see what she knows about it," offered Denise.

"Do you think she would answer something that inquisitive?"

"Can't hurt to try, can it?" Denise was pulling out her smart-phone, and had soon logged into the faculty directory. Within minutes I was listening to a one-sided conversation between Denise and Briar Nettles.

"And the reason was housing? So how did that come out and was it settled in their favour?"

More listening on Denise's part ensued, with her nodding. Not for the first time did I wish they could make speakerphones less echoey and such a give-away. Finally, she thanked Briar, said good-bye and hung up.

"Austin Stauffer and his wife didn't indicate to the university that they were back together after their separation, it turns out, so that they could apply for housing closer to the university, over in that row they made for the Universiade Games way back. There are some two-bedroom units in there, and they use one as his studio. If they had flagged themselves as married students, they were worried that they would get housing allocated way over south of the University Farm, amid all sorts of families

with little kids. Apparently, Stauffer uses earphones to drown out the sound of humanity while he creates."

"I wonder how he drowns out the sound of welding going on in the sculpture studio?"

Denise shrugged.

"Briar says that someone in the housing complex ratted them out recently, though why it mattered I haven't the faintest idea. The wife is doing a part-time degree while working, so she is technically not a full-time student but they're paying their rent and not making loud noises. Some people just want to get up in people's lives for no good reason."

"Okay, so he was pretending to be single, or at least walking into school from a single-type direction. Maybe when Kristin hooked up with him, she truly didn't know he was married."

"He may have fed her a line. Or maybe she seduced him."

"And we now know that his wife was nearby, and could have been watching every move. So we're back to having a second possible murderer in that single student flat."

"Was Diego Rivers' wife around all the time?"

"I am sure Steve has nailed that down. Rivers moved here two years ago for the one-year artist-in-residence gig, but I think this year he's covering off for a another professor who is taking a sabbatical. His wife is certainly living in Edmonton now. I'm not sure how much she enjoys that," I added, thinking back to our brief meeting with them during the food tour in Mexico.

"But maybe she wasn't planning to join him for that first year, and only moved when it looked like he'd be here for a good long

while. Maybe she was back home, wherever that was, when he and Kristin had their fling."

"What is it with professor-student relationships, anyhow? You would think by now that they were pretty uniformly seen as verboten or at least icky. Why do people keep falling into them?"

"The university is such a secluded place, set apart from the rest of the world. It's as if no other rules apply, I think. Our year begins in September, not January. Our nine to five routines shift depending on what day of the week it is, and our years are dictated by which grad seminars we teach, or which prerequisite we're allowed to enroll in. When you make the world that different, it's no wonder people begin to consider regular human rules, such as not combining power relationships with personal relationships, as more nebulous. You can justify it somehow if the student isn't technically in your class that year, or if they're a mature student older than you, or if you are only the second reader on their thesis, or if they were the ones who came on to you. I've seen all sorts of justification, haven't you?"

"Yes, but it never quite holds water."

"I don't think so, either."

"Have you ever been tempted to have a relationship with a student?"

Denise laughed.

"Oh good lord, no. But of course, I'm teaching higher-level Shakespeare. It's not as if beautiful actors or muscular aggies are registering in my courses."

"Whereas, in the first-year courses, I see them all."

"And have you ever been taken with a student?"

Janice MacDonald

"No, though every now and then there is a very beautiful one I can't seem to take my eyes off when lecturing. Or," I suddenly remembered, "I get taken with a voice, and find myself asking him or her to read passages more often than the other students."

Denise laughed.

"You're blushing."

"Yeah, well, I got caught once. He was originally from Ireland, and the timbre of his baritone voice still held just a bit of a lilt. And he could sight read well. I remember turning to ask him to read a poem, and the class starting to giggle, and I realized how obvious I was being. So I had to start working my way through the roster very consciously. But oh, that voice."

Denise laughed.

"Does Steve know?"

"He probably knew before I did. Anyhow, that was several years ago. None of them can read well anymore."

Denise looked at her watch and checked it on the green digits on our microwave.

"Oh good god, I have to head out. There are two stacks of essays waiting for me, and I promised I'd go to the movies with Justin tonight."

Justin was Denise's new beau, an erudite co-owner of a gaming company who had attended one of her public lectures on Shakespeare's plotting devices, and pursued her relentlessly until she agreed to go out with them. They had discovered a ton of shared interests, and it looked as if Denise had finally met someone she could enjoy spending more than just a short relationship with. I wasn't holding my breath, but I did wish her

well, in the way I suppose all married people do for their single friends. There really is nothing like having someone to come home to who is totally invested in your happiness.

She packed up her things, we hugged at the door, and I stood in the doorway till the elevator doors opened and she was whisked out of sight.

37

Our discussion kindled my need to write lists, so after putting away all the coffee detritus, I made a pot of tea and hauled out a notepad.

I wrote the three men's names at the top of the page, and drew columns down from each of them.

Under Diego, I wrote, "When did wife arrive in Edmonton?" "Were Kristin and Marta in his first class?" "Who dated him first?"

Under Austin Stauffer, I wrote, "Single student housing," "Where did Marta live?" "Was Marta a sculptor?" and "Connection?"

And finally, under Cole Vandermeer, I wrote, "Who broke whose heart?"

I wasn't completely certain Steve, Iain, and the gang would be quite so invested in gossipy sorts of questions, but it wouldn't hurt to share them when Steve got home.

I flipped back a few pages in my notepad, looking over some of the notes I'd made about the Kahlo book Kristin and I had

both been reading. I wondered if Marta's beach bag had contained the same book, and if so, what that might mean. For one thing, it could mean that Kristin hadn't purchased the book, the killer had. And it might mean he or she had bought two at one time. Would that have been enough for a salesclerk in a tourist town to recall, especially this far along?

It was one thing not to have much information from Steve's investigation, but there was a complete blank from the Mexican end of things. I couldn't even know from a physical view whether or not the police were out measuring the beach or combing through the sand. For all I knew, they were just happy to write it off as a Canadian crime transported thoughtlessly to their vacation paradise. So much for polite Canadians.

Maybe we were thinking about this wrong. Were these really art installations, or where they deliberate murders meant to target an artist as the supposed perpetrator? Maybe someone was trying to frame one of the men on my list by creating these macabre set ups, complete with a real dead body?

And maybe I needed to back away from it completely. This was Steve's case, and it was a police matter, and it had nothing to do with me or my work. We had only intersected with the case because of our choice of honeymoon destination. As much as I'd loved our stay in Puerto Vallarta, part of me wished we'd gone to the Dominican Republic and missed the case altogether.

My pen was tapping on the notepad as I stared blindly at it, the words blurring in front of me. It was the tapping that brought me back into focus. I was tapping the Mexican Hat Dance, the dance that all little Canadian children learned in movement or

music class, where couples danced individually, and slowly, and then whirled together, with arms linked, presenting politely and then coming together to spin passionately. Was that the manner of relationship Kristin had had with any of these men?

Her relationship with Diego Rivers would have been clandestine, because both of them would have known of the strictures against such a connection. Even if there hadn't been a Mrs. Rivers, or I should say Ms. Delahaya, in the picture, Kristin would have known to sneak around. That was certainly the relationship that her roommates condemned.

The situation with Austin Stauffer was more problematic. Had Kristin known about his marital status? Did he play up the break he and his wife were taking as an actual split? Or was he snowing her along with the housing authority? When she did find out, was it she who had called it off? And were we certain the Stauffers had such a strong and steady marriage, anyhow?

And finally, was Cole Vandermeer somehow secretly in Mexico to follow Kristin, or win her back? Or had Kristin known Cole was going to Mexico, and it was she who was pursuing him?

Cole was the only man Kristin had been involved with who didn't have a marital encumbrance. I paused, thinking that was a pretty cold way for a newlywed to frame a marriage, and decided not to write it down in exactly those words, just in case Steve should interpret them as dismissive of the state of the union in my mind. This whole relationship wording was tricky, and I wasn't even the person getting murdered.

Maybe Cole had been dating Marta at the same time as he

was dating Kristin? That would certainly seem to make him more in keeping with the sort of man Kristin went with, supposing that she did know about Austin's marital status. So, if Cole was dating Marta and Kristin, did it stand to reason that he would be their killer? Or would he have seen how incriminating that would look, to date women only to kill them and arrange them in artistic tableaux? They were sophisticated layouts, so did it stand to reason that there was a sophisticated mind behind the work? A mind capable of working in a way so as not to incriminate its owner?

And of course, I was not adding in the women concerned.

What about Diego's wife, Alessandra Delahaya? In the same way that Diego overshadowed Frida until his death, maybe our muralist's wife was an artist in her own right, using his discarded playthings as her materials.

And what about Austin's wife the nurse, while she was doing her part-time degree? There was some knowledge of anatomy inherent in these killings, and both girls had been drugged. Was she at all artistically inclined? Or maybe forensically focused?

And were there others?

I startled at the noise of the fridge grinding on and looked up. The sky outside the window was looking orange as the sun was heading toward setting, indicating that we must be receiving smoke from some of the early BC wildfires.

I had spent most of the afternoon, after Denise had left, worrying over these lists and hadn't even considered what to make for supper. These days, with the Marta investigation on the boil, it was never a sure thing that Steve would make it home for

supper, so I'd been aiming at stews and casseroles, which could reheat nicely for leftovers.

I padded over to the pantry to see if we had any cans of mushroom soup, my ingredient of choice when creating a casserole, and pulled out a can of corn, and a tin of tuna along with the soup tin. I checked the freezer drawer for green beans, and I was soon in business. The casserole was in the oven within ten minutes, and required an hour.

Dessert would be simple, just berries. I got the plastic clamshell out of the fridge and washed and cored enough strawberries to fill two bowls, then sprinkled powdered stevia to melt over them.

I decided garlic bread would be nice with the casserole, so I whipped up some garlic butter and spread it on several pieces of sourdough rye I'd bought earlier in the week at the K & K. I wrapped them in tin foil and slid them into the oven beside the casserole dish.

Soon the kitchen was filled with the smell of garlic, which made me think that everyone in the building would be wanting to come eat with us. There was nothing like the smell of garlic to get my taste buds salivating.

The thought of garlic bread reminded me of an Italian restaurant that Steve and I used to frequent near campus, and made me want to get out the candlesticks again. I wondered whether any sociological studies had been done of how long into a marriage people put candles on the table. To be perverse, I set the counter island instead of the dining table. It wouldn't do to look too Stepford.

I tidied up my papers and moved my satchel closer to the door, keeping the list of things I wanted to ask Steve on top. I checked the clock. Fifteen minutes to casserole, and still no word from Steve. This really wasn't like him. Normally, he would text to let me know that it was going to be a late night.

I put a load of laundry in to wash, and cleaned the sink and mirror in the half bath by the kitchen. When the buzzer rang, I pulled the casserole and garlic bread out of the oven, and set them on top of the range to cool a bit.

Still no word from Steve. I wandered into the bedroom to check whether he had somehow left a voicemail on the landline without me hearing it ring through. There was no blinking light, meaning no message.

I peeled open the garlic bread to pull out a gooey piece, and doled myself out a generous spoonful of casserole. I might as well eat while it was hot and fresh.

I cleaned away my dirty dishes and put away the setting I'd laid out for Steve. No need to make him feel awkward about not phoning. I wiped the counter and put the casserole in the fridge once it had cooled off enough. I took my phone over to the living room side table where I had my charger laid out, and plugged it in, so I'd be certain not to miss a call.

I tried to watch TV, but I couldn't commit to anything on, and nothing appealed on our massive list of waiting-to-be-watched shows. I turned the television off and picked up a book from the coffee table. It was the Frida Kahlo book I'd bought on our honeymoon, the one I'd had to write up a synopsis of for the police case. I'd not looked at it since.

Where was Steve?

The phone rang just as I was in the bathroom, so I ran back to the living room pulling up my sweatpants as I went. Thank goodness our living room windows looked out onto the vast expanse of river valley, and not another set of high rise windows. Unless someone was watching us with a high powered telescope, my indiscretion would go unnoticed.

"Steve?" I barked into the phone.

"Sorry, Randy, I was hoping to talk to him, myself." It was Iain, Steve's partner. "Isn't he home? I figured he'd be there by now."

"When did you last see him?"

"About, well, about two hours ago, I guess." Iain must have been looking up at one of the huge wall clocks in the station. "We've been working a case pretty steady…"

"The Marta Gainer death?"

Iain paused. He hated the way Steve talked to me about his work. Iain made sure the ugly of the job never went home with him to Myra. I wasn't all that sure Myra appreciated it.

"Er, yes, that one. Anyhow, Steve apparently took a call, said he was headed for home, and left."

"He hasn't called here, and I didn't call him two hours ago." A thought hit me. Steve wouldn't have said "headed for home." That was my sort of phrasing, and it drove him crazy whenever I mentioned to him that I was "heading out" or "headed for the grocery store." The fact that he so often pointed out my dialectic tic would mean he certainly wouldn't be using it himself.

On the other hand, we had been playing with the whole "Mr.

and Mrs." and "home sweet home" phrasing. Maybe I'd been wearing him down with my turns of phrase.

"Iain, did he say that to you? That he was 'headed for home'?"

"No, as a matter of fact, he told one of the officers at the front desk. Why?"

"Because I don't think that is what he would have said. Could you go and find out what his exact words were?"

"Do you think it's important?"

"Well, he got a phone call and left and isn't home now. Yeah, I think it is important."

"Hold your horses, I'll be right back."

It was about three minutes, and a grimmer sounding Iain was back on the phone.

"You were right, Randy. The officer just extrapolated. When he said to Steve, 'So, are you calling it a night?' Steve had smiled when he replied and said 'Dave, I'm rounding third.'"

"Rounding third?"

"Yes, and now I'm worried."

"Why, Iain?"

"Because that is our code for getting to the answers, Steve and I; a series of baseball metaphors. You know, 'out on first' means you tried something that didn't pan out. And 'stealing a base' means you are flying close to breaking a rule, but just barely."

"And 'rounding third'?" I asked.

"Well, Dave got the gist of it, but he interpreted it wrong. When we say we're 'rounding third,' it means we're heading for a home run, a win, the answer. Steve wasn't heading for home. He was off to solve the case."

Steve had gone after a murderer on his own and he hadn't been heard from in two hours. Something wasn't right.

"Now Randy, don't panic. We'll find him. I'm going to find out where that last call came from and figure out where he might have gone. You stay put, you hear?"

But I was beyond hearing Iain's sound advice. I clicked off the phone and stared out into the greying summer sky. My husband had gone to meet a murderer. I knew it in my bones.

But who was it, and where?

38

My first instinct was to get dressed. If I had to go out and find Steve, I wasn't going to be of much use in sweatpants and bare feet.

I traded the sweatpants for a pair of jeans and pulled on a thick sweatshirt, socks, and running shoes. Even though we were nearing the solstice, the early June nights could dip and get chilly, and I knew from experience that when I was tense, I felt the cold even more than usual. I pulled my hair back into a ponytail out of my eyes, and splashed cold water on my face to try to clear my thoughts.

Back in the kitchen, I set out my notes to try to find some sort of order in the lists I had made.

We had two young women murdered and placed in a similar format: in a bathing suit, on a beach, alone with a book and a towel and a sun hat. There were art card connections. One had been murdered in Mexico, on Playa de los Muertos, and the other had been killed and laid out in the waterpark in West Edmonton Mall.

It struck me once more that the Mexican tourism board had to be pretty sure of themselves to keep a name like "beach of the dead" for one of the tourist hotspots. It certainly hadn't seemed to slow down the scores of visitors. I had been told that the beach was named that for the currents, meaning that should there have been an accident in the Bay of Banderas, which was second in size only to Hudson's Bay here in Canada, eventually the body would wash up at Playa de los Muertos. So, it wasn't as if it was Murder Beach—that is, until recently.

Why had the murders been staged on beaches? Because, of course, that is what the waterpark approximated up here in land-locked Edmonton. They even painted the wave pool area's floor blue, and the surrounding area where the lounge chairs were lined up sandy brown. The murderer had gone to a great deal of trouble to use a beach setting, especially in the crowds that would have been present at the mall.

Frida Kahlo had some paintings that depicted the sandy desert, but nothing that was really an ocean view. And besides, the paintings that resembled the murder scenes the most were both set outdoors on solid ground with a blue sky very far back on the horizon. So why the need for the seaside? Was it that connection to Edvard Munch, with *The Scream* art card in their beach bags? There was water in that painting.

And why continue with the Frida homage with a murder set in Canada? Why not turn to Emily Carr or the Group of Seven to find a layout more suitable? There was something connecting Frida Kahlo, the shore, and the Fine Arts Department of the University of Alberta.

And I had to find out what it was, because it was now connected to Steve. I could feel that he was in danger like a low-grade hum in my blood. I wondered if he had felt like this any time he had been rescuing me or if this connection had been created when we'd recited our vows in the glass pyramid of the Muttart Conservatory.

I walked back over to the glass doors, and out onto the balcony, straining my eyes in the twilight to look for the pyramids. I could see the tips of them, just down to the far right, gleaming amid the trees on our side of the river valley. We hadn't been back to them together since our wedding in January, but we'd been talking about it recently as the weather grew nicer, and we could have tacked a visit onto a picnic nearby.

And suddenly I knew where I needed to go to find Steve.

I grabbed my phone, a mini-flashlight that we kept in the storage room, and the car keys. West Edmonton Mall wasn't the only place to find waterfront in Edmonton.

Accidental Beach wasn't the easiest place to get to. It was a spit of sand on the south side of the river, near the Muttart pyramids and the dock for the riverboat, but slightly east. It had been a sandbar in the middle of the river, but these days, with the activity upstream building the new bridges, the current had shifted to allow the sand to extend all the way along the shore.

It had been a big hit last summer, with photos all over social media of the sandy expanse with sunbathers dotted all over and the downtown skyline in the background. Edmontonians are always quick to celebrate anything fun or unusual, and people had been tromping down behind some rather fancy condos to

play beach volleyball, suntan, and picnic all last summer, chasing away the Franklin's gulls who normally set up a colony there every June.

Only the hardiest went into the water, because the North Saskatchewan is a tricky river with some strong currents, and the E. coli warnings were still pretty stern, but it looked inviting burbling past.

The beach was still with us this summer and there had been murmurings in the news that City Council was thinking of making sure it was a constant. Steve and I had been meaning to check it out, but what with my spring session work and his big case, it had slipped our minds.

I drove down to Gold Bar as if I was going to the Folk Festival, and aimed for the easternmost street in the neighbourhood. There had been rough steps cut out of the incline behind the riverside condos on the other side of the thoroughfare at that end, which the *Edmonton Journal* had noted in one of their articles about the pros and cons of the site. I saw neighbourhood parking restrictions signs up everywhere, but I figured those were enforced mostly at festival times, and besides, a parking ticket was the least of my worries at the moment.

I locked the car and pocketed the keys. I didn't need the flashlight yet, with the streetlights and the sun still streaking the western sky, but it would disappear soon; and besides, there would be no streetlights on the beach itself.

I crossed the avenue and headed toward the river. I soon found the steps the news article had mentioned. I was glad I'd brought the flashlight to navigate my way down to the sand, but

turned it off to see how much I could see without announcing myself, and once my eyes reacclimatized, I was okay. In another half an hour or so, it would be a different story. Of course, I was hoping I would have found Steve by then. It wasn't that big of a beach.

I wasn't sure what I was going to do once I found him, or what sort of state I was going to find him in, or whether he would be alone, or if I'd be walking in on a killer, but I really didn't have the time or ability to think of those things. All my energy was channeled into picking my way along the edge of the beach, where it met the rougher outcropping of what was normally the river's edge, avoiding bits of driftwood, and maintaining my footing in the sand.

It was odd to feel such fine sand here in the middle of a land-locked province, but of course, at one time this had all been a huge primordial sea, and the source of all sand—the moraine stones and scree of the mountains—were all upstream, happily eroding and sending this pretty silt along to find its way to this turn in the river.

There was a large condo complex built right up to the river's edge in a marvel of flood denial, with just a narrow road and a thin line of trees between the condos and the beach, making whatever ambient light I might have got from undrawn, draped windows diffused and dimmed. Still, I could see the general layout. I was just hoping I didn't stumble across a grumpy hobo or some drug deal happening in the shadows.

I stopped for a minute, trying to get my bearings and figure out how far I had come. What I wanted to do more than

anything was call out for Steve, but something told me to keep my presence as unknown as possible. If I had anything going for us and my rescue attempt, it was sneaking up on whatever was happening. If there was anything happening.

Maybe this was all a wild goose chase, based on hunches.

Just then I saw a light flicker, about a hundred yards away, further down the beach.

39

I gripped the flashlight, which I might be able to use as a cosh, and stepped forward as quietly as I could. The flowing river was covering up whatever noises were happening up ahead where the light was flickering close to the sand, and I hoped it was masking my footsteps, too.

The closer I got, the harder it was not to shout. A figure was bent over another figure, putting on or pulling off a jacket. The second person looked drugged or drunk. Maybe it was two tramps, one stealing the other's jacket. Or maybe it was the murderer posing Steve before killing him. I didn't even want to think that he might already be dead.

There was no way a solitary killer could get a big guy like Steve down here already dead. He would have to have walked to the beach on his own. I was praying the killer needed him alive long enough to set the scene.

I should have been praying to be silent and invisible, because all of a sudden the figure holding the other one stood up,

dropping the other person to the sand. The lantern I'd seen flickering was held up to shoulder height, and a distinctive voice I'd heard before called out.

"I've got a gun. Drop whatever weapons you may have and walk forward slowly."

"I don't have any weapons, Alessandra." I stepped forward with my hands up in the air, having tucked the thin flashlight into my back pocket.

"Ah, the old bride! This is perfect, better than I could have hoped. Move over here into the light."

Alessandra Delahaya was standing over Steve, holding a gun on me. She had brightened the lantern, and the scene it showed was bizarre. Steve lay on the ground at her feet, alongside an open duffle bag filled with tools and fabric.

"You really are too tall, but we'll make do. I could cover your shins with sand, and set the shoes just over your knees."

"What are you doing, Alessandra?"

"What does it look like I'm doing? This is Frida and Diego's wedding scene. I was going to create a Frida out of sand and lay the wedding dress on top, to signify the emptiness of the sacrament, but now that I have a real bride, it will be even better."

"Did you kill Kristin and Marta because they'd been having affairs with your husband?"

"Affairs is too dignified a word to describe what was happening. Diego was rutting, and they were handy. He cared nothing for them, but he couldn't help himself, just like Frida's Diego, who always came back to her."

I didn't like the look in Alessandra's eye, but I figured it was

best to keep her talking, because that seemed to be keeping her from doing anything else, like stabbing.

"Does Diego know you've done this?"

"He may suspect. But he hasn't said anything. I think he is afraid to say anything. He likes it here, and it suits him to be the flamboyant visiting artist."

"But you want him to know, don't you? You want him to admit his guilt?"

"At first, I thought it might implicate him, to have his student found there, all laid out like an iconic Kahlo painting. As if taking a weeklong vacation to the seaside made her an acolyte of Frida. Such a simpleton, so easy to peel away from her friends with a mere suggestion of a shrine to Kahlo." Alessandra laughed, not a pretty laugh.

"It was my husband's fault. He went and taught that course, the one that ignited all those little whores to see themselves as a potential Frida to his Rivera." She waved her lantern around, and the light bounced off some nearby trees. I thought I heard Steve groan, but it could have been the river. I was hoping he was still alive, and that my stalling for time wasn't actually killing him. Had she poisoned him? Or stabbed him so he was bleeding internally? Or was he just anesthetized until she could set up her tableau?

"But they didn't hold him for questioning, or delay our trip back to Canada, and then the investigation was taking so long, and Diego had to dip his wick another time, so I thought I'd up the ante. Marta was very easy to lure out, and the drugs I got from my brother made it easy to manipulate her to the water

park chair without anyone the wiser. I even went for a swim while she lay there!"

Alessandra's laugh was not a pleasant thing to hear.

"And even then Diego said nothing, though the wedding painting should have reminded him of our vows and his misdeeds. And still your policeman didn't drag Diego away to answer for his crimes! What was he doing; was he still on his honeymoon? Is he not a very good detective?"

"Steve's a great detective," I couldn't help myself. "Processes have to be followed, though. You can't just haul everyone in and browbeat them into a confession."

She sneered at me, and looked down at the man at her feet. My man.

"Well, he came to the right conclusion eventually, didn't he, with a little help."

"How did you get him down here?"

"I called him and told him to examine the names of his suspects."

"And he came here because of the river? Diego Rivers? Did he think he was meeting your husband?"

"Oh, I think after all he was brighter than that. In fact, if they were to check his computer history, I am sure they would see he had used a translation device before he left the police station."

"And what was he translating?"

She sighed and I felt insulted. After all, it wasn't as if I was against learning other languages. I spoke and read French at a working, if not poetic, level, and I had a smattering of German. In Puerto Vallarta, I had worked with a phrase book to attempt

to learn some Spanish. But apparently not enough for Alessandra, who had been so dismissive when I had thought she'd been introduced to me as Alexandra. Were we both going to die because of a social faux pas?

"He probably put 'Delahaya' into the translator, because he arrived here very quickly after we spoke on the phone."

"And what would he have seen on the translator?" I was really curious, but also I was still aware of trying to keep this madwoman talking.

"He would have seen 'of the beech,'" she smiled. My family is from northern Mexico, where the beech tree is more profuse, and the valley we are from is full of them. I thought it was something Diego would catch, since the paintings Frida made weren't set on the sandy shores. But like I say, I am not sure he wants to know the truth. And he has never really put his heart into learning Spanish, either."

Beech and beach. A homophone as the final clue, letting Steve know he was rounding third. He must have been certain he could hold his own against a tiny woman like Alessandra Delahaya, and got too excited to pull a full complement along with him.

It was as if she was reading my mind.

"I told him to come alone or my next victim would die. He thought he was coming to save someone else from my web, not become the fly."

"How did you manage to sedate him?"

"My cousin the pharmacist is such a handy man to know. The tranquilizer comes on little darts, for zoo veterinarians to

stick or blow onto their larger patients, who might be shy of a tranquilizer gun. When your man came up to me, I had a pop can with a straw in it. What he didn't know was that I had a blow dart in the straw. I hit him with the tranquilizer in the neck. It was very fast. He dropped like a tree being cut by a lumberjack. Timber!" She laughed again and I thought to myself, if I never heard that laugh again, it would be too soon.

So, Steve was tranquilized with some sort of large animal drug, not dead. Now that I had the time to think and notice, I realized that the gun she was pointing at me was Steve's police issue pistol. She had been planning to set him up in her so-called art piece, and then kill him. If I could keep her talking till the tranquilizer wore off, perhaps he could overpower her. Or maybe she would get tired herself, and fall asleep on her own and I could tie her up. Or maybe a flying pig would drop out of the sky and knock her out.

I was screwed. I had a flashlight, my phone, and some keys. She was out of reach with a gun on me, and totally in control.

"What brought you here, if you didn't get the play on words?"

"I just tried to think of the next setting in town where you would be going to create your art installation, and remembered Accidental Beach."

She shrugged.

"I'm impressed. You did it without a clue. Perhaps you should be the police officer in the family. Oh well, it doesn't really matter now, does it?" She took a step back from the duffle bag and Steve and waved me over to them. "You are just in time to be of service. I was relieved to see he had arrived in jeans, but I need

him dressed in a denim shirt and jacket. The shirt is almost on. Finish it."

I stumbled forward and reached out for Steve. Thank goodness, he was still warm, and I could feel his pulse faintly under his skin. She had stripped him of his thin cotton v-necked sweater, and managed to get one arm through a brand new denim shirt. I pulled him up into a sitting position and got the shirt around him, dusting the sand off his back as I did so.

"Don't worry about making him comfortable. It won't matter soon enough."

I buttoned up his shirt and pulled a denim blazer out of the duffle bag. This went on easier than the shirt, and soon Steve was lying down on his back again. I wasn't sure but I thought I heard him gasp a little as he settled into the sand. If only he would wake up.

"Now you, get changed." Alessandra waved at the duffle bag, in which I found a long green dress and a reddish orange pashmina. "Take off your shirt and jeans first."

I pulled off my jeans, kicking my running shoes off so that I could slip my feet out through the skinny legs. I tried to fold them so the items in my pockets didn't fall out, and set them beside my shoes. Then I pulled my sweatshirt off and reached for the green dress.

It didn't fit as well as Steve's clothes had fit him, which stood to reason if Alessandra hadn't actually meant to dress a real person with this costume. I couldn't get the zipper up all the way so I reached for the red scarf and draped it over my shoulders to hide the expanse of skin.

There was a plastic baggie in the duffle containing a green necklace and a green hair bow on a comb. My fingers shook as I tried to get the necklace clasps to meet behind my neck. The hair comb was easy to dig into the bun I made of my ponytail.

Alessandra motioned me to lie down next to Steve's left side.

"You really are too tall. Push your feet into the sand, and try to line up your knees with his ankles."

I sat up and tried to cover my legs with what was now rather cold sand. I shivered and couldn't seem to stop. The terror of being about to die was getting more and more real with every step I took to become Frida on her wedding day.

I too had worn a green dress on our wedding day. Had I subliminally been wanting to replicate this famous painting? I sure didn't want to be replicating it now.

Finally, Alessandra was satisfied with the height of my Frida, and I was allowed to set the little green shoes over top of where my legs began to be covered with sand. I was told to lie back and I did, reaching for Steve's left hand to hold. I was grateful to Kahlo for having painted them holding hands. If I had to die, at least it would be holding hands with the love of my life.

"You forgot the palette and brushes, you idiot." Alessandra was past being threatening, she was now just bossy. "No, don't move, you have to keep your legs covered. I'll get them."

She moved toward the duffle to get the palette and brushes that Diego held in his right hand, even on his wedding day, and as she did, I distinctly felt Steve squeeze my hand three times, our silent signal to say "I love you." He was alive, and what was more, he was aware of the situation.

Now I only hoped he had the strength and ability to move when he'd need to. I knew that he wanted me to lie still, and pretend I was still in Alessandra's thrall. I squeezed his hand back and tried not to smile and give it all away.

40

Alessandra grabbed my clothes and shoes, dropped them into the duffle, and pulled out the artist's props and an expandable rake, the sort I had seen and coveted in Lee Valley the last time we'd been there shopping for fruit fly traps. Lee Valley was the sort of store that made you want to crave a big lawn to mow and rake, which was saying something.

She pulled the duffle bag further away from us, her installation, and then moved around to Steve's right side to position the palette in his hand. I realized that she was no longer carrying either the lantern, which she had grounded into the sand behind her to illuminate the area, or Steve's gun. She had the palette in one hand and the rake in the other. She took some time to set the palette through Steve's thumb, and as she did, I felt Steve release my own hand.

Alessandra was just stepping back to stretch out the collapsible rake, probably to clear up the footprints all around, and maybe erase the traces of her on the beach entirely. She probably

didn't know what hit her, as Steve launched himself at her. I couldn't believe it myself. He went from completely prone to upright and diving at her, his head aimed at her chest, knocking her back. I sprang up to find the gun, which had to be somewhere near the duffle bag behind her, while Steve wrestled with her for the rake, which she was wielding like a sword.

In their scuffle, the lantern had been tipped over, and there was no light on the duffle. I scrambled out of my quarter grave of sand to where I thought it was, hauling the green dress up around my waist so as not to trip over the hem.

I couldn't find the gun. I reached around to pat the ground while Steve and Alessandra continued to battle. He was weak, I could tell, still fighting through what must have been a powerful tranquilizer, and though small and wiry, she was insane, so it was a fairly even match.

My hand found some of the paintbrushes stuck through the palette that she had been placing in Steve's hand. I grabbed them, figuring a pointed stick was better than nothing. Then my hand found the lantern, and I used it to sweep the ground around me. I still couldn't spot the gun, which led me to the awful realization that Alessandra must still have it.

I turned the lantern onto the fighting twosome. Steve was managing to hold her rake-wielding arm away from his face, but she was squirming out from under his pinning leg. She had madness and a clear blood stream on her side. Steve had training, adrenaline and a weight advantage. But somewhere in there, was a gun.

I aimed the lantern in her face, to give Steve more of an edge

and some illumination. I realized that I was screaming inartic-
ulate noises, possibly to summon people to our aid, but more
primal, motivated by sheer fear and fight instinct.

I saw Alessandra's non-rake hand move to her side, and a
flash of metal caught the light of the lantern.

"She's got the gun!" I screamed to warn Steve, who was still
wrestling the rake out of his eye and neck area. I saw him flinch
in understanding my shout, but there was nothing he could do
about it.

But I could. I launched myself onto her side, holding the
paint brush like a dagger, and aimed it straight into her arm pit,
where it wouldn't hit a rib or bone before it got to someplace
really painful.

As I struck, I felt Steve push toward her gun arm, as well. Two
shots went off, and then I felt her collapse under Steve's entire
weight, and I wrestled the gun out of her hand before the sear-
ing pain in my right shoulder set in.

I had seen it done a million times on television, but in reality
it took me two whacks of the gun barrel to Alessandra Dela-
haya's forehead before she lost consciousness. I added a couple
more just to be sure.

"Steve? Are you okay?"

"I've been shot, but I think I'll be okay. I've got my hand on
the wound. How about you?"

"My arm, she got me in the arm. I think she's out cold, unless
I killed her, which is okay by me, too."

Steve laughed shakily.

"She's alive. Randy, do you have your phone?"

"Mine's in my jeans, over in the duffle. Hang on. Are you okay to lie there?"

"Yep, take the gun away, though. And put it into the duffle so you don't set it off accidentally."

The Frida shawl I'd been wearing made do as a bandage around my upper arm, which I then flung over my neck and brought it around the front as a makeshift sling. That did nothing to ease the pain of the gunshot wound, but it did kept the pain from zinging up and down my arm with every movement.

I tried to get up, but felt too dizzy, so I crawled on my knees toward the duffle, trying not to bump my bullet-ridden right arm in the process.

I found the phone and dialed 9-1-1, and told them there was an officer down on Accidental Beach, that there had been shots fired, and that we'd need an ambulance as well as a police car for a murder suspect. The dispatcher wanted the address to Accidental Beach, which in my fuzzy state, I couldn't quite manage, though I did manage to say something like "98th Avenue and the North Saskatchewan River" before hanging up and dialing Iain.

I crawled back to Steve with my sweatshirt, which we used to staunch the wound in his left side, and took the rake from Alessandra's left hand, just in case. I tapped Steve on the shoulder lightly, to make sure he was still conscious. I couldn't have him passing out and her coming to.

He stirred and I saw him smile.

"We got our matching tattoos, after all."

"I guess we did." We laughed, but I could hear it hurt Steve to do so.

"Keller's really going to lace into me this time," I said, because I couldn't think of anything else while watching my lovely husband wincing in pain from a bullet wound and the previous fight for his life.

"I think he'll tone down the censure this time, Randy. You know you saved my life."

"Yeah, well, that was the promise, right? For better or worse."

"Yep, and this qualifies as 'worse.'"

"I'll say."

We lay there, conserving our energy, listening to the river and the torn breathing of an unconscious woman scorned. Somewhere a dog barked. It was turning back into an early summer night.

Eventually, we heard sirens.

Acknowledgments

This book has been an elegiac exercise, because it feels much like Dorothy L. Sayers' *Busman's Honeymoon,* the last Peter Wimsey tale. Nick and Nora aside, murder doesn't meld well with marriage on the whole. From the start, I had a feeling this might be Randy Craig's swan song. That said, who knows?

I would like to thank the people who helped me in this enterprise: Alex Hamilton helped with marriage in the pyramid details, Jana O'Connor filled me in on how to get down to Accidental Beach, my darling friend Marianne Copithorne gamely went on another "fact-finding" day with me—this time through the gallery district, and my own Randy Williams, who aside from being my ever-stalwart first reader, took several days out of his well-earned vacation to do murder walk research around town in Mexico. Carol Wright's sister donated quite a bit of money to Northern Light Theatre to get Carol into this book.

I would also like to thank all the lovely people of Puerto Vallarta who make us feel so welcome every time we visit. Please,

people, don't let a pesky fictional murder dissuade you from visiting this paradise of vacation cities.

The artists mentioned in the book, aside from the suspicious ones, are all real and very worth seeking out. We own several works by John Wright, Maria Pace-Wynters, Veronica Rangel and Larry Reese, and think everyone else should, too. We can't afford Sylvain Voyer, Ian Shelton, Harry Wolfarth or Margaret Mooney, but you should invest in them, too, if you are of a mind to. Edmonton is blessed with an actual Art Walk, the Works visual arts festival, and a glorious art gallery I contemplated sticking a body in, but at the final moment couldn't bring myself to besmirch.

I would also like to acknowledge all the people who have helped me out over the course of this series: Steve and Sharon Budnarchuk, Angie Abdou, Sharon Caseburg, Heather Dolman, Howard Rheingold, Jay Kuchinsky, Suzanne North, the late great Manuela Dias, and of course, my husband and true partner in crime, Randy Williams. What great fun it has been.

Sticks & Stones
by Janice MacDonald

How dangerous can words be? The University of Alberta's English Department is caught up in a maelstrom of poison-pen letters, graffiti and misogyny. Part-time sessional lecturer Miranda Craig seems to be both target and investigator, wreaking havoc on her new-found relationship with one of Edmonton's Finest.

One of Randy's star students, a divorced mother of two, has her threatening letter published in the newspaper and is found soon after, victim of a brutal murder followed to the gory letter of the published note. Randy must delve into Gwen's life and preserve her own to solve this mystery.

Spellbinding ...
—W.P Kinsella

...intelligent, thought-provoking and entertaining.
—Anna Babineau,
The Lethbridge Herald

This is one of those books that begs to be finished at 3 a.m. of the same day."

—Matthew Stepanic,
editor of *Glass Buffalo Magazine*

Sticks & Stones / $14.95
ISBN: 9780888012562
Ravenstone

The Monitor
by Janice MacDonald

You're being watched. Randy Craig is now working part-time at Edmonton's Grant MacEwan College and struggling to make ends meet. That is, until she takes an evening job monitoring a chat room called Babel for an employer she knows only as Chatgod. Soon, Randy realizes that a killer is brokering hits through Babel and may be operating in Edmonton. Randy doesn't know whom she can trust, but the killer is on to her, and now she must figure out where the psychopath is, all the while staying one IP address ahead of becoming the next victim.

[Janice MacDonald] has managed to convey the inherent spookiness … that a social cyberspace can invoke.

—Howard Rheingold

The Monitor / $10.99
ISBN: 9780888012845
Ravenstone

Hang Down Your Head
by Janice MacDonald

Some folks have a talent for finding trouble, no matter how good they try to be, especially Randy Craig. Maybe she shouldn't date a cop. Maybe she should have turned down the job at the Folkways Collection library—a job that became a nightmare when a rich benefactor's belligerent heir turned up dead.

Randy tried to be good—honest!—but now she's a prime suspect with a motive and no alibi in sight.

The Edmonton Folk Music Festival, the city itself and the fascinating politics of funding research in the arts lend a rich texture to this engaging mystery with the twisty end. If you enjoy folk music, you're in for an extra treat. Once again, Randy Craig is a down-to-earth, funny and realistic amateur sleuth: it's good to reconnect with her.

—Mary Jane Maffini, author of
The Busy Woman's Guide to Murder

I have been a performer at the Edmonton Folk Festival for 20 years. I always knew there were a lot of characters there, but until reading Janice's book, I never thought of the festival itself as a character, and a fine place for a murder mystery!

—James Keelaghan

Hang Down Your Head / $16.00
ISBN: 9780888013866
Ravenstone

Condemned to Repeat
by Janice MacDonald

For anyone other than Randy Craig, a contract to do archival research and web development for Alberta's famed Rutherford House should have been a quiet gig. But when she discovers an unsolved mystery linked to Rutherford House in the Alberta Archives and the bodies begin to pile up, Randy can't help but wonder if her modern-day troubles are linked to the intrigues of the past.

Condemned to Repeat *is a compelling tale of secrets from the past colliding with the present, along with a heavy dose of history and travelogue. Plus a murder or two. Not to be missed!*

—Linda Wiken, Mystery Maven Canada blogger, author, and former bookstore owner

Does for historic sites what she did for music festivals: strews corpses and intrigues in trademark MacDonald style, with giggles and gusto.

—Candas Jane Dorsey, author of
A Paradigm of Earth

Edmontonians in particular will enjoy following the genial Randy Craig through buildings and districts that are as familiar to them as their neighbours, and yet now imprinted with murder and mystery.

—Tom Long, Public Interpretation Coordinator,
Fort Edmonton Park

Condemned to Repeat / $16.00
ISBN: 9780888014153
Ravenstone

The Roar of the Crowd
by Janice MacDonald

Wherever Randy Craig goes, trouble seems to follow. With the help of her friend Denise, Randy has landed a summer job with a high school theatre program linked to the FreeWill Shakespeare Festival. But when a local actor shows up dead and Denise is the prime suspect, Randy has to find to a way to solve the mystery while surrounded with suspects who have no trouble lying to her face.

The Roar of the Crowd *is a terrific little mystery.*

—The Winnipeg Free Press

The Randy Craig books are like tourist guides wrapped in won-derfully-written mystery stories. They'll make you want to go to Edmonton and experience the vibrant cultural scene and explore the beautiful river valley.

—Stuff and Nonsense

The Roar of the Crowd / $16.95
ISBN: 9780888014702
Ravenstone

Another Margaret
by Janice MacDonald

Anxiety is the watchword at most school reunions, with side-eye comparisons of greying hair and extra pounds. Not for Randy Craig. She's more concerned with resolving a twenty-year-old CanLit scandal. While helping her best friend organize their reunion at the University of Alberta, Randy's tumultuous past as a graduate student comes rushing into the present, as she faces off against old ghosts and imminent death.

MacDonald does a terrific job capturing the seasons of the academic year: the heightened expectations of autumn, and then come April, everybody is crying. The send-up of academia is fun and smart, and also important in what Randy's work as a sessional instructor has to tell us about the precarious nature of academic work at the moment.

—Kerry Clare, Pickle Me This

Randy Craig is that longtime friend you can depend on to be high-spirited, witty, thoughtful, and best of all, fun. Another Margaret, the latest mystery in the series, revisits, updates, and solves the English Department murder committed in the first book, leaving the reader satisfied and looking for more.

—Catherina Edwards, author of *The Sicilian Wife*

Another Margaret / $16.95
ISBN: 9780888015518
Ravenstone

Find out more about Janice MacDonald and her writing at

www.janicemacdonald.ca